◆ *Art, Tea, and Industry*

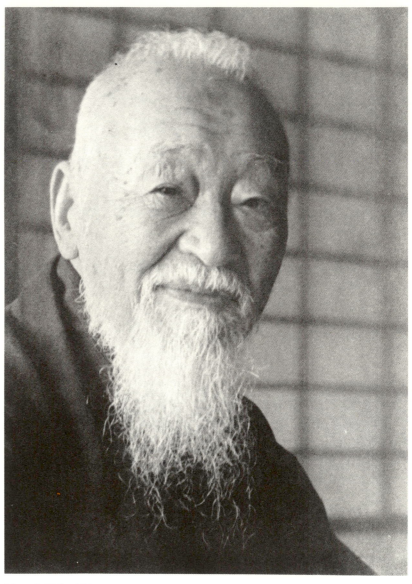

Masuda Takashi in 1938

Art, Tea, and Industry

◆

*Masuda Takashi
and the
Mitsui Circle*

Christine M. E. Guth

Princeton University Press
Princeton, New Jersey

Copyright © 1993 by Princeton University Press
Published by Princeton University Press, 41 William Street,
Princeton, New Jersey 08540
In the United Kingdom: Princeton University Press,
Chichester, West Sussex

Library of Congress Cataloging-in-Publication Data
Guth, Christine.
Art, tea, and industry : Masuda Takashi and the Mitsui
circle / Christine M.E. Guth.
p. cm.
Includes bibliographical references and index.
ISBN 0-691-03206-8
1. Art, Japanese. 2. Masuda, Takashi, 1848–1938—Art
collections. 3. Art—Private collections—Japan. I. Title.
N7352.G83 1993
709′.52′07452135—dc20 92-16173

The costs of publishing this book have been defrayed in part
by the 1992 Hiromi Arisawa Memorial Award from the
Books on Japan Fund with respect to *Noh Drama and the
Tale of Genji* and *Of Heretics and Martyrs in Meiji Japan* and
the 1990 Award with respect to *Crisis and Compensation:
Public Policy and Political Stability in Japan, 1949–1986*
and *The Artistry of Aeschylus and Zeami: A Comparative
Study of Greek Tragedy and Nō*, all published by
Princeton University Press. The Award is financed by
The Japan Foundation from generous donations contributed
by Japanese individuals and companies.

This book has been composed in Linotron Galliard
Designed by Jan Lilly

Princeton University Press books are printed on
acid-free paper and meet the guidelines for permanence
and durability of the Committee on Production
Guidelines for Book Longevity of the
Council on Library Resources

Printed in the United States of America

10 9 8 7 6 5 4 3 2 1

Collectors are, indeed, the last feudal lords.

Pierre Cabanne,
The Great Collectors

Contents

Illustrations

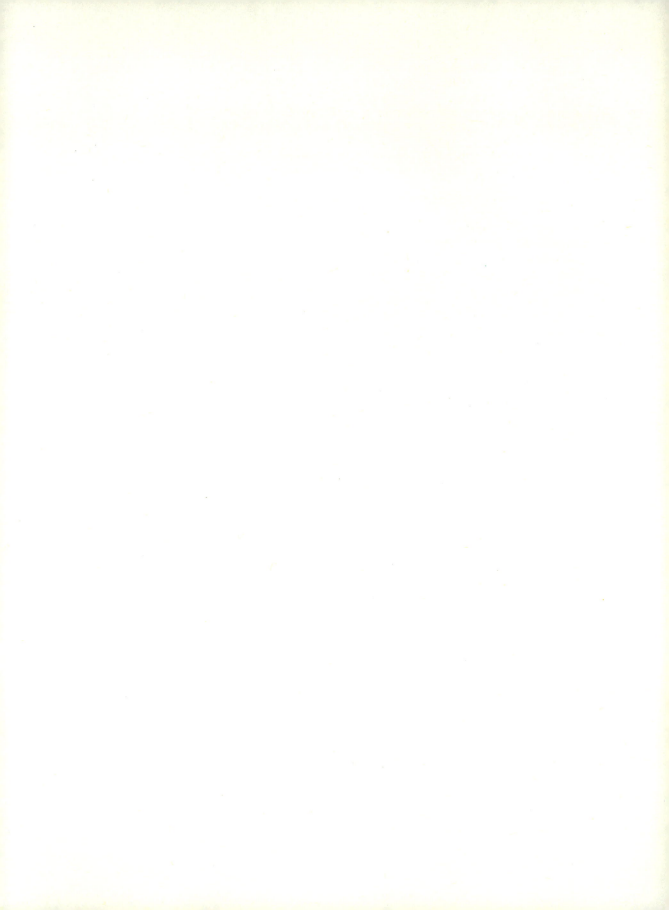

◆ Acknowledgments

This book had its beginnings in a visit to Richard and Peggy Danziger, the owners of several tea utensils that once belonged to Masuda Takashi. At the time, I knew Masuda simply as a name attached to a large number of exceptionally fine Buddhist paintings and sculptures. It was the Danzigers who first suggested that Masuda might be a good focus for a study of art collecting in Japan. In the years following that first visit, they were unfailingly generous in allowing me to study the tewares in their collection, often in the company of students or visiting scholars. In 1982 they agreed to loan a selection of works from their collection to a small exhibition entitled "Tea Taste in Kyoto" held at the Princeton Art Museum. The process of selecting and arranging objects for that exhibition was my introduction to *tori awase,* the "mixing and matching" that is essential to *chanoyu.* My interest in tea was whetted still further by visits to the Danzigers in the company of Professor Kumakura Isao of Tsukuba University. Following one visit, Professor Kumakura presented me with a copy of *Kindai chadōshi no kenkyū.* His discussion of the role of Meiji industrialist art collectors in the development of *chanoyu* offered both inspiration and guidelines for my own work.

In the research and writing of this study I have been assisted by many friends and colleagues in Japan and the United States. In Tokyo, Suzuki Takako, Shirasaki Hideo, and Iida Konichidō helped me locate and examine works that had belonged to Masuda, and the staff of the Mitsui Bunkō was kind enough to allow me to make copies of photographs of Masuda and other Mitsui men in their archives. For many of the personal photographs of Masuda and members of his family, I must thank Masuda Takashi's great-niece, Hatakeyama Hisako. I owe a special debt of gratitude to Takeuchi Jun'ichi, chief curator of the Gotoh Art Museum, who provided me with photocopies of many rare publications, suggested avenues of research I might not otherwise have considered,

and even sent me his copy of *Daichajin Masuda Don'ō*, a rare and indispensable publication I had been unable to locate in any library.

Over the years, many people have read and offered helpful comments on various parts of this book. In the early stages of my research, Professor Sidney deVere Brown was kind enough to answer my queries about Kido Takayoshi and his activities as a collector. Felice Fischer of the Philadelphia Museum of Art arranged for the loan of rare Meiji and Taishō era publications by Takahashi Yoshio in the museum's library. Mrs. Kim of the Gest Library at Princeton University arranged for interlibrary loans and helped identify my "Meiji mystery men." Karen Brock, Martin Collcutt, Louise Cort, Marius Jansen, Sandy Kita, and Melinda Takeuchi read and commented on preliminary versions of various chapters. Julia Meech and Thomas Rimer also offered many helpful suggestions. I owe a special word of thanks to Andy Watsky and, especially, Greg Levine, graduate students at Princeton University, for their thoughtful observations about both the form and content of the manuscript. I would like to express my deep gratitude also to Ellen Conant for her encouragement and, above all, willingness to engage in lively debates that helped me identify many of the issues that would become central to this book. I am also grateful to Beth Gianfagna at Princeton University Press for her careful oversight of the production of this book. The final words of thanks must go to my husband Tom, without whose advice and encouragement this manuscript could not have been completed.

Travel and research for this book were assisted by grants from the American Council of Learned Societies and Social Sciences Research Council and from the National Endowment for the Humanities. Acquisition of photographs and photographic rights was supported by the Metropolitan Center for Far Eastern Art Studies. Publication has been assisted by the Hiromi Arisawa Award Fund.

◆ *Art, Tea, and Industry*

Masuda Takashi's death on December 28, 1938, at the age of ninety brought to a close the golden age of Japanese art collecting. The half-century between 1878 and 1930 during which he formed his collection was an auspicious time for art collectors. In the political, social, and economic upheaval that followed the abolition of feudalism, many of the great art collections that had been assembled over the centuries by temples, rulers, and merchants were dispersed. It is probable that more art changed hands during this short time than at any other period in Japanese history. Although Masuda was only one of the new industrialist elite to benefit from this dispersal, his fierce acquisitiveness and eye for art enabled him to amass a collection of such staggering scope and quality that it was a legend during his lifetime. So influential was he in inspiring the activities of other collectors during and after his lifetime that he might well be called the prototype of the Japanese industrialist collector.

The director of Mitsui Trading Company from its founding in 1876 and of its parent, the Mitsui Company, from 1901 until 1913, Masuda belonged to the generation of men, born during the feudal rule of the Tokugawa shoguns, who laid the foundations for "Japan's modern economic miracle." Unlike the more cosmopolitan industrialist collectors who would follow him in the postwar years, Masuda was drawn to art forms whose aesthetic values were rooted in the Sino-Japanese cultural tradition. His collection, totaling more than four thousand items, included examples of Chinese, Korean, and even Southeast Asian art, but it was especially rich in Japanese art. It was so comprehensive that it could serve to illustrate a history of Japanese art from the seventh through the nineteenth centuries. Nearly every medium—painting, calligraphy, sculpture, lacquer, ceramics, metalwork—was represented by works that rank among the finest of their respective genres.

Despite the renown of his collection during his lifetime, Masuda's name is not as familiar today as that of many other collectors of his generation or the generation that followed him. Unlike Okura Kihachirō and Fujita Densaburō, or Nezu Kaichirō and Hatakeyama Issei, Masuda did not found a museum bearing his name. Nor did he donate his treasures to a public institution, as did the Western industrialist collectors of his generation whom he resembled in so many other ways. Neither the cultural climate nor the tax laws of prewar Japan encouraged philanthropy on the part of individuals.

The relative obscurity of the Masuda collection is due as much to the personality of the man who formed it as to the circumstances of its dispersal. When Masuda Takashi died in 1938, his collection was inherited by his son Tarō, a European-educated businessman who was less interested in traditional Japanese art than in Irving Berlin–style musicals. His apathy, together with the outbreak of the Pacific War only three years after his father's death, impeded efforts on the part of both family and friends to insure the future of this remarkable art collection. The collection survived the war unharmed, only to be dispersed as part of the dismantling of Japan's major industrial combines (*zaibatsu*) and purging of the business leaders associated with them.

Like most of the very wealthy men associated with Japan's four great industrial and financial combines—Mitsui, Mitsubishi, Sumitomo, and Yasuda—Masuda was not viewed very favorably in the frugal and reform-minded postwar years. As the chief executive of one of the nation's largest producers of armaments, he was seen as an agent in Japan's involvement in the Pacific War. Moreover, his extravagant life-style and monopolistic business practices, once widely accepted, if not admired, were now condemned. Like America's empire builders, Masuda and the other free-wheeling capitalists of his generation were now identified as "robber barons." He differed from his American counterparts only by merit of the fact that he actually was a baron, having been bestowed the title by the emperor in 1918.

Renewed recognition of Masuda's twin roles as entrepreneur and collector has come only in the past decade. The first hints of changing attitudes toward him came in a private exhibition held in 1980 at the galleries of Setsu Iwao, the son of the Tokyo art dealer

who bought most of the Masuda collection. There, gathered to-gether for the first time since the war, were nineteen works that had formerly belonged to Masuda. Most of them were on loan from the museums and private collectors to whom the Setsus, father and son, had sold them.

To anyone familiar with Japanese art, the quality and scope of the objects displayed left no doubt about Masuda's aesthetic dis-crimination. The exhibition included seventh-century camphor-wood figures of a heavenly musician and bird originally from the Golden Hall of Nara's Hōryūji temple; an eighth-century land-scape painted in ink monochrome on hemp and a ninth-century gilt bronze ritual tray, both thought to have come from the Shō-sōin Repository; an eighth-century drum core from Tōdaiji; a frag-ment of the eighth-century *Illustrated Sutra of Cause and Effects*; a fragment of calligraphy inscribed by ninth-century monk Kōbō Daishi; a twelfth-century statue of Shō Kannon from Kōfukuji; a twelfth-century lacquer saddle with mother-of-pearl inlays; a section of the twelfth-century illustrated scroll of *The Tale of Genji* and a thirteenth-century illustrated scroll of *The Diary of Lady Mu-rasaki*, both now classified as National Treasures; a thirteenth-century painting of the Buddhist deity Fugen Bosatsu; a fragment of a scroll with poems inscribed by Hon'ami Kōetsu over paintings of deer attributed to Tawaraya Sōtatsu; *Odawara*, a bamboo flower container made by tea master Sen no Rikyū; *Dontarō* a black Raku teabowl by Gensō; *Hirosawa*, a Shino ware teabowl; a square cov-ered dish with a design of pine trees and waves by brothers Ogata Kenzan and Kōrin; a painting of a musk cat attributed to Southern Sung Emperor Hui-tsung; and a calligraphic scroll by the four-teenth-century Chinese monk I-shan I-ning.

The Setsu exhibition was followed by other, more widely publicized shows at the Hatakeyama Art Museum and Mitsukoshi Department Store, both reflecting the enduring importance of family and business ties in the Japanese art world. The former, held on the fiftieth anniversary of Masuda's death, was a tribute to the role he had played in guiding the artistic development of Hatake-yama Issei, the museum's founder. It also reflected the relationship between the Masuda and the Hatakeyama families: the wife of the heir to the family headship is the granddaughter of Masuda's brother Eisaku. The latter exhibition was organized by the *Nihon*

keizai shinbun, Japan's leading financial newspaper, which Masuda founded in 1876, and was held at the Tokyo branch of Mitsukoshi, a department store founded by the Mitsui family.

Today, Masuda is hardly a household name in Japan, but he is no longer the obscure figure he once was. Nor does his name inspire the kind of suspicion or resentment it once did. In an era when Japan is enjoying the fruits of the success of its industrial pioneers, the public has come to recognize the energy, initiative, and vision Masuda and the other capitalists of his generation brought to Japanese trade and industry. Indeed, Masuda's opulent life and passionate pursuit of art have become the source of inspiration for a new generation of aspiring business magnates.

MASUDA and his peers' taste in art challenges the widespread assumption that the fall of the Tokugawa Shogunate in 1867 irrevocably changed Japan's cultural values. Meiji Japan, despite its aura of modernity, remained a deeply conservative society with values rooted in those that had prevailed during the 250 years of feudal rule. Meiji Japan's attitude toward its cultural heritage was very complex, to be sure, and Masuda's activities do not reflect it in its entirety. His aesthetic outlook, however, was typical of that of many men who formed the new industrialist class that emerged during this era and whose activities as collectors played an important part in the formation of the canon of traditional Japanese art.

Masuda's passionate pursuit of art was a manifestation of a personal quest for social legitimacy and of an effort to affirm Japan's cultural identity vis-à-vis the West. His taste for traditional art, especially treasures that had belonged to the great feudal rulers, was not simply motivated by a desire to retreat into a glorious past at a time when the nation's self-confidence was deeply shaken by its encounter with the West. In assuming ownership of these artistic treasures, Masuda was also assuming the political and social responsibilities traditionally associated with them. Like the rulers of feudal Japan, Masuda saw art collecting as a pleasurable activity that afforded the opportunity to demonstrate the personal cultivation that was expected of the ruling elite. He recognized that entrepreneurial success would follow from the adoption of modern Western technology, but he also recognized that political and social prominence required more than business acumen. Art col-

lecting for *chanoyu* was the time-honored means he chose to demonstrate that he possessed the cultural requisites of a true national leader.

Chanoyu, which literally means "hot water for tea," is in essence a practice that transforms an everyday activity into a ritual. Today chanoyu, generally translated as "tea ceremony," is widely regarded as an unchanging ritual practiced chiefly by women to promote self-discipline, outward humility, and good taste. This view does not accurately reflect historical reality, for chanoyu has evolved dramatically since its origins in the fifteenth century, and its status as a "feminine" art form is a modern phenomenon. Until the Meiji era, the practice of tea was a male prerogative, and tea utensils were valuable commodities as well as emblems of Japanese artistic taste.

Many of the qualities that distinguish Japanese art from that of other cultures are manifestations of "tea taste." Chanoyu contributed to the practice of viewing art as part of an ensemble arranged within the *tokonoma* (alcove) and adjoining shelves that are standard features of traditional Japanese residential architecture. It also contributed to the esteem for utilitarian articles such as teabowls, incense burners, and lacquer containers. Above all, it contributed to the Japanese taste for rough-textured, often deliberately crude and misshapen ceramics that served as aesthetic counterpoints to more elegant wares of Chinese inspiration.

The artistic requirements of chanoyu guided the activities of Masuda and his peers just as they had generations of Japanese collectors since the fifteenth century. And, just as earlier collectors had adapted the practice of tea to suit the needs of their age, so too Masuda did for his. Masuda developed a personal style of tea that included the display of works of art not traditionally associated with chanoyu. Many of these were religious objects that had been sold by impoverished Buddhist temples and shrines. He was among the first collectors to display Buddhist devotional painting, Buddhist and Shinto sculpture, and even iconographic drawings in the tearoom. He was also a pioneer collector of narrative handscrolls, another art form largely ignored by practitioners of chanoyu, because their themes and horizontal format did not lend themselves to display in the *tokonoma*. Masuda's taste was tactile as well as visual, and he was quick to recognize the beauty inherent in objects as unlikely as a saddle and a broken drum core. His imagi-

native yet timely arrangements for the alcove of his tearoom and clever incorporation of "found objects" among the utensils he used in preparing tea were so widely admired and emulated that scholars today liken his influence in the modern history of chanoyu to that of tea masters Sen no Rikyū and Kobori Enshū.

In an era when there were few art museums in Japan, Masuda's tea gatherings functioned as a kind of salon where fellow businessmen, art dealers, teachers, architects—anyone with a genuine interest—could view, discuss, and even handle fine works of art. In this way he not only helped to shape the artistic taste of his age, but also contributed to the growth of the market and study of Japanese art. Although Masuda hosted many intimate chanoyu for his friends and business associates, he is best remembered for his large-scale gatherings attended by hundreds of guests. The most famous of them was the Daishi kai, an annual tea gathering held on the grounds of his Tokyo estate that honored Kōbō Daishi, the ninth-century founder of the Shingon sect of Buddhism. This celebrated event, inaugurated in 1896 (and still held annually), was an impressive affair whose guest list read like a Who's Who of the Tokyo business, government, and cultural worlds. Guests at this event were invited to drink tea prepared by one of his friends or business associates in one of the many teahouses on his estate, to stroll around his beautiful garden, and to admire selections from his and other art collections displayed in an eighteenth-century building that served as his personal art gallery.

Masuda was initially drawn to chanoyu because of its ties to art collecting, but he was by no means oblivious to the social, political, and economic dimensions of its practice. He recognized the potential it offered as an agent of cultural and social change, and he hosted small tea gatherings for Mitsui employees to convey company values and structures, reduce conflict, and foster group bonding. A master at handling things behind the scenes, he used large-scale gatherings such as the Daishi kai to advance his own and, by extension, Mitsui's business interests. He even used this cultural extravaganza, which was well-publicized in the newspapers controlled by Mitsui and its allies, to curry public favor by exploiting the conviction, widespread among the Japanese public, that the nation's artistic treasures were being looted by foreign collectors. Art collecting, he claimed, was his patriotic duty.

Although Japan took intense pride in its rich artistic heritage, in the massive redistribution that occurred during the Meiji and Taishō eras, relatively few works of art were turned over to the government. Unlike postrevolutionary France, the Meiji government did not seek to nationalize works of art that had been in the possession of religious institutions, merchants, or aristocrats. Nor did it enact laws regulating the sale of the vast numbers of art treasures in private hands. Comprehensive art legislation designed to insure the protection of national treasures in both public and private collections was not enacted until the last decade of Masuda's life. Many of his younger collector friends supported these restrictions on their right to buy and sell art, but Masuda vehemently opposed what he saw as the government's infringement of his property rights. Masuda, who had outlived all the industrialist collectors of his generation, rightly foresaw that such legislation signaled the end of the era of Japanese art collecting in which he had been such a dynamic force.

THE STUDY of art collecting has a long history in the West. This is not true of art collecting in Japan. There are no Japanese counterparts to Francis Taylor's *The Taste of Angels*, a survey of the history of art collecting in the West; Francis Haskell's richly textured studies on art collecting and patronage in Italy, France, and England; or Gerald Reitlinger's monumental *The Economics of Taste*. Nor has there ever been any attempt to explore art collecting and its "linked phenomena" of art history, art markets, art forgery, and art museums, the theme of Joseph Alsop's unwieldy though provocative *The Rare Art Traditions*. Indeed, students of Japanese art rarely distinguish between the very different activities of art collecting, the acquisition of ready-made works of art, and patronage, the commissioning of works to one's personal taste or requirements.

Until very recently, with the possible exception of the personal possessions of the eighth-century Emperor Shōmu stored in Nara's Shōsōin and the collection of Chinese art formed from the fourteenth through the sixteenth centuries by the Ashikaga shoguns, there has been little systematic study of the development of art collecting in Japan. Although there are some studies treating the taste of celebrated tea masters, these tend to be narrowly focused and devoted primarily to determining the provenance of

existing works. This gap in Japanese scholarship is not due to a paucity of source materials: there are many records of temple and private collections as well as diaries and other sources that provide data concerning connoisseurship, transmission, value, art dealers, and the occasions and modes of artistic display. While there is no simple explanation for this seeming disinterest in the phenomenon of art collecting, it may be attributed at least in part to the legacy of the Neo-Confucian view that art collecting is an individualistic and selfish activity that is incompatible with a society in which self-interest must be subordinated to community interests. Although this Neo-Confucian ideology did not hinder courtiers, warriors, or merchants from forming vast art collections, it did hinder the glorification of the collector in writings of the Tokugawa (1615–1868) and Meiji (1868–1912) periods. This emphasis on communal values also helps to explain why chanoyu became an indispensable adjunct to art collecting. Chanoyu was an officially sanctioned activity that, under the guise of self-cultivation and statesmanship, made it possible for the nation's social and economic elite to indulge in the pursuit of art.

Because of the prominent role chanoyu has played in shaping Japanese taste in art and the importance its devotees have traditionally attributed to provenance, documentary materials pertaining to the collections formed for use in tea are abundant. In addition to records of private collections and catalogues of "famous objects" (meibutsu), the most important of these are tea diaries. Keeping a diary of the chanoyu one hosted or attended was a common practice among tea devotees that helped to keep track of who had been invited on a particular date, what they had been served, how the tokonoma was arranged, and which utensils had been used. Tea diaries, the earliest of which date to the sixteenth century, are invaluable tools for tracing patterns of artistic taste, display, and transmission. They also help to highlight the major personalities in the world of collecting and the political, business, and artistic networks to which they belonged.

The tradition of the tea diary did not die out in the Meiji era. Although their diaries are not as well known or as readily available in printed editions as those of earlier periods, Masuda and many of his powerful friends kept detailed records of all the gatherings they hosted or attended. Beginning in the 1890s, moreover, records of their teas became regular features in the nation's leading newspa-

pers. Many of the firsthand accounts of chanoyu held between the 1890s and the 1930s were written by Masuda's friend, Takahashi Yoshio (also known as Sōan, 1861–1937). Takahashi, a graduate of Keio University, worked as a journalist for *Jiji shinpō* before joining Mitsui Bank and Mitsukoshi Department Store, of which he became director. After taking an early retirement, he took up writing again, devoting himself chiefly to cultural and artistic matters. During the Taishō (1912–26) and early Shōwa (1926–89) eras, he was a regular columnist for the newspaper *Kokumin no tomo*. His columns were so popular that they were subsequently printed in book form. Renewed interest in Takahashi's writings in recent years has led to new editions of some these publications. For instance, *Tōto chakaiki*, a five-volume compilation of articles spanning the years from 1911 to 1919, has been reprinted with an introduction and extensive annotations by Kumakura Isao.

Takahashi was singularly well placed to record the activities of Masuda and other industrialist collectors in the Mitsui circle, but his observations on art and art collecting are also valuable since he was himself a devotee of tea and a highly regarded connoisseur. He is the author of *Kinsei dōgu idō shi* (History of the transmission of teawares in modern times), the first and, until quite recently, only survey of art collecting in early industrial Japan. Despite its somewhat anecdotal style, it remains a unique source of information about collectors, collecting, and auctions between 1868 and 1929. Takahashi also compiled the well-known *Taishō meikikan*, a multivolume annotated and illustrated catalogue of famous teawares, that contains the only photographic record of many articles lost during the Kantō earthquake of 1923.

Takahashi's many publications, especially his detailed records of tea gatherings and exhibitions, were the indispensable, primary tools in my efforts to locate works, many of them still in private hands, that once belonged to Masuda. With few exceptions—such as works contained in boxes with Masuda's seals or inscriptions, or works recorded in photographs of the period—the attribution of the works described in this study as "Ex-Masuda Collection" is based on Takahashi's voluminous records.

Publications dealing with collectors and collecting were rare in the years following World War II. Since 1980, however, several Japanese scholars and journalists have begun addressing the subject from various perspectives. In 1981, scholar Tanaka Hisao

published *Bijutsuhin idō shi: kindai Nihon no korekutatachi* (A history of the transmission of art: Japan's modern collectors), an overview of the activities and artistic taste of more than thirty collectors of the nineteenth and twentieth centuries. His pioneering study begins with a discussion of Masuda, whom he considers to be the prototypical modern collector. Shirasaki Hideo, a journalist with close ties to the art world, has written even more extensively on Masuda and other collectors in his circle. Although his lively two-volume biography of Masuda, *Don'ō: Masuda Takashi*, vividly conveys the interplay among art, tea, and industry that characterized Masuda's activities, the information presented is not altogether reliable. Kumakura Isao, a cultural historian with a particular interest in chanoyu, has made the most serious effort to grasp the role of individual collectors in the changing taste for art used in chanoyu. Among his many publications, *Kindai chadō shi no kenkyū* (A study of the modern history of tea), published in 1980, remains the most systematic treatment of the subject.

While the few studies that have appeared in Japan offer a valuable starting point for identifying major industrialist collectors and their collections, they do not address the larger issues that make the subject so compelling to Western readers. The need to view patterns of art collecting in nineteenth- and early twentieth-century Japan from a broader vantage point than has heretofore been the case is especially important since it was during this period that Japanese art first entered the international market, a development that had important consequences for collecting both in Japan and abroad. The examination of Masuda's activities and attitudes throws light on the role of art in the formation of Japan's self-image and its impact on the sale of art abroad.

Despite the widespread interest in Japan's industrialist art collectors engendered by their involvement in the contemporary art market, with the exception of Julia Meech's brief study of Matsukata Kōjirō, a pioneer collector of Japanese woodblock prints and Impressionist paintings, no Western scholar has yet written on the subject. Masuda, who like his American contemporaries Charles Freer, Henry Clay Frick, and John Pierpont Morgan both shaped and mirrored the artistic taste of his generation, offers an ideal focus for such a study. It is impossible to deal with every aspect of so multifaceted a phenomenon as art collecting through the activities of a single collector, yet Masuda's activities from 1878 until his

death sixty years later do illuminate many larger artistic questions. What motivated industrialists like Masuda to take up collecting? What cultural forces shaped their taste in art? What social functions did art collecting fulfill? What do their collections tell us about the history of Japanese art? Both the questions and the answers tentatively offered in this study should leave us reflecting about the present as well as the past.

◆ The Lacquer Writing Box

Masuda's lifelong passion for art collecting began in 1878 with the purchase of a lacquer box containing a writing brush, inkstone, inkwell, and inkstick—the implements traditionally used by the cultivated gentleman for writing and painting.[1] He bought this writing box just after Mitsui Trading Company (Mitsui Bussan Kaisha), of which he had only recently been made director, had successfully completed its first major venture in foreign trade: selecting and shipping Japanese crafts to the International Exposition in Paris. At the time, Masuda was a progressive young businessman who took pride in his fashionable Western attire, in his ability to record business transactions according to Western accounting principles, and in the ease with which he signed his name in roman script. Why would a man who had adopted all the outward signs of Westernization choose to buy a work of art that symbolized the cultural values of a society he had seemingly rejected?

The lacquer writing box was a prophetic purchase that tells much about the traditional aesthetic outlook that, despite his Western veneer, would guide Masuda's taste in art throughout his life. The timing of its purchase foreshadows the close ties between art and business that would characterize Masuda's activities as a collector. It also reveals that contact with the West heightened rather than diminished his sensitivity to his own culture.

Until the midnineteenth century, Japan had defined itself in the mirror of Chinese culture. In the Meiji era, however, the West replaced China as the standard against which Japan measured its strengths and weaknesses. Men like Masuda, who were both educated and, by the standards of the day, cosmopolitan, were among the first to see themselves through Western eyes. They rationalized that while Japan was technologically backward by comparison with Western nations, it was nonetheless the heir to a long and rich artistic tradition that was widely admired in the West. This early Western orientation not only set the stage for Masuda's professional career, but gave him the intellectual and economic means to explore his own artistic heritage through art collecting.

◆ *A Cosmopolitan Education*

Masuda was born in Aikawa, a town on Sado Island located in the Japan Sea about 150 miles northwest of the shogunal city of Edo, where five generations of Masudas, a minor samurai family claiming descent from a seventeenth-century physician, had lived. Sado Island was hardly a place one would choose to live or visit; because of its remoteness, it had long served as the place of exile of emperors, courtiers, Buddhist monks, and even ordinary criminals. Masuda's father Takanosuke lived there because, like his father before him, he supervised convict labor in the shogunal government's Aikawa gold mines, an important source of cash revenue in the largely agrarian economy of the Tokugawa period. Although Masuda Takanosuke belonged to the samurai elite that comprised a mere 6 or 7 percent of the country's total population, he was essentially an administrator, and as such, was as skilled in the abacus as he was in the brush. His ability to perform complex mathematical computations using the abacus set him apart from the majority of his peers.

In 1853, when his son was five, Masuda Takanosuke was appointed superintendent of the shogunal lead mines in Hakodate, a town even more remote than Aikawa, located on the southern tip of the island of Hokkaido. At that time Hokkaido, Japan's northernmost island, was still called Ezo, the name of the "barbarian" Ainu who had been its early and predominant inhabitants. It had long been noted as a prime fishing ground, but when Masuda was transferred there it had taken on new strategic and economic significance because the port of Hakodate, which overlooked the Tsugaru Straits through which ships heading for China and Russia needed to pass, made an ideal place to refuel. Western powers were especially eager to see Hakodate opened to their great steamships because the mines in the region promised an ample supply of coal.

Masuda's family first lived near the lead mines in a village whose only attraction seems to have been the splendid view of nearby Ezan, an active volcano. The family remained there only a short time, however, because of the limited educational opportunities it offered Takashi and his younger brother Kokutoku (1852–1903). Their next home was a large residence in Hakodate, a town of single storied houses with shingle roofs heavily weighted down

with rocks. Hakodate, like Gibraltar, nestled round the foot of a rocky promontory and opened up to a spacious bay that Perry described as one of the most accessible and safest in the world.[2]

Commodore Perry sailed into this bay the year after the Masuda family had moved to Hakodate. Although his entry was officially sanctioned by the commercial treaty he had just negotiated with the shogunate, local officials, who had not yet been informed of the terms of this so-called Kanagawa Treaty, were much alarmed by the arrival of his squadron of black ships.[3] Alarm, however, was soon replaced by curiosity. Since enforcement of the regulations limiting contact between Japanese and Westerners was difficult in this remote outpost, many local residents had close contact with their Western visitors. The diary of a merchant who was head of one of the city's blocks, for instance, "discussed whether [Commodore Perry and his crew's] buttons were genuine gold, examined their manners in the street, and judged each individual's taste in souvenirs. Evaluating them by the standards that applied to Japanese samurai, [the merchant] concluded disdainfully that some of the American officers were of inferior calibre."[4]

With the opening of its port to ships bearing American, Russian, British, and even occasionally French flags, Hakodate quickly became one of Japan's most cosmopolitan centers. With considerable foresight, Masuda Takanosuke arranged for both his sons to begin studying the alphabet. Masuda Takashi recalls that he began studying English in Hakodate under Namura Gohachirō, who had been sent there as the government's interpreter, but he must have studied Dutch, for at the time, Namura himself knew little or no English. Even a few years later, when Namura served as interpreter for the negotiations between the shogunate and the United States, he translated the Japanese ambassador's words into Dutch and an American interpreter then had to render them into English.[5] Although the Tokugawa government had first ordered its Dutch interpreters to learn English in 1808, Japan's negotiations with the West continued to be conducted in this manner until the 1870s.

The Masuda family remained in Hakodate for only six years before being transferred yet again, this time to the Office of Foreign Affairs in the shogunal headquarters at Edo. Such a transfer was not as unusual as it might at first appear since Masuda, having served the government in a port town, had had more firsthand exposure to Westerners than had most government officials in Edo.

Once in Edo, the eleven-year-old Masuda's education began in earnest. Like many other youths of his class, he studied the Four Books and Five Classics, the Confucian writings that were the foundations of traditional Japanese education. Under his father's tutelage he also learned calligraphy and the use of the abacus. A more unusual part of his curriculum was the study of English, which he pursued at Zenpukuji, the Buddhist temple that became the site of the first American Consulate in Edo. This early involvement in Western studies would prove valuable when Masuda's samurai status no longer guaranteed his livelihood.

Masuda's teacher was Tateishi Onojirō, an interpreter-in-training only a few years older than he, who had been nicknamed Tommy when he traveled to the United States in 1860 as part of Japan's first diplomatic mission abroad. Although one can only guess at the extent of his teacher's mastery of the English language, Masuda was fortunate in studying under Tateishi's tutelage since he was one of only two Japanese in Edo considered proficient enough to take on students.[6] His path smoothed by family connections as well as his study of English, young Masuda lied about his age to enter the Office of Foreign Affairs when he was only thirteen. (The normal age would have been fourteen or fifteen, following the traditional coming-of-age ceremony.) His first job was as an apprentice interpreter at the American Mission at Zenpukuji, one of several temples that, because of their large size and tradition of hospitality to travelers, had been pressed into service as residences for foreign diplomats. Although he served there only briefly, his experiences, particularly his contact with the Consul Townsend Harris, made a lasting impression.

Harris, whose chief mission was to conclude a treaty providing for expanded access to Japanese ports, freedom of trade, and the establishment of an American ministry in Edo, had been appointed as American consul in 1855. Masuda entered his service in 1861, just after his devoted Dutch interpreter Henry Heusken was assassinated by a band of antiforeign ruffians seeking revenge for the unequal treaties the shogunate had concluded with Western powers. The mood at the consulate was tense. The lives of foreigners and of the Japanese who cooperated with them were constantly threatened by the faction, whose motto was *sonnō jōi*, "revere the emperor and expel the foreigners." Following Heusken's death, the situation was so serious that the British and French ministers left

Edo for safer quarters in Yokohama. Harris, however, remained, gaining for himself the respect and admiration of Masuda and many others.

Masuda had such strong memories of Harris that years later, on December 19, 1936, when xenophobia had reached a hysterical frenzy matching that of the 1860s, he helped to dedicate at Zenpukuji a stone monument with a bronze inset bearing on one side a likeness of Harris and on the other a dedication in English, in his own handwriting. Masuda, who was ninety at the time, was not only the oldest living Japanese to have known this influential diplomat, but, in the words of then American Ambassador Joseph Grew, he was the "principal custodian of the Townsend Harris tradition."[7] Indeed, in the seventy years since his death in Brooklyn, Harris had been appropriated by Japanese business and government leaders as a symbol of the positive influence of the West. He had become the personification of *kaikoku*, "the opening of the country," that had led to Japan's emergence as a modern industrial power. As such, Harris was a valuable propaganda tool for those factions seeking to maintain a balanced outlook toward the United States. For Masuda, having already lived through one period of cultural dislocation, and now facing another, the dedication of the monument was as much a personal as a political statement.

Masuda's contact with Harris and other foreigners combined with his knowledge of English must have contributed to his being allowed to accompany his father as a member of the third shogunal mission sent to Paris to renegotiate the unfavorable terms of the Kanagawa Treaty of 1854. Masuda senior was the mission's paymaster. The earliest known photograph of Masuda Takashi is thought to have been taken about that time (fig. 1-1). Their ship, with its mission of thirty-three shogunal retainers under the direction of Ikeda Shigeaki, and including Masuda's future brother-in-law Yano Jirō among its official interpreters, left Yokohama on February 6, 1864, and returned in August of the same year. The mission traveled to Paris by land and sea, via Shanghai, Hong Kong, Singapore, Ceylon, Suez, Cairo, and Marseille.

The Japanese mission arrived in Paris at a time when it was the undisputed artistic capital of Europe. This cultural preeminence had been achieved largely through the spoils of the Napoleonic incursions into Italy, Belgium, Germany, Spain, and Egypt. Although there were museums in cities throughout Europe, the

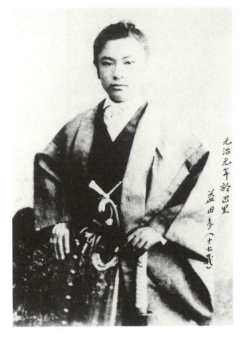

元治元年於巴里
益田孝（十七歲）

Figure 1-1. Masuda Takashi
circa 1864

Louvre, founded in 1793, was unchallenged in the scope and qualities of its holdings. Masuda himself may not have visited this museum, but other members of the mission must have been aware of its existence and recognized its value in preserving and protecting Europe's cultural heritage against the ravages of war.

Typical of most early Japanese visitors to Europe and the United States, Masuda's attention was drawn primarily to evidence of the West's technological and military superiority. He was awestruck by Paris's wide avenues, multistoried brick buildings, running water, and elevators, but above all by the horsemanship displayed by the French cavalry, which he saw in a military parade in Paris. So great was his admiration that when he returned to Japan, he joined the Western-style Japanese cavalry being organized under the direction of the Frenchman Chanoine. Masuda's lifelong interest in horseback riding may have been the catalyst for his purchase, years later, of an exquisite twelfth-century lacquer saddle decorated with delicate floral and animal motifs fashioned from mother-of-pearl inlays.[8]

Masuda was serving the shogunal cavalry on January 3, 1868, when the forces of the domains of Chōshū and Satsuma (in modern-day Yamaguchi and Kagoshima prefectures) staged a coup

d'état in Kyoto that marked the end of Tokugawa rule and beginning of the reign of Emperor Mutsuhito, known posthumously as Emperor Meiji. Masuda and his father were among the legions of men who lost their traditional means of livelihood as the new government, led by a coalition of progressive officials, plunged into ambitious institutional, economic, and social reforms intended to gain Japan the respect accorded Western nations. Feudal fiefs and class distinctions were abolished. Communications were revolutionized as railroad tracks and telegraph wires stretched across the countryside. Agricultural and textile production was mechanized. New eating habits and dress styles were promoted. Wrote one Western observer, "To have lived through the transition stage of modern Japan makes one feel preternaturally old; for here he is in modern times with the air full of talk about bicycles and bacilli and 'spheres of influence' and yet he can himself distinctly remember the Middle Ages. . . . Old things pass away between a night and a morning."[9]

◆ *Career in Foreign Trade*

Masuda fared better than most members of the former samurai class during the first decade of the Meiji Restoration because, unlike them, he was ready to change with the times. Commerce had been a marginal part of the rice-based Edo economy, and merchants, considered unproductive, were ranked lowest in the rigid class system. When faced with the loss of their fiefs and stipends, few former samurai were ready to challenge the traditional value system and enter the business world, and even fewer possessed the actual skills necessary to compete with experienced merchants. Those who did have economic and administrative experience—primarily from the Chōshū and Satsuma domains where there had been some effort to develop local industries before the fall of the shogunate—chose government service. Masuda, however, probably more out of necessity than choice, took a job as a clerk-interpreter in a small import-export firm.

A formal photograph taken about this time testifies to the curious synthesis of East and West that characterized the early years of the Meiji era (fig. 1-2). Masuda still has his hair in the traditional samurai manner, yet he wears Western-style trousers, a short

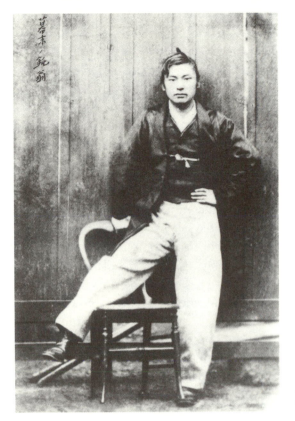

Figure 1-2. Masuda Takashi
circa 1868

jacket, and boots. His awkward pose, with one leg straddling a
chair, could almost stand as an emblem for the culture of the
period.

Both family background and advice from friends played a role
in Masuda's decision to enter the business world. He was doubt-
lessly predisposed in this direction by his father's administrative ex-
perience as well as by his own familiarity with the use of the abacus,
an indispensable tool of the Sino-Japanese business world, compa-
rable perhaps to knowledge of bookkeeping in the West. He may
also have been influenced by the progressive views of educator Fu-
kuzawa Yukichi (1835–1901), who was regarded by his countrymen
as the leading expert on all matters pertaining to the West. Masuda
would have been familiar with Fukuzawa's ideas not only through
his lectures and writings, but also through personal contact. The
two men had met in the 1860s and remained in touch after the fall
of the shogunate, when Masuda's father became Fukuzawa's secre-

tary and his younger brother Kokutoku became a student at Fukuzawa's school, the forerunner of Keio Gijuku Daigaku. Fukuzawa's experiences abroad had convinced him that trade was a key to Japan's becoming a modern, independent nation. Believing that the nation's prestige and glory depended on those who were willing to shed their traditional attitudes and take on practical employment once shunned by the educated classes, he urged men to fulfill their patriotic duty by going into business, law, and publishing rather than government. This theme was developed in his influential essay *Gakumon no susume* (An encouragement of learning):

> In former times, all the areas of life were constrained by the ancient system, so that even a scholar with a will had no scope to fulfill his ambitions. Today it is different. A new world is opening up before scholars, now that restrictions have been removed. There is no area in society to which he cannot devote his energies. There are hundreds of things to be done—farming, business, scholarship, government life, writing books, writing for newspapers, giving lectures on law, studying the techniques of learning, developing industries, opening the Diet chambers, etc. Moreover, our motive need not be mutual struggle among brothers, but intellectual competition with the West.[10]

Like many of the great entrepreneurs of the Meiji era, Masuda began his career in the port city of Yokohama, where trade was monopolized by foreign merchants experienced in international trade. His first job was as a clerk at Nakaya Seibeie. This was followed by a brief period as an employee of Walsh, Hall & Company, the leading American trading company in Yokohama. Both firms dealt chiefly in rice and tea, the commodities most in demand in the European and American market. And both hoped, by employing able Japanese clerks, to dispense with the services of Chinese middlemen.

Masuda's head for figures and working knowledge of English made him an unusual and highly desirable employee. He must have been aware of his rare qualifications: a photograph taken about this time shows a handsome youth with a Western-style haircut, jacket and tie, and a smile that radiates self-confidence (fig. 1-3). His talents brought him to the attention of Robert Alwin, a fellow employee and later partner at Walsh and Hall, who became a lifelong

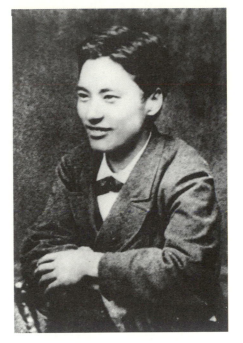

Figure 1-3. Masuda Takashi
circa 1870–75

friend and business adviser. Years later, when Masuda was already
established as one of the nation's leading traders, he still consulted
Alwin before undertaking new business ventures. The relation-
ship between the two men helped to cement Masuda's special ties
with the United States and also may have prompted the decision to
send Masuda's younger sister Nagai Shige (d. 1928) to study in the
United States.

 Nagai Shige was the daughter of Masuda Takanosuke's sec-
ond wife but had been adopted into the Nagai family—a common
practice among childless couples. In 1871, she was one of five girls,
aged eight to fourteen, carefully selected from among former samu-
rai or court families, to accompany the so-called Iwakura Mission,
the first delegation sent abroad by the Meiji government. At eleven,
Shige was neither the youngest nor would she become the most
acclaimed of the female diplomats: that honor went to Tsuda
Umeko, who later founded Tsuda College, Japan's first college for
women. Although Shige's long sojourn in the United States did
not have such a far-reaching public impact, it did have serious and
poignant personal consequences that give some idea of the enor-
mous price paid by the young Japanese of that time who traveled
abroad in the service of their country.

On the surface, her story seems perfectly straightforward. Shige lived in the United States for nine years, five of them with the family of the New Haven minister and amateur historian John C. Abbott, and four as a student at Vassar, where she majored in music, literature, and modern languages (fig. 1-4). When she returned to Japan in 1881, she was hired as a music teacher by the Department of Education. While in the United States, however,

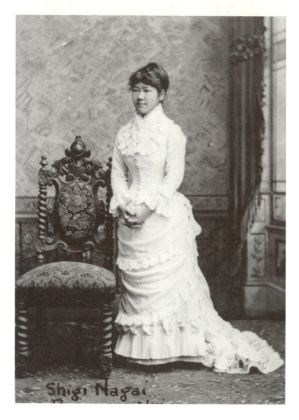

Figure 1-4. Vail Brothers Portrait of Nagai Shige (Baroness Uryū) while a student at Vassar, 1870s

Shige had met another young Japanese, Uryū Sotokichi (1857–1937), who was studying at the United States Naval Academy at Annapolis. He, like Shige, had converted to Christianity, and in 1882, after overcoming mild family opposition, the two were married in a Western-style church wedding. Later Uryū, who became a much decorated admiral due to his role in the Russo-Japanese War, is said to have claimed that "Vassar girls make good wives."[11]

Behind this apparent success story, however, there lies a very different story, of which Masuda gives only hints in his memoirs.

Sent abroad to assure a distinguished marriage, Shige returned a graceless alien in her own country. During her long stay in the United States, she completely forgot her native language. Her brother recalled that the only word she could remember was *neko*, cat, so that he had to tutor her himself. Despite his efforts, Shige's grandson recalled that family members often felt awkward when with her. When Shige and her sister-in-law went shopping, the need to interpret "the strange foreign tongue" she used caused other shoppers to stare in astonishment at this Japanese woman unable to speak properly. And, he added (doubtlessly with some exaggeration), "Although the Baroness [Shige] wore Japanese clothes and lived in a Japanese-style house, she never in all her life spoke Japanese fluently. In fact, she always spoke her native tongue with an English accent and she often coined words that confounded her friends. Most of her complicated conversations with the Admiral were carried out in English, even until the last day of her life."[12]

While his sister was away, Masuda moved from one job to another before finally settling into the position he would occupy for nearly half a century. His nine months at Walsh and Hall were followed by an even briefer tenure in 1871 as vice-president of the Mint. The Mint had been set up in Osaka only a year earlier as part of the new government's efforts to establish a standard currency, the yen, pegged to the Mexican dollar. Until the establishment of the Mint, over sixty kinds of gold, silver, copper, and iron coins of various forms, sizes, and qualities were in use. There were as many as 1,600 kinds of coins current within the feudal domains alone. This situation was made still worse by the fact that the Restoration government also issued its own coins.[13] In the absence of a national currency, much less international monetary standards, domestic and foreign trade was nearly impossible.

Masuda's appointment to the Mint came at the recommendation of Inoue Kaoru (1835–1915), an influential government official and entrepreneur, who recognized the young trader's business acumen and linguistic skill. Inoue would become one of Masuda's closest business associates as well as an early mentor in artistic matters. One of the central figures in the Chōshū bureaucratic faction that dominated the Meiji government, Inoue, like Masuda himself, had seen something of the world during his formative years. In 1863, with the approval of the lord of Chōshū, he and four other young

men, including Itō Hirobumi (1841–1909), who would become Japan's first prime minister, secretly went to England to study military and naval developments. They returned ardent admirers of Western technology, and in time they became active in the fight against the shogunate. When the new regime was declared, Inoue entered government service, holding a dizzying succession of posts including minister of foreign affairs, minister of the interior, and minister of finance.

Masuda remained at the Mint for barely a year before resigning to assume management of Senshū Kaisha, First Profit Company, a trading venture the enterprising Inoue and several partners had set up. Despite Masuda's managerial skills, problems soon arose because Inoue's partners made abrupt capital withdrawals and were involved in bribery, speculation, and counterfeiting.[14] One of these partners was Fujita Densaburō (1841–1912), who would go on to found his own successful business and become one of the most avid art collectors in the Osaka region. Another associate was Magoshi Kyōhei (1844–1933), later known as "Japan's Beer King." He too would become an important art collecter who often competed with Masuda for the acquisition of prized works of art. The fledging Senshū Kaisha was soon dissolved, but at the government's urging it was reorganized in 1876 through a merger with Mitsui's Kokusankata, National Products Company. The new company was called Mitsui Bussan Kaisha, Mitsui Trading Company.

Mitsui Trading Company was one of several enterprises operated by the Mitsui, a family of merchants who had been in business since the seventeenth century. Mitsui had become one of the most prosperous merchant houses of the Tokugawa period through its operation of a nationwide network of dry goods stores and money exchanges. Mitsui had introduced the marketing innovation of *genkin kakene nashi*, "cash payments and a single price," promoting cash payments instead of long-term accounts so as to charge less, and promising a single price to discourage interminable bargaining. They had pioneered the practice of selling fabrics of any length rather than the fixed kimono length that had been the norm. They had also created the prototype of the modern department store.

Admiration for the enterprising Mitsui family and the successful business they established is evident in a seventeenth-century collection of stories about the rise of the merchant class. The hero

of this account is thought to be Mitsui Takahira Hachirōemon (1655–1737), the eldest son of the founder of this merchant dynasty.

> In Suruga-chō . . . a man called Mitsui Kurōemon, risking what capital he had in hand, erected a deep and lofty building of eighteen yards frontage and eighty yards depth, and opened a new shop. His policy was to sell everything for cash, without the inflated charges customary in credit sales. There were more than forty skilled workers in his service, constantly under the master's watchful eye, and to each he assigned full charge of one type of cloth: one for gold brocades, one for Hino and Gunnai silks, one for habutae, one for damask, one for scarlets, one for hempen overskirts, one for woolen goods, and so on. Having divided the shop into departments in this manner, he willingly supplied anything which his customers asked for, however trifling—a scrap of velvet an inch square, a piece of imported damask suitable for the cover of an eyebrow tweezer, enough scarlet satin to make a spear-head flag, or a single detachable cuff of *ryūmon* silk. . . . By such means, the business flourished, and the average daily sales amounted to 150 *ryō*. The shop was a marvel of convenience to all. To look at, the master was no different from other men—he had the usual eyes, nose, hands, and feet—but in his aptitude for his trade a difference lay. He was the model of a great merchant.[15]

By the middle of the nineteenth century, the Mitsui shop in Suruga-chō—the forerunner of Mitsukoshi Department Store—had become such a landmark that it was featured among the "One Hundred Famous Views of Edo," the celebrated woodblock print series by Ando Hiroshige (1797–1858).

Although he may not have been aware of it initially, when Masuda joined the Mitsui family business, he was entering a world with its own cultural traditions. Like other wealthy merchant families, the Mitsui had long been noted for their patronage of the arts. They were important patrons of Kyoto painter Maruyama Ōkyo (1733–1795), for whose painting Masuda would also have an affinity (see figs. 5-11 and 5-12).[16] They were also enthusiastic devotees of chanoyu, the practice of which had been popular among affluent members of the merchant class since the sixteenth century. Over

the centuries, successive members of the family had amassed large collections of paintings, calligraphy, teabowls, tea caddies, and other tea utensils required in the pursuit of this elegant pastime (see fig. 1-5). For merchants of the Tokugawa period, these treasures were valuable financial assets as well as emblems of culture—a dual role they continued to assume among the industrialists of the Meiji era.[17]

Figure 1-5. Katatsuki Tea Caddy *Kitano*

That Mitsui was one of the few old, well-established merchant houses to survive and prosper under the new Meiji regime was due in large part to its long-standing practice of entrusting the actual management of the firm to a head clerk or *bantō* from outside the family. This tradition would contribute to the extraordinary power and respect that Masuda as *bantō* would later achieve vis-à-vis members of the Mitsui family.

Minomura Rizaemon (1821–1877), who was appointed *bantō* in 1866, helped Mitsui to navigate safely through the risky political waters of the final years of the Tokugawa regime, and so insured

the future government leaders' good-will toward the Mitsui House. Minomura's cultivation of the Chōshū faction was rewarded by Mitsui's appointment as the new government's treasury agent, a privilege that helped Mitsui regain financial stability during the early years of the Restoration. Minomura also pushed forward a variety of important organizational reforms. Despite objections from the Mitsui family, he had the company move its headquarters from Kyoto to Tokyo, which he rightly foresaw would become the nation's economic center. He separated the old-fashioned and now unprofitable Echigoya from other family enterprises. He was also behind the formation of both the Mitsui Bank and the forerunner of Mitsui Trading Company.[18]

Since its own trading firm was not profitable, Mitsui bought Senshū Kaisha very reluctantly. The deal was made more attractive through Inoue's promise to make the new firm the official government agent for various goods required by the army. A further incentive was that Masuda, who had, despite all odds, turned a modest profit at Senshū Kaisha, agreed to assume management of the new company. Because of uncertainty about the venture, however, the Mitsui Bank allowed the new firm only fifty thousand yen, a relatively small line of credit, and insisted that Masuda himself invest all his savings in the new company.

Despite the minimal financial outlay, Masuda's able management and Inoue's behind-the-scenes advice insured that the new company got off to a good start. Mitsui Trading Company earned lucrative commissions from the sale of army supplies to the government during the Satsuma Rebellion of 1877. Soon after, commissions from the sale of coal from the government's Miike Mines enabled the firm to establish branch offices in Shanghai, Hong Kong, and New York. These steps were the prelude to its metamorphosis into Japan's largest general trading company.[19]

Masuda's work at Mitsui Trading Company led to a variety of related entrepreneurial activities. One of the most influential was the publication in 1876 of Japan's first business journal, the *Chūgai bukka shinpō* (Domestic and foreign price reports). The first Japanese publication to provide information about domestic and international market conditions, it enabled Japanese traders to buy and sell goods more profitably by dispensing with the need for foreign middlemen. The newspaper was an immediate success, spawning many similar publications, but its association with Mitsui gave it a

clout few others could match. The *Chūgai bukka shinpō* was the forerunner of the *Nihon keizai shinbun*, Japan's equivalent of *The Wall Street Journal*.

Masuda's choice of advisers in this enterprise showed that he knew how to surround himself with the right people. Indeed, his facility for choosing capable men to advise him in areas where he had no expertise would be one of the keys of his success. One of his partners in this venture was his brother-in-law Yano Jirō, formerly an interpreter for the shogunal government and now the director the Tokyo School of Commerce (Tōkyō Shōgyō Gakkō), Japan's first business school and the forerunner of Hitotsubashi University. Yano had become director when financial difficulties forced the school to dispense with the services of the American, William Whitney. His daughter, Clara Whitney, though hardly unbiased, described Yano as "a tyrant who rides everyone to death, a hard cruel, unrelenting broker with an eye to business in every bargain."[20] The second partner was long-time friend Fukuchi Gen'ichirō (1841–1906), the chief editor of the *Nichi nichi shinbun*, Japan's leading daily newspaper. Fukuchi was an enthusiastic promoter of Western business practices who also enjoyed traditional cultural pursuits, including chanoyu and art collecting. The third partner was Shibusawa Eiichi (1841–1931), an idealistic banker and industrialist with close ties to Mitsui. Masuda had met Shibusawa when both had served in the Finance Ministry. Just before his death in 1876, Minomura Rizaemon tried to persuade Shibusawa to succeed him as Mitsui's chief clerk, but Shibusawa declined. He did, however, agree to serve as an adviser to Mitsui and in this capacity became one of Masuda's close friends and business associates.

◆ *Art Collector Kido Takayoshi*

Masuda's network of acquaintances in the government and business worlds grew steadily over the course of the 1870s. Although it is often assumed that the progressive leaders of Meiji Japan totally discarded traditional cultural values, only to rediscover them suddenly in the 1880s, art collecting, poetry and paintings gatherings, and even chanoyu continued to be popular pastimes among the new elite. While Masuda himself did not yet have the means to collect art on more than a modest scale (additional income, he claimed, was the chief motivation behind the founding

of the *Chūgai bukka shinpō*), his relationship with men who did fostered a taste for art as well as an awareness of the social value of art collecting.

Art collecting was hardly a new avocation for either government officials or men involved in commerce. Samurai and merchants of the Tokugawa period had played an important role in the promotion and patronage of painters, calligraphers, and craftsmen. Most also practiced, with varying degrees of skill, at least one of the four gentlemanly accomplishments of music, calligraphy, painting, and *go*, a game like chess. Convivial gatherings where both professionals and amateurs, often fortified with sake, painted, versified, practiced calligraphy, or discussed works of art from their collections were central to the social and cultural life of cities, towns, and villages throughout Tokugawa Japan. Participation in such artistic activities was the mark of a cultivated gentleman. The advent of the new Meiji regime altered neither the importance traditionally attributed to self-cultivation nor the ways in which it was demonstrated.

Art afficionados among Masuda's early acquaintances included government officials Kido Takayoshi and Inoue Kaoru, bankers Shibusawa Eiichi and Yasuda Zenjirō, and entrepreneurs Okura Kihachirō and Fujita Densaburō. All were men somewhat older than Masuda himself who had in common an education centered on the knowledge of Chinese language and culture that, in feudal Japan, had been the prerequisites of the educated man. And yet, all were progressives who simultaneously promoted Western technology and traditional cultural values.

Kido Takayoshi (1833–77) was an influential senior government official originally from Chōshū, whom Masuda met while employed at Inoue's Senshū Kaisha.[21] During the short nine years period between the inauguration of the Meiji era and his death of tuberculosis at age forty-three, Kido held many influential posts in the new government. He was instrumental in laying the foundations for the abolition of the feudal system, the establishment of the prefectural system, the revision of treaties with foreign countries, and the establishment of a national assembly. His official duties, however, did not diminish his involvement in cultural pursuits. His journal, the most reliable source of information about traditional culture in the first decade of the Meiji era, paints a richly detailed picture of the public and private worlds of a conscientious official

whose unfulfilled dream it was to retire from public service and devote himself to the pursuit of the arts.

Like many of his peers, Kido was a collector of literati art—a style of painting and calligraphy that had been introduced from China to Japan in the seventeenth century. Literati art, like all things associated with China, had been in vogue throughout Japan during Kido's youth and continued to enjoy favor in the early Meiji era as much for ideological as for aesthetic reasons. Two of its leading exponents, calligrapher and painter Rai San'yō (1780–1832) and painter Watanabe Kazan (1793–1841), were seen by Meiji leaders as forerunners of the Restoration: San'yō as the author of a history of Japan advocating the restoration of the emperor and Kazan as an early advocate of opening Japan to West. Tanomura Chikuden (1777–1835), Kido's favorite artist, was a disciple of Rai San'yō.[22]

Kido may have owned as many as twenty-five or thirty paintings by Chikuden.[23] One early acquisition was a scroll of plum blossoms purchased from the Osaka antiquarian Yamanaka, a member of a highly successful dynasty of art dealers that by the end of the Meiji era would have shops in Japan, Europe, and the United States. Another, a painting showing a white-robed Kannon, had been a gift from the governor of Shimane Prefecture. Still another had been purchased for forty yen from his protégé and fellow collector Inoue Kaoru.[24] His favorite work, however, was a series illustrating "the artist's travels on the Inland Sea," a scenic region not far from his hometown. Kido was so fond of this album that he carried it with him—perhaps to prevent homesickness—when he went to the United States and Europe in 1871 as part of the Iwakura Mission.[25]

Although he was chiefly interested in Chinese and Japanese painting, Kido was open to Western art as well, and during his travels abroad he visited many art galleries and museums. In Washington he marveled at the fact that paintings were selling for more than ten thousand dollars, and at the hundreds of "pictures showing Indians hunting, fishing, or else engaged in other traditional activities," on display in the Smithsonian.[26] But nothing impressed him more deeply than his visits to ancient Roman sites. The account of his visit to Pompeii in the company of arms dealer Okura Kihachirō (1837–1928), who would become the first industrialist

collector to found a private museum, is the single longest entry in his nine-year journal.[27]

Kido was also a patron and friend of many painters, calligraphers, and craftsmen. He regularly attended sales exhibitions organized by fellow patrons or dealers and invited his favorite artists to join him at parties. Women painters Okuhara Seiko (1837–1913) and Noguchi Shōhin (1847–1917) and lacquermaker Hashimoto Ichizō (1817–1882) were often among the guests when Kido and his political and business affiliates gathered at teahouses.[28] These club-like gatherings provided the relaxed atmosphere and privacy for discussions of the latest political developments as well as the occasion for amateur artists and calligraphers, like Kido himself, to demonstrate their skills. Occasionally, as depicted in a painting of the period by Kawanabe Kyōsai, professionals and amateurs collaborated in the creation of a work, each contributing a pictorial motif or calligraphic inscription, usually in Chinese (fig. 1-6). Well-prepared guests carried fans with them, ready for decoration. Once completed, they were exchanged, like photographs, as mementos.

In East Asia, where Chinese was the lingua franca, gatherings of this type were also an accepted part of international diplomacy. The inability to participate in such cultural activities was but one of many factors that prevented the development of friendly, informal relations between Japan and the West during the early Meiji era. Although Chinese, Korean, and Japanese diplomats could not converse with one another, they could at least communicate with the brush. When Japanese entertained Westerners, however, they were often forced to improvise. British diplomat Sir Ernest Satow recalled a banquet where "while we drank and conversed, a pair of anatomical models of the male and human female body, life size, were exhibited and taken to pieces for my especial edification."[29] But more often than not, artists were called in to dash off amusing sketches that the guests kept as souvenirs. The painter Kawanabe Kyōsai was especially renowned for his skill in executing impromptu compositions.[30]

While art collecting might be a solitary pastime, art appreciation was invariably a communal activity. Kido was fond of both chanoyu and the more informal Chinese-style *sencha* (steeped tea) that was closely allied to his interest in literati art, and many of his acquisitions were intended for display in the tokonoma or adjoin-

Figure 1-6. Painting and
Calligraphy Party, Kawanabe
Kyōsai

ing shelves during tea gatherings. Although he, like fellow collec-
tors all over the world, complained that "most antiques now are
trashy," he had frequent dealings with antiquarians in Osaka,
Kyoto, and Tokyo who specialized in items associated with the
Chinese and Japanese tea cultures.[31] On one occasion alone, he pur-
chased a flower vase, an imported tile, a writing box, a lacquer tray,
and a dish from China.[32] He also acquired fashionable Western-
style wares. One day, when Inoue Kaoru was among his guests for
tea, the alcove of his tearoom held an eclectic arrangement that in-

cluded a crystal vase and a celadon incense burner.[33] The popularity
of both tea styles among cultured government officials and busi-
nessmen during the first decade of the Meiji era assured a small but
significant domestic market for the many varieties of crafts, both
old and new, that were increasingly finding buyers outside Japan
as well.

◆ *The Lacquer Writing Box*

Because of the extraordinary favor lacquer, silk, ceramics, and
other crafts found in Europe and America, their production was a
high priority for the debt-ridden Meiji government. Japan had al-
ways taken great pride in its cultural heritage, and in the early Meiji
period that pride helped to lessen the embarrassment caused by the
nation's technological backwardness. Eager to develop domestic
industries to bring in foreign exchange, both state and local gov-
ernment officials were quick to recognize that until Japanese-run
shops could be opened abroad (Mitsui Trading Company's Paris
shop would be the first), the international expositions were the best
means of reaching this foreign market. Domestic political prob-
lems, the lack of a fixed medium of exchange, and inexperience in
international trade, however, prevented either the government or
private enterprise from taking advantage of the growing enthusi-
asm for Japonoiserie until the mid-1870s.

Although Japanese crafts had been included in the London
Exhibition of 1862 and in the Paris International Exposition of 1867,
the Vienna International Exposition of 1873 was the new govern-
ment's first effort to promote the sale of crafts abroad. The Japa-
nese display was so successful that it was followed by still larger
ones at the Philadelphia and Paris expositions of 1876 and 1878.
These international expositions were intended primarily to pro-
mote technological and commercial development, but in an age
when international travel and communications were still relatively
restricted, they were also instrumental in fostering greater aware-
ness of other cultures. Japan capitalized on this by including in its
displays models of famous architectural landmarks and examples of
traditional art, as well as by preparing informative catalogues with
data on such topics as Japanese geography, history, and even the
techniques used in the production of lacquer and ceramics.[34] By

placing at the disposal of European and American visitors both the best of contemporary artistic production and selected examples of the arts of earlier eras, the expositions also contributed to the growth of an international market for Japanese art.

Many men whose artistic appetites were first whetted by the expositions—the Goncourt brothers and Louis Gonse in France and William Walters and William Sturgis Bigelow in the United States, to name only a few—went on to assemble major collections of Japanese art. Ironically, the same art dealers who aided these Western collectors in their quest for Japanese art were also instrumental in guiding Masuda's first steps in the world of art collecting. One of them was Wakai Kenzaburō (1834–1908), a knowledgable and well-connected Kyoto antiquarian with a special interest in tea utensils whom Masuda first met through his firm's involvement in the 1878 Paris Exposition. The fact that Wakai was active in both Japan and the West was one of many signs of the new internationalism in the market for Japanese art.

Wakai had helped select Japan's well-received contributions to the Vienna International Exposition of 1873 and the following year helped to found the Kiritsu Kōshō Kaisha (Kiritsu Industrial and Commercial Company) for the purpose of supplying high-quality crafts for the Western market. Many of the ceramics, lacquerware, and metalwork displayed at the 1876 Philadelphia and 1878 Paris Fair were either products of or brokered through this company. For the Paris Exposition, Wakai also displayed a selection of tea ceremony utensils from his own collection. These sober ceramics, however, did not appeal to European viewers accustomed to brightly colored porcelains and enamel wares. The disparity between his personal taste and that of his European clients is highlighted by the comments of French critic and collector Philippe Burty. "M. Wakai," he wrote, had "paid less attention to the study of European taste than to classical traditions. He had placed on his shelves specimens but little varied, with flat covers of ivory, cups of all sizes with mouths more or less widened, and whose outlines were constantly indented with fantastic fingermarks."[35] Although Wakai would subsequently open a successful Paris shop together with Hayashi Tadamasa, a dealer noted for his fine woodblock prints, his activities there ceased around 1886, when he returned to Japan and became one of the chief agents of industrialist collector Kawasaki Shōzō (1837–1912).[36] Masuda also resumed his

acquaintance with Wakai during this period: one of his prize acquisitions, a painting of Ch'an (J. Zen) eccentrics Han-shan and Shih-te (J. Kanzan and Jittoku) by Yuan master Yin-t'o-lo, was purchased from him around 1890 (fig. 1-7).[37]

Figure 1-7. Han-shan and
Shih-te, Yin-t'o-lo

Masuda's initial encounter with Wakai and his then assistant Hayashi, who would later be employed as one of Mitsui Trading Company's Paris agents, must have occurred in 1877, when the government ordered the firm to help supply and ship a selection of crafts for display in Paris.[38] While the 1878 Paris International Exposition was the first in which Mitsui Trading Company was participating, its parent company already had been promoting the production and sale of crafts to the domestic and foreign markets for some time. Mitsui had been among the first of the established merchant houses to open a branch of its dry goods store in Yokohama to sell brocades to the town's foreign residents and visitors

Figure 1-8. View of the
Yokohama Branch of Mitsui's
Drapery Store, Sadahide

(fig. 1-8). Its involvement in Kyoto's textile industry had also led it
to help underwrite the Kyoto Exhibition of 1872, an event that in-
cluded displays of the arts and crafts for which the old imperial
capital had long been celebrated.[39]

Helping to select his firm's contributions to the International
Exposition gave Masuda his first real opportunity to meet art deal-
ers and to handle works of art, and it culminated in the purchase of
the lacquer writing box he considered the beginning of his art col-
lection. Since his memoirs do not include a description of its ap-
pearance, it is not known if it was a contemporary work or one of
an earlier era, or even if it was an item included in the exhibition.
In his capacity as president of Mitsui Trading Company, however,

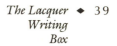

Figure 1-9. Lacquer Writing
Box with Irises and Bridge,
Ogata Kōrin

Masuda would have had the opportunity to examine both the old
and the new lacquers sent to Paris. He also would have had the
opportunity to purchase works exhibited in Paris but not offered
for sale to foreign collectors. One of the most celebrated examples
of Japanese lacquer, the so-called Yatsuhashi or "Eight Bridges"
writing box by Ogata Kōrin (1658–1716), for instance, was exhibited
in Paris before its purchase by Tokyo National Museum (fig. 1-9).[40]

Although nothing is known about the writing box, the fact
that Masuda considered it to be the start of his collection is a telling
sign of his special responsiveness to three-dimensional art forms. In
later years, his appreciation of the plastic arts would be manifested
in the acquisition of objects as diverse as Buddhist sculpture, sad-
dles, and drum cores, but above all in his search for ceramic and
lacquer tea utensils that appealed to both the hand and the eye.

At the time Masuda acquired his writing box, lacquer was
considered one of the quintessential forms of Japanese artistic ex-
pression. While fine lacquerware was a rarity admired in the West
for its exotic designs and technical perfection, in Japan it was a part
of daily life. Many articles in affluent households were coated with
this lustrous, durable, and waterproof substance: containers for
food and drink, chopsticks, racks on which clothing was draped,
and boxes of various sizes and shapes for clothing, documents, and

other valuables. While a Western collector who bought a writing box might marvel at its craftsmanship and delight in the exotic motifs figuring on its lid, to that collector the box was no more than a curiosity, a bibelot whose display evinced an up-to-date and fashionable interest in Japonoiserie. To a Japanese collector like Masuda, however, a lacquer writing box was a work of art with a practical function.

Despite the popularity of fountain pens among progressive businessmen, Masuda, trained from childhood in the art of calligraphy, continued to use the traditional hair brush for personal correspondence and special occasions, priding himself in his fine hand. Throughout his life, he thought of calligraphy not simply as a means of written communication like Western penmanship, but as a highly expressive art form linked to poetry and painting, whose practice enhanced aesthetic sensitivity (fig. 1-10). Through the acquisition of a beautifully crafted lacquer box containing all the implements required for writing and painting, Masuda sought to identify himself as a man of taste and cultivation.

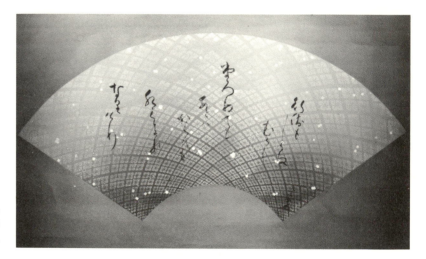

Figure 1-10. Calligraphy on Decorated Paper in the Shape of a Fan, Masuda Takashi

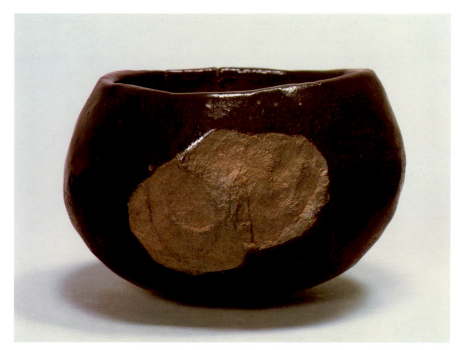

Plate 1. Raku Teabowl *Dontarō*

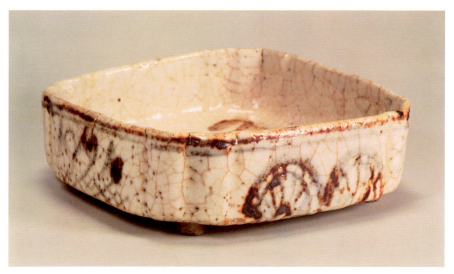

Plate 2. Shino Plate with Half-Wheel Motif

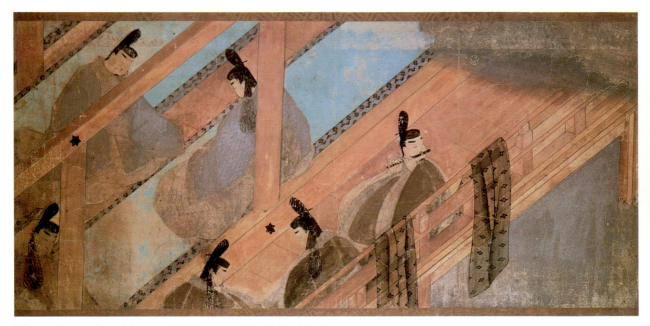

Plate 3. Illustration of Suzumushi Chapter of *The Tale of Genji*

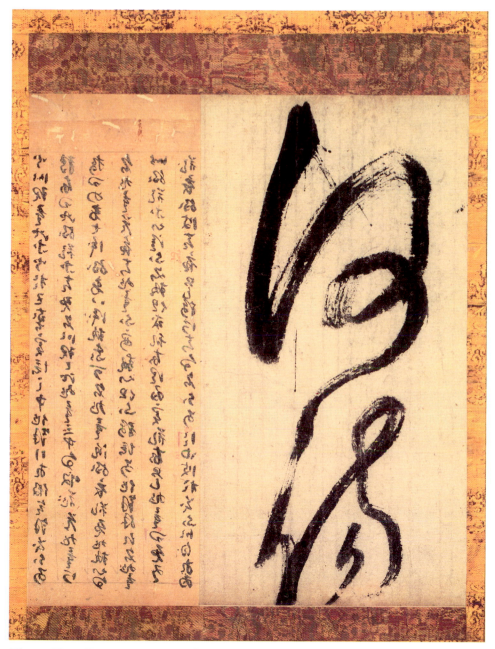

Plate 4. Two-Character Fragment of *Tsu yu Ming* (*Zayu no Mei*) Inscribed by Kōbō Daishi

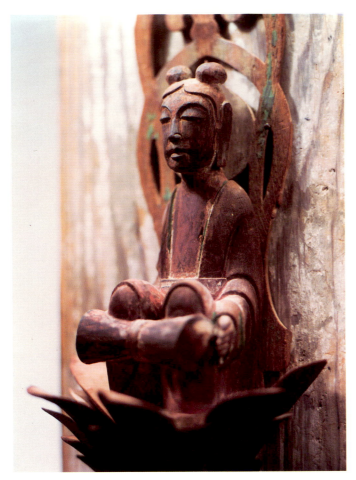

Plate 5. Heavenly Musician
(Apsaras) from Hōryūji

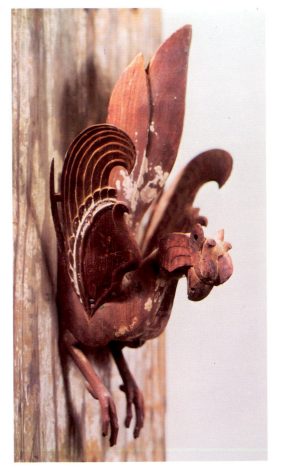

Plate 6. Heavenly Bird from
Hōryūji

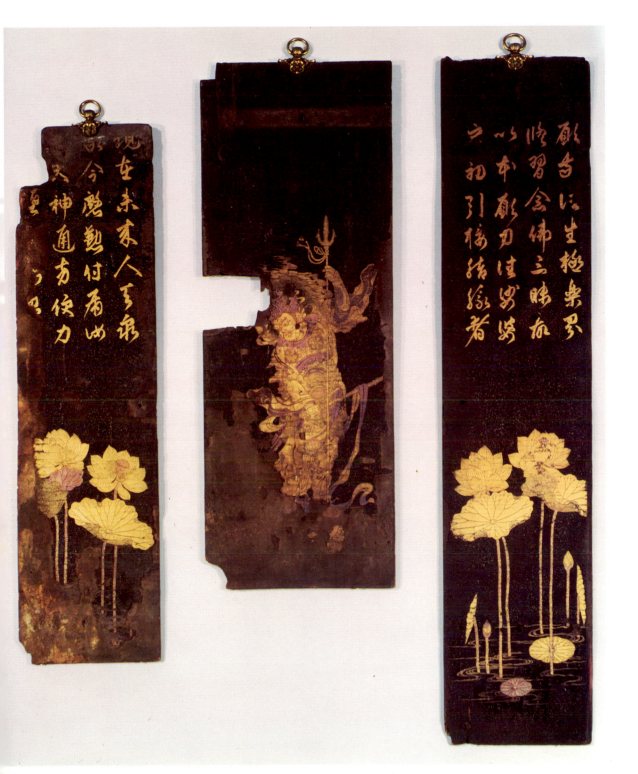

Plate 7. Lacquer Shrine Panels with Maki-e Design of Lotus Flowers and Bishamonten

梵天王来下聽法放
道真也至第四夜大
德雖盛然故不如我
弟子言年少沙門神
其先 于時迦葉語
提桓曰来下聽法是
定事火佛言不也釋
諸佛所問沙門言汝
事火也重於明旦往
白師言年少沙門定

Plate 8. *Illustrated Sutra of Cause and Effects, Past and Present*

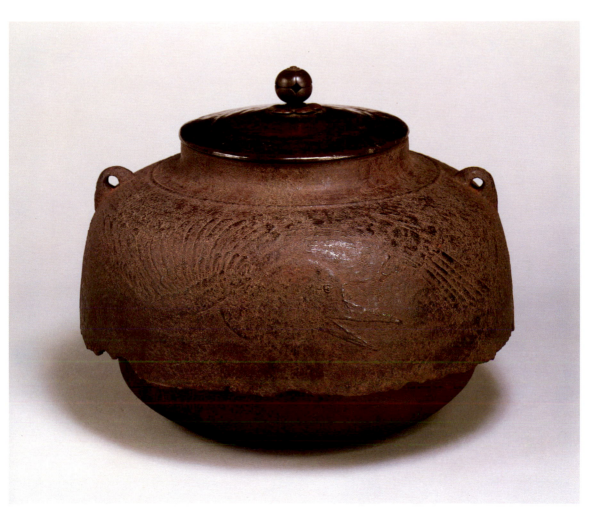

Plate 9. Old Ashiya Kettle *Nuregarasu*

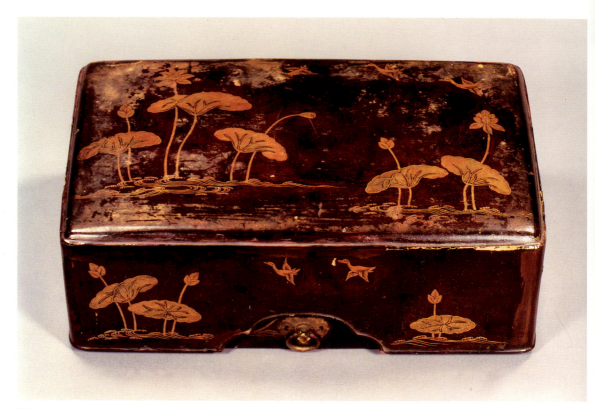

Plate 10. Lacquer Sutra Box with Maki-e Design of Lotus and Waterfowl

If Masuda's encounter with the West provoked his interest in art collecting, it did not guide it. His vision of himself as a collector was grounded in the cultural values that had prevailed in feudal Japan. The image of the cultivated gentleman, accomplished in one or more of the traditional arts, was central to this cultural ideal. Although Masuda also practiced both painting and calligraphy, chanoyu was the art form he chose to carve out a place for himself in late nineteenth-century Japanese society. In chanoyu, Masuda discovered not only a means of artistic self-expression particularly well suited to his character and profession, but an approach to art that would give coherence to his activities as a collector. To appreciate fully the way that this artistic pursuit would shape Masuda's taste requires tracing the personalities and patterns of art collecting, display, and appreciation as they developed in the world of tea from the fifteenth through the nineteenth centuries.

◆ *The Artistic Requirements of Chanoyu*

Tea drinking, primarily for medicinal purposes, had been popular in Japan since the ninth century, but chanoyu, the ceremonial preparation and consumption of powdered green tea using prescribed utensils and following particular codes of behavior, originated only in the fifteenth.[1] Tea fostered a highly organic approach to collecting, as well as considerable aesthetic discrimination and creativity on the part of the collector. Connoisseurship was essential in selecting, evaluating, and discussing each painting or calligraphy hung in the tokonoma and each utensil used in preparing tea, but creativity was also needed to combine these works of art into a harmonious ensemble appropriate to the season, location, and occasion. If these requirements made art collecting for chanoyu demanding, they also made its rewards all the more satisfying.

The rise of chanoyu also led to the emergence of a new kind

of collector who combined the roles of consumer and producer, audience and performer. The devotee of tea not only bought works of art, sometimes commissioning them to suit his personal taste, but also painted, wrote, and fashioned his own tea utensils. Furthermore, since chanoyu has some of the aspects of a performing art whose success depends on the participation of both host and guest, one had to be familiar with the ritualized gestures and carefully choreographed movements used in preparing, serving, receiving, and drinking tea.

The term "chanoyu," literally hot water for tea, is generally translated as "tea ceremony," giving the impression that it has a ceremonial character like that of a Catholic mass or other religious service. While chanoyu may have spiritual overtones reflecting its indebtedness to Zen Buddhism, it is not directed toward a deity, and the benefits of its practice do not extend beyond the immediate circle of participants. Simply put, its aim is to allow the participant to remove himself temporarily from the stresses of daily life to a tranquil setting where he may enjoy the fellowship of other like-minded individuals. This setting is usually a room, suite of rooms, or independent structure equipped with tokonoma where works of art may be displayed, but large commemorative tea gatherings may require many structures especially erected for the occasion. Viewing, handling, and discussing the works of art displayed in the tokonoma or used in the preparation of tea play a central role in achieving the communion between host and guest that is the essence of chanoyu.

The artistic requirements of tea are extensive. The arrangement in the tokonoma, the aesthetic focal point of the gathering, must include a painting or calligraphic scroll and a simple arrangement of seasonal flowers. A small lacquer or ceramic box holding incense or other decorative objects that complement the scroll and flowers may also be displayed. If the tea gathering is preceded by a meal, which is the case at formal occasions where thick tea (*koicha*) is served, an assortment of special serving utensils is needed. These include bowls, plates, and covered dishes of varying sizes, shapes, and decors; lidded lacquer bowls for soup; lacquer, ceramic, or metal flasks for sake; and a lacquer tray for presenting each individual meal. The process of boiling water, making tea, and serving it also requires an assortment of specialized utensils, each a work of

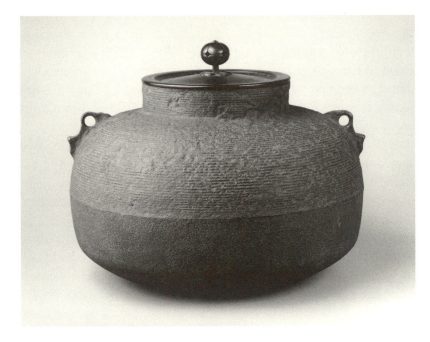

Figure 2-1. Temmyō Water Kettle *Taya Itome*

art. Two kinds of iron kettles are used for boiling water, one set on a trivet in the hearth for winter (fig. 2-1) and another standing on a portable brazier for summer. Special implements, including a bamboo basket used to carry the charcoal, iron-tipped chopsticks for handling the coals, and a cluster of feathers for sweeping ash, are required to lay the fire. The tea is stored in various containers, large ceramic jars for the leaves, and small caddies for the powder. Ceramic caddies are used to hold the powdered tea for the more formal *koicha*, while lacquer ones are the norm for thin tea (*usucha*). A slender tea scoop is necessary to measure and transfer the powdered tea from its caddy to the teabowl, and a whisk to stir the water and tea. Both of these implements are generally made of bamboo. Another requirement is the ceramic jar from which the host draws fresh water for tea. While this jar may be quite large and eye-catching, the wastewater jar, its functional counterpart, must be inconspicuous. Although the tea caddy was formerly the most important utensil, today it is the teabowl from which all guests drink. When all the guests have had tea, the teabowl is passed from hand to hand, giving each an opportunity to study its aesthetic qualities.

Although chanoyu has had a profound impact on all aspects of art collecting, nowhere has its influence been more dramatic than in the esteem for ceramics. Since lacquer was the medium of choice for the eating and drinking utensils used by the aristocracy, domestic ceramic production was relatively limited until the sixteenth century. Production in kilns at Shigaraki and Bizen consisted of rough, unglazed stonewares used chiefly by farmers, although kilns producing glazed wares were also operated in Seto and Mino. The diffusion of chanoyu led to the reevaluation of these wares, stimulated the import of ceramics from the continent, and promoted the establishment of many new kilns. Flower containers, water jars, and tea leaf jars were made at the old Shigaraki, Bizen, and Ise kilns as early as the sixteenth century, but by the mid-seventeenth century new kilns, many of them using firing and glazing techniques introduced by naturalized Korean potters, were in operation throughout the country. The province of Mino, northeast of the modern city of Nagoya, for instance, became the center of production for Shino, Oribe, Yellow, and Black Seto tea wares (pl. 2). The Ōkawachi kiln, located in the Arita area of Hizen Province (in modern Saga Prefecture), specialized in porcelain tableware for the use and gift giving of the Nabeshima lords. Some kilns operated under the auspices of feudal lords who were themselves eager practitioners of chanoyu. Production at others was guided by professional tea masters who desired tea utensils reflecting their personal tastes (*konomi*). Kobori Enshū (1579–1647), for instance, is known to have supplied potters with paper cutouts to insure the creation of tea caddies made to his exact specifications. Even after his death, the Seto kilns continued to produce works like *Hakuro*, a tea caddy once in Masuda's collection, in conformance to Enshū's taste (fig. 2-2).

The esteem for ceramics and other crafts led to the practice of naming favorite teabowls, caddies, or even kettles. This practice was neither new nor unique to tea culture: as early as the Heian period, it had been common to give names to favorite possessions, such as musical instruments.[2] Names personified and created a historical context that would become central to the aesthetics of tea. They also aided in identifying tea utensils without resorting to lengthy descriptions of their physical properties. Since craftsmen rarely signed their work, many tea utensils came to be known by

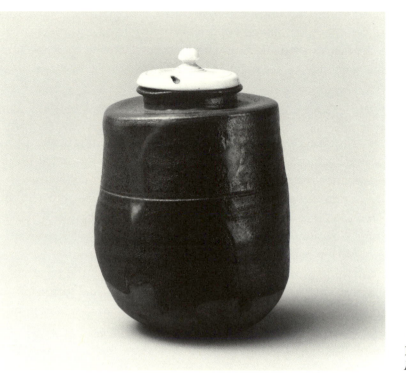

Figure 2-2. Seto Tea Caddy
Hakuro

the names of their owners or of the region where they lived. It is possible that such names initially represented a kind of shorthand, a code familiar only to practitioners of tea. Some collectors, however, gave their tea utensils names inspired by their aesthetic attributes or even by verses in classical poetry. These names were not necessarily permanent but could be altered following a change in ownership or to commemorate their use at a special tea gathering. Occasionally, collectors identified so closely with the "persona" of a favorite tea utensil that they in turn adopted sobriquets inspired by them. The self-deprecating sobriquet Don'ō, "Old Fool," by which Masuda Takashi is widely known in tea circles derives from a black Raku teabowl named *Dontarō* that he acquired on his sixtieth birthday (pl. 1).[3] The bowl had been named after the seventeenth-century playwright and poet who had once owned it.

Although the basic artistic requirements of chanoyu have remained constant over the centuries, the forms and styles of the articles collected by men of tea have not. The evolution in tea taste has come about in response to the personal tastes of professional tea

masters and the ruling elite who were their patrons. Supply and demand have also played important roles. The most powerful force in the history of chanoyu and art collecting, however, has been the interplay between the taste for domestic and imported wares.

◆ *The Taste for* Karamono

The taste for *karamono*, "Chinese things," ubiquitous to the Japanese aristocracy since the eighth century, is a dominant feature of tea taste. If their appeal to collectors reflected a fascination with the exotic, the prestige that came from their ownership reflected China's role as Japan's cultural mentor. Despite their designation, many karamono—whether painting, ceramics, or lacquerware— were not in fact of Chinese origin but were produced in Korea or even regions along the Silk Route. Occasionally, the reverse was also true. Stoneware tea bowls known among tea aficionados as E-Korai, painted Kōryo, after the Korean dynasty that lasted from 918 to 1392, were produced in northern China (fig. 2-3). Regardless of country of origin, these imports were rare and therefore costly.

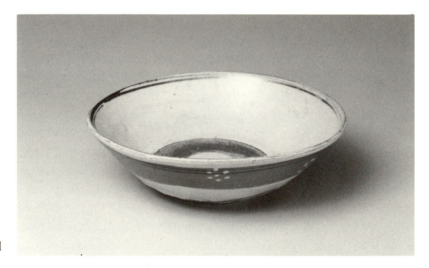

Figure 2-3. E-Korai Teabowl

Ashikaga Shogun Yoshimasa (1436–90), a man more noted for his aesthetic sensitivity than for his rulership, is generally considered in tea circles to be the prototypical collector of karamono. His legendary collection—which included many articles acquired by his predecessors—became the standard against which later col-

lectors would measure their own. Respect for his taste resulted in works of art in the shogunal collection being designated *ōmeibutsu*, "objects of great repute." *Ōmeibutsu* from the shogunal collection, which was dispersed at the end of Ashikaga rule, were much sought after by later collectors, including Masuda and his peers.

More is known about the artistic taste of the Ashikaga shoguns than about that of any previous Japanese collectors. The contents of their painting collection is recorded in the *Gyomotsu on'e mokuroku*, a catalogue thought to have been compiled around 1470 under Yoshimasa's patronage by his cultural adviser Nōami (1397–1471), which identifies, describes, and evaluates 279 Chinese paintings. The shogunal paintings, ceramics, and lacquers are also described and classified in the *Kundaikan sayu chōki* (also known as *Kundaikan sōchōki*), written by Nōami and expanded by his grandson Sōami (d. 1525). In addition, the *Muromachi-dono gyōkō okazariki*, a record of Emperor Hanazono's 1437 visit to the palace of the eighth Ashikaga shogun Yoshinori, offers a remarkably detailed account of the manner in which paintings and other objets d'art were displayed. Finally, a surprisingly large number of works from the shogunal collection, many of them impressed with the Dōyū and Tensan seals of ownership, still survive.[4] Both Masuda and his artistic mentor Inoue Kaoru would acquire works bearing the Tensan seal (see figs. 2-4 and 5-4).

The shogunal painting collection consisted almost exclusively of works from the Southern Sung period (1127–1278). Polychrome flower and bird compositions by or attributed to Ma Yuan, Hsia Kuei, and even the Emperor Hui Tsung (fig. 5-4), and themes with Zen connotations painted in ink monochrome by monks artists such as Mu-ch'i and Liang K'ai were especially well represented. A somewhat stiff, contrived painting of the imaginary ha-ha, a bird of good omen in China, is one of a number of works from the shogunal collection acquired by Masuda. However, its traditional attribution to Mu-ch'i is questioned by modern scholars (fig. 2-4).[5]

The ceramics most favored by the Ashikaga were thick-walled stoneware bowls with a smooth, lustrous brown glaze called *tenmoku* in Japan, and thin-walled green "celadons" made at the Lungch'uan kilns in Chekiang Province. Their collection also included some ceramic tea caddies, flower containers made of bronze alloys, and an assortment of intricately carved lacquer boxes that were used to hold incense. Japanese collectors often used these imported

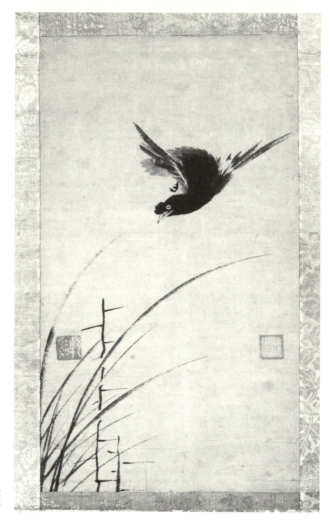

Figure 2-4. Ha-ha Bird,
Attributed to Mu-ch'i

wares for purposes quite different than those for which they had
been made. The containers used to hold tea, for instance, are
thought to have been made to hold medicine.

While this enthusiasm for karamono was not new, increased
trade and cultural exchange with China made imported goods
more readily available during the rule of the Ashikaga shoguns than
in earlier periods. Some of the works in the shogunal collection
were brought to Japan by the wave of Chinese monks who emi-
grated to Japan following the fall of the Sung court in 1279. Others
were brought by Japanese monks returning from their studies in
Chinese monasteries. Still others reached Japanese shores as part of

the import-export trade that flourished in the fifteenth century under the auspices of provincial lords and Zen monasteries.[6]

The Ashikaga shoguns were not the only collectors of kara-mono, however. Their vassals, provincial lords such as the Ōuchi and Hosokawa, and wealthy merchants of the seaport of Sakai, all of whom were active in trade with China and Korea, also amassed impressive collections of imported treasures for use in chanoyu. The demand for karamono is reflected in the extraodinarily high prices paid for them. A now lost profile portrait of Bodhidharma painted in ink monochrome by Mu-ch'i, for instance, was sold in 1498 for the equivalent of twenty-two *kan*. (A kan was a unit equiv-alent to 3.76 kilos of silver.) Another documented sale involved a triptych by fourteenth-century Chinese artist Yen Hui. The three compositions, featuring Taoist sages flanked by bamboo and mon-keys, sold for one hundred kan.[7] Annotations in the ceramics sec-tion of the early sixteenth-century *Kundaikan sayu chōki* suggest that they were even more valuable than painting: a *tenmoku* bowl with a spotted glaze was worth one thousand kan, while one with an oil spot glaze was worth five hundred kan.[8]

The taste for karamono remained strong among Yoshimasa's successors. This was especially true of Oda Nobunaga (1534–82) and Toyotomi Hideyoshi (1536–98), two ambitious warlords of humble background who sought to reunify the country after the fall of the Ashikaga shogunate. During the Momoyama era (1568–1615), cha-noyu was not merely an elegant social pastime but a ritualized and socially sanctioned setting where men of disparate backgrounds could meet. Its popularity among warlords, aristocrats, and mer-chants stemmed from its role in political and economic negotia-tions and from its value as a mechanism for restructuring society.

Like aspiring rulers before them, Nobunaga and Hideyoshi recognized cultural knowledge to be as important an attribute of leadership as military might and took up the practice of chanoyu as a means of demonstrating their cultivation. To further enhance their image as legitimate rulers, they also sought to acquire works of art that had belonged to the Ashikaga shoguns. How these two mighty warlords went about forming their collections tells as much about their character as it does about their taste.

Nobunaga acquired some treasures as tokens of allegiance from warlords and merchants with whom he had formed political alliances. Others he simply ordered confiscated from the hands of

their unfortunate owners, often men whom he had defeated on the battlefield. Matsunaga Hisahide, a warlord who had earlier "presented" Nobunaga with a famous tea caddy, later chose to destroy a treasured tea kettle rather than let Nobunaga lay hands on it.[9]

Hideyoshi's preferred method of amassing a collection of teawares befitting the most powerful man in the nation, though often more subtle, was no less effective. Instead of ordering his agents to go on treasure hunts to requisition the articles he coveted, he invited collectors to tea gatherings, requesting that they bring with them their finest utensils for his inspection. If Hideyoshi admired an item belonging to a guest, the latter had little choice but to present it to him.[10] On occasion, he even sought to appropriate the treasures displayed at chanoyu hosted by other men. This reputedly occurred when Hideyoshi was the guest of merchant Kamiya Sōtan (1551–1635).

Sōtan was a prosperous merchant of Hakata active in trade with China and Southeast Asia whose aid Hideyoshi sought first in establishing a stronghold in Kyushu and later in financing his invasion of Korea. In the course of a tea gathering held by Sōtan in Hideyoshi's honor during the Korean campaign, Hideyoshi first coerced his host to part with a famous landscape Chinese painting, "Evening Rain over the Hsiao and Hsiang Rivers," that was displayed in the tokonoma, and later tried, unsuccessfully, to steal his Chinese tea caddy, *Hakata Bunrin*. Although the veracity of this particular event has been questioned, it was well enough known for Masuda, who greatly admired Sōtan, to have alluded to it when Inoue Kaoru left a gathering carrying a painting belonging to their mutual friend, journalist Fukuchi Gen'ichirō.[11]

Although the full scope of Nobunaga's and Hideyoshi's collections is not known, there is no doubt that they considered their greatest treasures to be the pictures from two sets of handscrolls depicting the "Eight Views of the Hsiao and Hsiang Rivers," one by twelfth-century painter Mu-ch'i and the other by fourteenth-century painter Yü-chien, and three Chinese *katatsuki* tea caddies, *Hatsuhana*, *Narashiba*, and *Nitta* . The special aura surrounding these works of art tells much about the unique combination of values that has guided tea taste over the centuries.

"Eight Views of the Hsiao and Hsiang Rivers" is the collective name for paintings depicting the scenic region in China's Hunan Province where these two rivers flow into Lake Tung-t'ing.

The evocative sights along these rivers, favorite subjects of Chinese painters, so appealed to Japanese taste that works inspired by them laid the foundations for the development of Japanese landscape painting.[12] Mu-ch'i's and Yü-chien's impressionistic versions of this classic theme were originally in the form of handscrolls painted in ink monochrome with a keen sense of the ever-changing atmospheric conditions that gave the region its picturesque beauty. Because of their muted tones and absence of angularity, they came to be considered the quintessential expression of *wabi*, a concept to be discussed below. Ashikaga Yoshimasa, who owned both handscrolls, is thought to have ordered them cut and remounted as hanging scrolls so that he could display them in the tokonoma of a tearoom.[13]

It is more difficult to explain how the three thirteenth-century tea caddies achieved such renown. Although only *Hatsuhana* (first blossom) survives, all three are known to have been imported jars with a warm brown glaze, of a type called *katatsuki* (square shouldered), after their distinctive profile. The crisp shape and the soft glaze characteristic of Chinese *katatsuki* tea caddies like *Kitano* (fig. 1-5), for instance, inspired domestic production of tea caddies like *Hakuro* and *Hirano* (figs. 2-2 and 3-11).

The mystique associated with these and other imported tea caddies cannot be attributed solely to their intrinsic aesthetic properties, however. More than any other utensil, a tiny tea caddy was equated with the living essence of its owner. It was small enough to be carried on one's person or in one's baggage, and it could in fact insure its owner's protection: the owner who presented his tea caddy to his adversary was often trading it for his life. Because of this, tea caddies often served as tokens of fealty or succession. Nobunaga, who confiscated *Hatsuhana* from its owner in 1569, eventually presented it to his son and heir.[14]

As the embodiment of unique aesthetic and symbolic properties, tea caddies were also valuable commodities. The Portugese missionary Valignano, who had been shown *Nitta* by its then owner, the daimyo Ōtomo Yoshishige, remarked: "It is quite incredible how highly they esteem these utensils, which are of a certain kind only the Japanese can recognize. Often they give three, four, or six thousand ducats and even more for one of these pots. . . . The king of Bungo [ōtomo] showed me a small porcelain jar which among us would have no other use save to put into a

birdcage as a water container. But he had bought this for nine thousand taels, which is about fourteen thousand ducats."[15] Another western visitor to sixteenth-century Japan rightly concluded that all tea "utensils are regarded as the jewels of Japan, much in the same way as we value rings, gems, and necklaces made of many costly rubies and diamonds."[16] His assessment would be as true of the nineteenth and early twentieth centuries as it was of the sixteenth century.

Taste in karamono changed considerably during the Tokugawa period (1603–1868) as chanoyu became an integral part of the formal entertainment provided for guests at official receptions. Kobori Enshū, who occasionally served tea to the third shogun Iemitsu (1604–51), played a leading role in reshaping the aesthetics of tea, bringing it in line with the values of a hierarchical society that would increasingly endorse the reinterpretation of the forms and styles of the past rather than artistic innovation. Enshū, who as a daimyo (domain lord) was himself a member of the ruling elite, saw the practice of tea as an aid in governing the nation. In an effort to make this popular pastime conform with the Neo-Confucian teachings that guided all state activities, he declared that "chanoyu is nothing but loyalty, filial piety, minding family affairs, and cultivating relations with old friends."[17] The emphasis on social hierarchy fostered by Neo-Confucian writings would lead some collectors to justify their huge expenditures on karamono by claiming that the practice of tea required the use of utensils commensurate in quality to the social status of their guests.[18]

Prompted by the loss of art treasures during the provincial wars, Enshū sought to expand the canon of karamono used in chanoyu by discovering and promoting articles unappreciated by earlier collectors as well as those only recently imported from China. In painting, he promoted the work of conservative Yuan (1279–1367) and Ming (1368–1644) artists who had continued to paint small, detailed bird and flower and landscape compositions in the Southern Sung manner. In calligraphy, he preferred decorative one-line epigrams inscribed in large, bold strokes to the lengthy didactic writings by eminent Zen monks that had been promoted by fifteenth- and sixteenth-century tea masters. A scroll with the two characters *chu shan* (dwelling in the mountains) inscribed by Lan-ch'i Tao-lung (1213–78), the Chinese abbot of Kenchōji, a prominent Zen temple of Kamakura, exemplifies this

taste (fig. 2-5). In ceramics, Enshū was fond of porcelains with blue and white underglaze designs, especially a variety known in Japan as Shonzui, produced at the Ching-te chen kilns during the late Ming period (fig. 2-6). Unlike the ceramics acquired by earlier men of tea, these are thought to have been made expressly for the

Figure 2-5. "Dwelling in the Mountains," Lan-ch'i Tao-lung

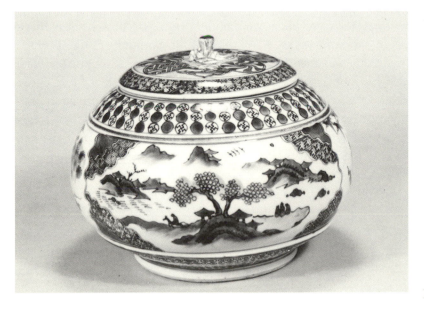

Figure 2-6. Shonzui Water Jar

Japanese market. Enshū also liked a type of southern Chinese low-fired ware decorated in bright green and yellow overglaze enamels that was known in Japan as Kōchi (fig. 5-2).[19] Enshū's taste established the parameters of official taste in karamono for the duration of the Tokugawa rule and would also influence the aesthetic outlook of Masuda and his generation.

◆ Wabi *Taste*

Wabi is a central animating principle of chanoyu that has had a profound influence on the development of tea taste. A term first used in Japanese poetry with the connotation of material deprivation, in the world of tea wabi has come to refer to the rejection of luxury and the taste for restrained and simple things, even those that are imperfect or worn with age.[20] Although wabi is often thought to pertain specifically to Japanese works of art, especially ceramics, this was not originally the case. This aesthetic was first formulated in the late fifteenth century in an effort to create a distinctive style of tea into which both Chinese and Japanese art were integrated, and it was part of a syncretic trend that affected painting and literature as well.

Sen no Rikyū (1522–91) and his heirs were instrumental in the diffusion of wabi taste, but Murata Shukō (d. 1502), a cultivated monk in the circle of Ashikaga Yoshimasa, was the first to apply the wabi aesthetic to chanoyu. His influence is reflected in both the setting and the works of art collected for use in tea. Shukō popularized the *sōan* (grass hut), a small room with roughly finished walls and bamboo lattice ceilings that provided an intimate and unpretentious alternative to the large and formally appointed reception room (*shōin*) where tea was customarily served. The sōan, whose inception and appearance were informed by Zen ideals, was intended to serve as a temporary spiritual refuge from the concerns and desires of the outside world. Whereas Shukō's tearoom was four and one-half mats in size (roughly nine feet square) and could accommodate no more than four guests, the reception room could range in size from eight to sixteen mats and could accommodate a large party. In the latter room, tea was prepared "offstage" by a servant, then presented to the assembled guests, but in the sōan the host himself, as a sign of humility, prepared tea for his guests.

Both types of room were equipped with tokonoma, but the

reduced scale and more informal ambiance of the sōan called for a different style of decor than that of its more spacious counterpart. Because of the room's Buddhist overtones, ink monochrome paintings and calligraphy by Zen monks were deemed especially suitable. Sen no Rikyū and his heirs, who emphasized the practice of tea as a spiritual discipline, advocated the display of paintings featuring buddhas, bodhisattvas, and arhats. However, a passage in the *Nanbōroku*, a compendium of Rikyū's thoughts and tastes said to have been compiled by his disciple Nanbō Sōkei, implies that tea devotees were reluctant to do so for fear of giving the tearoom the appearance of a devotional hall.[21]

Although calligraphy was highly esteemed by Japanese collectors, it was rarely displayed at the formal tea gatherings hosted by the Ashikaga shoguns. Shukō, however, thought writings by Zen monks especially well suited to the character of the sōan, and he is thought to have set the precedent for its use by displaying a scroll by Yuan-wu K'o-ch'in (J. Engo Kokugon) that he had received as a certificate of enlightenment from his Zen master Ikkyū (1394–1481).[22] Years later, Masuda would acquire a calligraphic scroll inscribed by Ikkyū with the words "The First Patriarch, the Great Master Bodhidharma," which, according to the seventeenth-century certificate accompanying it, was also given to Shukō by Ikkyū (fig. 2-7).

Shukō's promotion of calligraphy, a manifestation of his efforts both to instill the practice of tea with spiritual values and to harmonize Chinese and Japanese tastes, continued under Sen no Rikyū, tea master to Hideyoshi. According to *Nanbōroku*, Rikyū believed calligraphy to be the supreme art form. "The hanging scroll is the most important article used in tea . . . and calligraphy by Zen monks (*bokuseki*) is foremost among scrolls."[23] However, since the low ceiling and small size of the tea hut made it difficult to accommodate even a single scroll, regardless of subject, tea aficionados often trimmed both painting and calligraphy. Shukō is thought to have fostered this practice by trimming the calligraphic scroll he had received from Ikkyū so as to display it in his sōan tearoom.[24]

In ceramics, both Shukō and his successor Takeno Jōō (1502–55) indicated a preference for the "chilled and withered" stoneware produced at the Shigaraki and Bizen kilns. A simple bucket-shaped Shigaraki ware water jar (*mizusashi*) decorated only with a mean-

dering line incised around the body is a work that reflects Jōō's concept of wabi (fig. 2-8). It is an early example of a Shigaraki ware vessel made specifically for use in chanoyu.[25]

The more assertive Rikyū personally commissioned ceramics to suit his concept of wabi. These wares came to be known as Raku (pleasure), a name deriving from one of the characters of Hideyoshi's Jurakudai Palace. Teabowls, the predominant form of Raku ware, are vessels with thick clay bodies and red or black glaze. They draw attention to themselves not for their formal symmetry and decorative refinement, but rather for their irregular forms, softly textured surfaces, and surprising lightness when held in the hand. Since Raku ware is hand-sculpted, no two bowls are alike: each one bears the imprint of its maker's personality. Raku teawares were first made in 1585 under Rikyū's direction by Chōjirō, a tilemaker employed at the Jurakudai Palace. In the Tokugawa period, Chōjirō's heirs took the name Raku and became the official suppliers of teabowls and other utensils used by the tea schools founded in Kyoto by Rikyū's three grandsons.

The advent of Raku ware stimulated the production of many hand-modeled ceramics exhibiting the irregularity of form and surface associated with wabi. Since modeling bowls by hand required little or no technical experience, many amateur potters made them, leaving the glazing and firing to professionals. Idiosyncratic Raku bowls made by Hon'ami Kōetsu (1558–1637), a gifted calligrapher and tea devotee, were often more coveted by collectors than those of their professional counterparts. The black Raku *Shichiri* (Seven miles), distinguished by its boxlike shape and the evocative irregularity of its glaze, was among Masuda's favorite teabowls (fig. 3-2). Masuda so admired Kōetsu's Raku teabowls that he modeled a number of those he made himself after them (fig. 2-9).

Tea utensils created by men without professional artistic training were admired for their lack of artificiality but also as the direct expressions of their creator's personality and taste. Since personal charisma and the relationship between individual practitioners were major preoccupations in tea culture, many tea devotees fashioned teawares—bamboo tea scoops and vases as well as Raku teabowls—for their personal use or for giving to friends. In time, however, these came to be bought and sold like other teawares. If, as often occurred in the process of transmission from one generation of collectors to the next, one of these fragile articles became

Figure 2-8. Bucket-shaped
Shigaraki Water Jar

Figure 2-7. "The First Patri-
arch, the Great Master
Bodhidharma," Ikkyū Sōjun

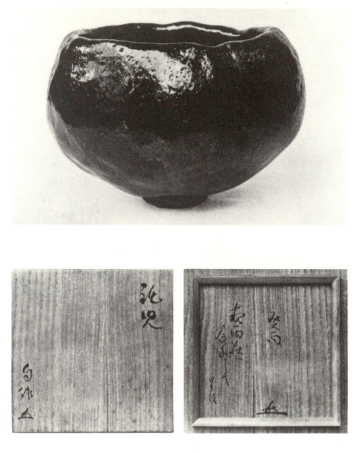

Figure 2-9. Black Raku Teabowl *Donko* and box, Masuda Takashi

cracked or damaged, it mattered little. Signs of wear were thought to add to the character of a tea utensil, and records of the circumstances in which the damage occurred were often kept as carefully as those of its past ownership. Damage, repaired, became part of the object's aesthetic interest.

Professional potters also exploited the taste for imperfection associated with the wabi ideal. Those working at kilns in Bizen, Shigaraki, and Iga, for instance, learned how to control the chance effects by varying clays and kiln temperatures. They also used straw ropes and ash to create natural-looking decor. Iga became especially noted for rugged, asymmetrical flower vases and waste water containers (fig. 3-1). The warping or cracking that often occurred in the process of firing these heavy-bodied vessels made them all the more desirable to tea devotees.

Wabi taste, which had been the source of such artistic creativity in the world of tea, was standardized in the Tokugawa period by three tea schools—Urasenke, Omotesenke, and Mushanokōji Senke—each founded by one of the sons of Rikyū's grandson Sen Sōtan (1578–1658). This process of standardization was not an isolated phenomenon, but one of many manifestations of the ideological control of artistic expression that would characterize the culture of the period. As part of their effort to insure faithful preservation of Rikyū's style of tea, these schools codified every aspect of chanoyu, from the architectural details of the tearoom and choice of utensils to the gestures used in preparing tea. Each school also oversaw, and therefore had a financial stake in, the production of the utensils required for the practice of its style of tea. Although all three had their headquarters in Kyoto, they commanded wide influence through the establishment of nationwide networks of branch schools.

The resulting diffusion of codified wabi taste had a profound impact on patterns of collecting in the Tokugawa period. Although all kinds of wabi wares were collected, those classified as *meibutsu* because they had been owned or made by Shukō, Jōō, or Rikyū were especially coveted. As the demand for such treasures drove prices ever higher, extravagant and often uninformed collectors sometimes led their businesses and even their domains to the brink of bankruptcy. Criticism of wabi taste, emblematic of the excesses associated with chanoyu, became quite common, especially in the late eighteenth and early nineteenth centuries, when famines and poverty threatened the national economy. Neo-Confucian scholars were particularly vocal in condemning wabi taste:

Today's tea men take filthy and damaged old bowls, whose ages they cannot know, repair them with lacquer and other materials, and then use them. It is an unspeakably disgusting custom. . . . People today who amuse themselves with *chanoyu* spend vast sums of money on ordinary ceramic objects that have nothing unusual about them and no distinctive merits—and regard them as priceless treasures! Insignificant bamboo tubes and shafts are purchased for a hundred pieces of gold and are thought to be extraordinary objects. It is all quite baffling.[26]

Over the course of the nineteenth century, Neo-Confucian writings would play an important role in efforts on the part of professional and amateur men of tea to reform the image, if not the actual practice, of tea.

◆ *Courtly Taste*

Although scrolls featuring poems inscribed by Japanese courtiers were occasionally displayed in the sixteenth century, the refined aesthetic of the Heian nobility with its nostalgic overtones of an ideal past did not become a distinguishing feature of tea taste until the seventeenth century. First manifested in a growing interest in classical Japanese poetry and calligraphy, it later led to the production of painting and ceramics decorated in styles, motifs, and colors inspired by those of the Heian period. While scrolls and teawares reflecting this courtly aesthetic did not replace those of continental origin, over the course of the Tokugawa period they were used increasingly as decorative alternatives to karamono.

Kobori Enshū, who had an unusually wide network of friendships in the tea world, was a dominant figure in the development of courtly tea taste.[27] In this as in other respects, Enshū was less of an innovator than a consolidator. His interest in the classical tradition was an outgrowth of his study of *waka* poetry and, above all, of his admiration for Fujiwara Teika (1162–1241), a renowned court poet whose cramped, spidery calligraphy Enshū emulated. Although many poetic genres were practiced in Japan, the thirty-one syllable waka, associated as it was with the courtly culture of the Heian period, remained by far the most influential. Many of the animating principles of Japanese aesthetics were first given expression in the *Kokinshū*, an imperial anthology of waka compiled by the poet Ki no Tsurayuki between 902 and 920. The influential essay that prefaces the anthology established poetry as the best means of conveying human emotions, and the metaphorical use of natural imagery as the best means toward that end. It is thus to the *Kokinshū* that one may trace the aesthetics of "obliqueness, the expression of the thing perceived not in the language of the moment of perception, but in different, more highly contrived terms,"[28] which would characterize many forms of artistic expression in Japan, including chanoyu.

This poetic tradition profoundly influenced Enshū's concept of tea. His love of waka prompted him to give many of the tea utensils in his collection names inspired by them. Masuda's tea caddy *Hakuro* (White dew) (fig. 2-2), for instance, was so named (probably by his son rather than by Enshū himself) after a poem in the *Kokinshū*:

> Spinning out
> Tender green threads
> And slipping off
> Beads of white dew
> The willow in spring[29]

But Enshū's poetic vision of tea is perhaps best summed up in the random notes he wrote near the end of his life: The essence of tea is "the mists of spring, the cuckoo hidden in the fresh green leaves of summer, the loneliness of the evening sky in autumn, and daybreak in the snow of winter."[30]

Despite Rikyū's belief that calligraphy was the most important art form in chanoyu, writings displaced painting as the preferred centerpiece of tokonoma decor only in the seventeenth century.[31] Until then, calligraphy had been collected primarily to serve as models for its owners, and examples were generally contained in booklets or handscrolls, often inscribed on lavishly decorated papers. As a result of this shift in taste, writings by Teika and other court poets of his generation achieved a stature in tea circles comparable to that once held only by works of Chinese origin. The demand for examples of their calligraphy was so great that many impoverished aristocratic families began to dismember and sell books of poetry that had long been treasured as family heirlooms. Single or double pages inscribed with one or more waka were then remounted as hanging scrolls. Their small size made them ideally suited for display in the tearooms of wealthy merchants and daimyo who sought to identify themselves with the cultivated tradition they represented.

The diffusion of courtly literature was not limited to poetry but included also works of prose such as *The Tale of Genji* and *The Tales of Ise*, two Heian literary classics that had long served as sources of inspiration for the visual arts. Widespread enthusiasm for classical literature, combined with greater access to it through printed

books, led Kyoto artists such as Tawaraya Sōtatsu (act. 1600–40) to create fan paintings, screens, and hanging scrolls inspired by episodes in *The Tale of Genji* and *The Tales of Ise*.[32] Sōtatsu's compositions were not slavish copies, but reinterpretations executed in bold colors with a lively sense of pictorial design that was in keeping with the artistic taste of the day (fig. 2-10). Sōtatsu and his workshop also painted scrolls and album leaves with seasonal motifs to serve as supports for the calligraphy of his friend Hon'ami Kōetsu, a multitalented personality who played a leading role in Kyoto's courtly renaissance (fig. 6-7). Although such works enjoyed the favor of collectors during the Tokugawa period, they were not displayed in the tearoom until the early twentieth century,

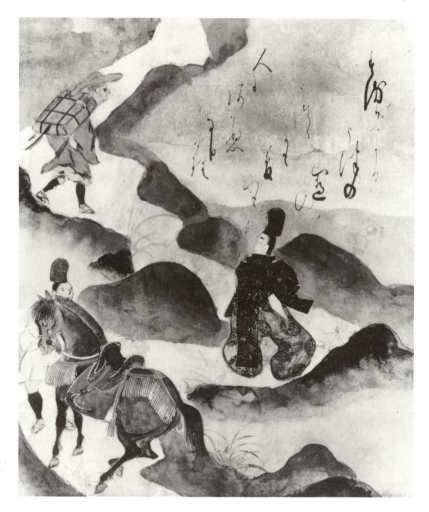

Figure 2-10. Illustration of the Mount Utsu Episode of *The Tales of Ise*, Tawaraya Sōtatsu

when, in keeping with time-honored practice, they too were cut into sections suitable for mounting and hanging in the tokonoma.

The infusion of courtly elegance into the ceramics tradition occurred as a result of the collaboration between two men, Nonomura Ninsei (fl. mid-17th c.), a Kyoto potter, and Kanamori Sōwa (1584–1656), a devotee of tea with close ties to members of the imperial family. It was under Sōwa's guidance that Ninsei began creating thin-bodied wares with refined overglaze enamel designs that have come be be recognized as the finest expression of Kyō-yaki (Kyoto ceramics).[33] Many of these wares were expressly made for members of the imperial family. Ninsei's genius lay in his adaptation of the Heian tradition of fine craftsmanship and use of gem-like pigments in combination with gold and silver to the technically demanding medium of ceramics. Many of Ninsei's finest teawares feature motifs also found in painting and textiles of the era (fig. 2-11).

The work of Ninsei's spiritual heir Ogata Kenzan (1663–1743), although more fluid and relaxed in style, retained this emphasis on surface decor.[34] Many of his ceramics were created in collaboration with his brother, the painter Kōrin (1658–1716). Although Kenzan

Figure 2-11. Pair of Teabowls with Overglaze Gold and Silver Enamels, Nonomura Ninsei

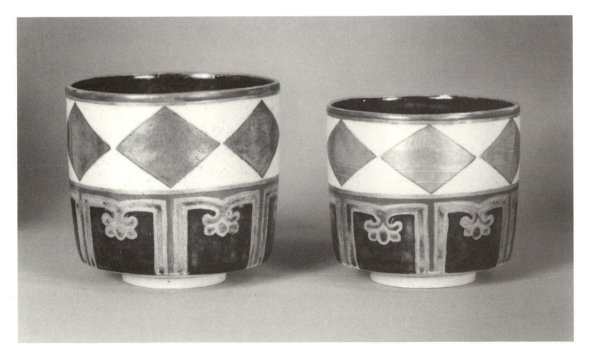

lacked Ninsei's skill as a potter, he brought to tea ceramics a new exuberance bordering on flamboyance that was the antithesis of wabi taste. It was perhaps for this reason that many men of tea preferred the serving dishes he designed to teabowls and other implements he created for use in the preparation of tea.

◆ Tori Awase

The true man of tea is measured by the skill with which he combines articles from his collection so that they form a harmonious ensemble in the tearoom. This process, known as *tori awase* (selecting and matching), requires broad cultural knowledge, connoisseurship, and creativity.[35] The host must consider the context: the season, the occasion, and the identity of the guest or guests. He must take into account the size, shape, texture, color, and material of each work of art. Functional considerations are also important. The tea scoop, no matter how visually appealing, has to function effectively in transferring tea from the container, and the teabowl has to have a spacious and smooth interior so that the bamboo whisk used to mix the powdered tea and water can move about freely. Although he must also keep in mind historical connotations such as the origins, history of ownership, and previous use of each article, he must use this knowledge creatively, so as to make each gathering a unique and memorable experience. Rikyū is generally acknowledged to have been the most inventive of all tea masters, but the *Nanbōroku* has little to say on the subject of creativity. His disciple Yamanoue Sōji, however, believed that no student of chanoyu, no matter how gifted, could become a great man of tea without this most elusive of all qualities.[36]

Creativity is essential to every aspect of chanoyu, but it is most clearly manifested in the *tori awase* process, which requires the host to select and combine a predetermined set of articles in novel ways.[37] The principle of creativity that underlies the *tori awase* process might be likened to that employed in the composition of waka, where words and motifs from an older poem are incorporated into a new one. The host of a chanoyu, like the poet, must adhere to a fixed lexicon and grammar and yet create something fresh and vibrant in response to the season, occasion, and guests. The *tori awase* process challenges the collector to reveal his artistry by manipulat-

ing the material emblems of a common cultural past in response to the conditions of the present.

In Masuda's day, mastery of the many requirements of *tori awase* was achieved through practice, usually under the guidance of a professional tea master, and by study of the models contained in the records of tea gatherings hosted by noted practitioners of the past. Before the Meiji era, however, when many forms of artistic knowledge were considered professional secrets that could only be transmitted orally from master to disciple, members of the economic and ruling elite generally entrusted preparations for their tea gatherings to their artistic advisers or their tea masters.

Nōami, a gifted painter, connoisseur, and interior decorator, is the prototype of the artistic adviser. His duties to his patrons, who included Ashikaga Yoshimasa, ranged from cataloguing and appraising the objects in the shogunal collection to supervising preparations for receptions where tea was served. His pioneering efforts in both areas are recorded in the *Kundaikan sayu chōki*, a guide to the connoisseurship of Chinese art and to the arrangement of paintings and other objets d'art in the tokonoma and adjoining shelves. Handwritten as well as printed editions of this work, as expanded by Nōami's grandson Sōami (d. 1525), circulated widely among the shoguns and their retainers, laying the foundations for connoisseurship and formal tearoom decor throughout the Tokugawa period.

The *Kundaikan sayu chōki* is divided into three parts. In the first and third, Nōami, influenced by Chinese art criticism, offered a method of connoisseurship based on stylistic and typological criteria. The first part lists and evaluates paintings by more than 150 Chinese artists, mainly of the Sung and Yuan dynasties, arranged according to their quality—"upper grade," "middle grade," and "lower grade." The third part offers a similar classification and ranking of the varieties of Chinese ceramics and lacquer used in preparing and serving tea. This established the canon of Chinese painting, tea caddies, teabowls, tea jars, and lacquer boxes that would be most esteemed by collectors.

The second part of the *Kundaikan sayu chōki* offers guidelines for the arrangement of paintings and other articles in the tokonoma and adjoining shelves of the *shōin*. Annotated diagrams assist the reader in visualizing the placement and interrelationship of each

article within the ensemble. The typical tokonoma arrangement centered on a set of two to five hanging scrolls. Nōami especially favored triptychs composed of Zen figural themes flanked by compositions featuring birds and flowers or other motifs with seasonal associations. Vases holding flower arrangements, an incense burner, and a candle holder were placed in front of these paintings, and a lacquer box, ceramic bowl, and book were set on the adjacent shelves. The operative principle in this tastefully simple arrangement was balanced asymmetry.

The style of tearoom decor popularized by Murata Shukō was essentially a reduced and simplified version of the arrangement described in the *Kundaikan sayu chōki*,[38] with one important difference: Shukō's arrangements included both Chinese and Japanese art. In describing this synthesis to one of his disciples he noted that, "in pursuing the way of tea, extreme care should be taken to harmonize native and foreign tastes."[39] He specifically cautioned against novices singling out the irregularly shaped and coarsely glazed domestic wares of Bizen and Shigaraki, whose aesthetic values were the antithesis of those of Chinese ceramics. It was fine to appreciate the "cold" and "withered" beauty of such pottery, but the taste for such objects had to be kept in perspective. Simple, everyday Japanese wares should be used to offset the magnificence of their Chinese counterparts. Or, to use an analogy attributed to Shukō himself: "Tethering a fine horse to a straw hut is fine. So too is placing a *meibutsu* in a rough setting."[40]

Rikyū reiterated this principle of complementarity between domestic and imported, humble and refined, adding that even damaged wares might be suitably used to express the wabi spirit. According to the *Nanbōroku*, "In the small tearoom, it is better if all utensils are defective. Some people dislike a piece when it is even slightly damaged, but this outlook is totally unacceptable. Contemporary ceramics that are cracked or broken are hard to use, but Chinese tea caddies and other such respectable utensils have been used repeatedly even though mended with lacquer."[41]

The kind of arrangements favored for teas hosted by feudal lords of the Tokugawa period, a style known as daimyo tea, was considerably more elaborate than that advocated by Rikyū and his heirs. Unlike wabi tea gatherings, which were confined to a single tiny enclosure, daimyo gatherings were held in a suite of rooms, usually a small room where a meal followed by thick tea was served,

and an adjoining larger room where guests were offered light tea and entertainment. A tea hosted by Kobori Enshū, the man credited with popularizing this style, illustrates the more comprehensive scope of the *tori awase* required.

For this gathering, held on the evening of the twentieth-eighth day of the fourth month of 1647, a scroll with a poem about falling cherry blossoms by court poet Fujiwara Teika was hung in the tokonoma of the tearoom. On the two-tiered shelf below it were placed a censor in the shape of a lion and, below it, a mother-of-pearl incense container of foliate shape and a feather brush used for sweeping ashes. During the recess following the meal that preceded the preparation of tea, the host removed the scroll and placed in the tokonoma a vase containing a variety of water lily. The utensils used for preparing tea included a Seto waste water jar, the tea caddy *Noda*, and a Seto teabowl. The spacious room where the guests retired after the tea had two tokonoma; in one Enshū displayed a set of three scrolls mounted with fan paintings by the fifteenth-century ink painter Sesshū; in the other a single scroll by the Southern Sung painter Liang K'ai depicting the Zen eccentrics Hanshan and Shih-te. A book of poems by Fujiwara Teika was displayed on one of the adjoining shelves.[42] Enshū's all-embracing artistic approach to *tori awase*, as revealed in this synthesis of karamono, wabi, and courtly taste, would provide the model for Masuda's practices.

Although the record of Enshū's gathering does not specifically identify any of the articles as meibutsu, it is likely that at least one was included. Tearoom arrangements of all styles were often designed to highlight these "objects of renown." Rikyū's disciple Yamanoue Sōji (1544–1590) believed ownership of a meibutsu to be an important attribute of the true man of tea, and devoted a large part of the record of his views on tea to listing and evaluating such works.[43] Although this definition is refuted by many scholars today, there is no question that meibutsu loomed large in the tea world. As noted above, even the *Nanbōroku* allowed that the owner of a meibutsu scroll should design his tearoom—raising or lowering the ceiling if necessary—to show it to advantage.[44]

Originally the word meibutsu designated articles imported from China that had belonged to or reflected the taste of the Ashikaga shoguns, but over time this definition broadened to include almost any exceptionally fine, valuable, or pedigreed work of art,

whether of Chinese, Korean, or Japanese origin. Since many collectors lacked the connoisseurship necessary to appreciate meibutsu on their own, they often relied on external criteria such as seals of ownership, inscriptions, and authentifications rather than aesthetic merit. In the case of particularly famous articles, they could also consult catalogues offering professional appraisals of the artistic and financial value of a particular item. The catalogues compiled during the Tokugawa period both shaped and mirrored the expanding parameters by which an object was designated a meibutsu. The *Sansatsu meibutsuki* (Record of renowned wares in three volumes), compiled around 1700 by Matsudaira Norimura, for instance, lists 380 meibutsu in the collections of daimyo and merchant families. Unlike earlier catalogues, only eighty articles, or roughly one-fifth of the total, are of Chinese origin.[45]

Classifying and evaluating the vast corpus of fine teawares bequeathed by tradition was a preoccupation of many men of tea, but none took the task more seriously than Matsudaira Fumai (1751–1818), lord of Matsue, and the owner of one of the finest collections of his day. Fumai, with the aid of noted art dealers and professional connoisseurs, compiled an exceptionally comprehensive compendium of meibutsu entitled *Kokon meibutsu ruijū* (Classified collection of renowned wares of ancient and modern times). This work in eighteen volumes describes, illustrates, and ranks a vast number of teawares and related objects in his and other collections that had gained a reputation in the day.[46] The *Kokon meibutsu ruijū*, together with the *Unshū kurachō*, a catalogue of the 518 items in Fumai's personal storehouse, revised, updated, and essentially completed the codification of the canon of teawares begun by Nōami.[47]

◆ Grand Tea Gatherings

Although the number of guests at most chanoyu was limited to five or less, gatherings attended by hundreds of guests were often held on special occasions. These gatherings required the use of many tearooms or tea huts especially decorated for the event by the principal host and his assistants, who also helped him to prepare tea. Since such gatherings were the occasion for the use and display of an exceptionally large number of meibutsu utensils, paintings, and calligraphy, they often resembled art exhibitions.

By drinking tea served by their hosts, however, those who attended were transformed from passive viewers into active participants. The most celebrated of these grand teas was hosted by Hideyoshi on the grounds of Kyoto's Kitano Shrine. Over the course of the Tokugawa period, similar though less grandiose gatherings were hosted by individuals as well as by the various schools of tea. Most had subtle, or not so subtle, political, social, or economic overtones.

The Grand Kitano Tea, held in the tenth month of 1587, was scheduled to extend over a period of ten days but—for reasons that are unclear—was abruptly canceled after a single day.[48] It was one of many extravaganzas staged by Hideyoshi as part of his quest for legitimacy through cultural authority. All serious Japanese practitioners of chanoyu—warriors, attendants, townspeople, farmers, and men of lower classes—as well as people on the continent were invited to attend and participate. The inaugural day opened with an impressive display of Hideyoshi's meibutsu. Their selection and arrangement, in three tea huts, installed within a twelve-mat structure normally used as a worship hall, was determined by three tea masters close to Hideyoshi. The most dramatic display was the portable three-mat hut with ceilings and walls covered in gold leaf and matching gold utensils that the hegemon had ordered constructed in 1586 for use when he visited the Imperial Palace. Within its tokonoma Rikyū had arranged two of Hideyoshi's greatest treasures, a calligraphic scroll by the Chinese monk Shu-t'ang and a celadon flower vase. On the shelves were the Chinese tea caddy *Hyōtan*, resting on a square tray, and a bamboo tea scoop that had belonged to Murata Shukō. In the tea huts arranged to each side were displayed Yü-chien's "Temple Bell in Evening Mist" and Mu-ch'i's "Autumn Moon," both part of celebrated series of Hsiao and Hsiang pictures. Hideyoshi's prized Chinese *katatsuki* tea caddies, *Nitta* and *Hatsuhana*, were also on view. Most of the other articles included were karamono with impressive pedigrees linking them to the Ashikaga shoguns, to great men of tea, or to daimyo whom Hideyoshi had subjugated in his rise to power.

Following the public's inspection of his treasures, Hideyoshi and his three tea advisers prepared tea for 803 guests. Finally, before returning to his Jurakudai Palace, he toured the Kitano pine grove to greet his guests and examine the meibutsu they had brought with them. One of the articles that caught his attention

was a *katatsuki* tea caddy named *Karasumaru* belonging to the courtier Karasumaru Mitsunobu. After Hideyoshi had admired it, it was renamed *Kitano* (fig.1-5). This caddy was one of the many articles that became celebrated largely as a result of its display at the Grand Kitano Tea, an enduring symbol of Hideyoshi's extraordinary but short-lived cultural hegemony.

Although there is less information concerning a large-scale tea gathering held by Matsudaira Fumai in the spring of 1816, it too was a gala event attended by many guests who both drank tea and admired the array of treasures Fumai had arranged in various buildings on the compound of his Shinagawa estate. The selection paid homage to the taste of great men of tea including Rikyū, his son Sen Shōan, Kobori Enshū, and his disciple Shokadō Shōjō. Since this gathering was held when the cherry blossoms, for which Shinagawa was famous, were at their peak, it may have been inspired by a cherry blossom viewing party hosted by Hideyoshi in 1598 at Daigo, an area southeast of Kyoto.[49] For Fumai, as later for Masuda, the activities of Hideyoshi were a source of admiration and emulation.

The anniversaries of influential tea masters were also occasions for great tea gatherings, most of them sponsored by the tea schools with which they were affiliated. Masuda's *Dontarō* teabowl (pl. 1) was one of fifty black Raku bowls made in 1721 by Gensō, the head of the Nagoya branch of the Omotesenke school, for use at a gathering commemorating his ancestor. These grand events, which anyone could attend for a fee, often doubled as fund raisers or public relations vehicles. One held in 1766 under the auspices of Kawakami Fuhaku, the founder of the Edo branch of the Urasenke tea school, was part of a subscription drive to raise funds to refurbish a subtemple on the compound of Tōkaiji, a temple in Shinagawa with close ties to the tea world.[50] Another, held in 1839 to celebrate the 250th anniversary of Rikyū's birth, was part of an effort to promote interest in chanoyu among the residents of Kyoto at a time when patronage of the tea schools was waning. This gathering was organized by Gengensai (1810–77), the influential grandmaster of the Urasenke school of tea, possibly in collaboration with the Omotesenke and Mushanokōji Senke branches. Records of this huge, well-publicized affair reveal that countless treasures associated with Rikyū and later masters of the Sen school were used and displayed for the occasion.[51]

Commemorative teas held under the auspices of the various tea schools during the waning years of Tokugawa rule were instrumental in fostering interest in chanoyu and its attendant art forms among the public while reinforcing the authority of the three Senke. They would continue to serve as valuable mechanisms for insuring the future of the Senke, after the Meiji Restoration, when tea masters, no longer able to rely on stipends from the shoguns and their feudal lords, had to devise ways of attracting a new following.

In 1869, when invited to the private apartment of his then employer, tea trader Nakaya Seibeie, Masuda mistook a bamboo tea scoop for a knife and, to the horror of the tea master Takahashi seated nearby, used it to cut himself a piece of bean-paste candy.[1] Although Masuda later recalled this incident to illustrate how ignorant of chanoyu he was at that time, it is more likely that this gesture reflected his disdain for tea. During his youth, chanoyu had been associated with a world of privilege and wealth to which his family no doubt aspired but did not belong. Although its practice was theoretically open to all social classes, in reality the nineteenth-century tea world was dominated by wealthy daimyo and merchants who had both the leisure to master its intricate etiquette and the means to assemble a large collection of utensils. As a result, most men of Masuda's socioeconomic standing had rejected chanoyu in favor of *sencha*, a more informal and less costly kind of tea gathering associated with forms of Chinese artistic and literary expression.[2]

It is not certain when Masuda began studying chanoyu, but it was probably in the mid 1870s, possibly in 1876, when he and his family rented an apartment from Takahashi, the tea master to whom he had been introduced under such inauspicious circumstances in 1869. The practice of chanoyu was a natural complement to Masuda's nascent interest in art collecting since it afforded a congenial setting for developing visual acuity as well as the opportunity to meet other collectors and art dealers. Chanoyu was also a time-honored means of developing business contacts, and Masuda, observing the professional success of tea aficionados such as banker Yasuda Zenjirō (1838–1921) and government official Inoue Kaoru, no doubt recognized that for him, too, tea might prove a useful as well as an enjoyable cultural pursuit.

Masuda took up the practice of chanoyu at a time when it had reached the lowest ebb in its history. With the abolition of the shogunate, tea had lost the official patronage that it had enjoyed for 250 years, and although there were some who continued its practice for their private pleasure, they could collect only on a comparatively modest scale.

The upheaval in the world of art collecting and chanoyu was dramatically illustrated by two events that took place in 1872. That year, Sakai Tadayoshi, the heir to one of the great collections of tewares, offered eighty-one items for sale but was able to sell only sixteen of them. The works that did find buyers were all exceptional meibutsu—fragments of calligraphy by Fujiwara Teika and the Chinese Zen monk known in Japan as Daitō Kokushi, ink paintings by Sesshū and Shōkadō Shōjō, Chinese incense containers, tea caddies, and celadon vases. Although all were sold at prices considerably less than their pre-Meiji value, the celebrated teabowl *Seppō* (Snow peak) by Kōetsu is said to have changed hands at 500 yen, and *Kokushi Nasu* (fig. 5-2), one of the Chinese tea caddies, was sold for 2,000 yen, both enormous sums compared to the prices of other art forms.[3] In 1872 also, tea masters, already facing the loss of status and guaranteed livelihood they had enjoyed under Tokugawa rule, were classified by the government as entertainers—the same classification accorded geisha.

Efforts to restore chanoyu's prestige began almost immediately. Recognizing that the fate of the three tea schools founded by Rikyū's heirs depended on him, Gengensai, hereditary grandmaster of the Urasenke branch and the senior member of the group, began a movement to reform both the image and the practice of chanoyu. To redress its image as a "flowery art" that fostered self-indulgence and extravagance, he addressed to the government a petition, couched in ethical terms of Neo-Confucian inspiration, demanding recognition of the moral and social qualities fostered by its practice. In his petitition he linked the practice of tea to Chinese philosophical doctrines, by designating it *chadō*, "the way of tea," rather than the more straightforward chanoyu. This was clearly designed to appeal to the Meiji government's social and political agenda.

The original meaning of the way of tea lies in the diligent pursuit of the five virtues, filial conduct and loyalty. Economy and understatement are its most cherished values. Never has conduct in accord with social status been neglected as the duty of our house. As beneficiaries of an ordered society through the benevolence of the emperor, we implore men to mingle without feelings of estrangement and regardless of wealth or position in society. We hope that through the timeless bounty of nature our descendents continue to enjoy the blessings of good health. As the task of beseeching is that of the instructor, the standard for the tea gathering insists upon the most exacting sense of propriety. It is with most sincere efforts that we undertake to preserve formal decorum. Consequently, even within the scope of preparation of a single bowl of tea, all of these intentions may be clearly manifest.[4]

To make chanoyu more appealing to the new, more cosmopolitan Meiji society, Gengensai also began promoting a style of tea called *ryūrei shiki* (standing bow style), which allowed guests to sit on chairs rather than directly on the tatami mat of the tearoom. This form of tea was inaugurated at the Industrial and Arts Exposition held in Kyoto in the winter of 1872, the first occasion in the Meiji era when foreigners were officially allowed to visit the former imperial city.[5] Although the *ryūrei shiki* style of tea appeared to be a Western adaptation of traditional chanoyu, it was in fact an adaptation of a style of tea of Chinese inspiration that had been practiced during the Muromachi period.

Efforts to revive chanoyu took other highly visible forms as well. In 1839 the declining fortunes of the three Senke had led Gengensai to sponsor eighty large-scale tea gatherings to commemorate the 250th anniversary of Rikyū's death. In 1877, following Gengensai's own death, a similar memorial tea was held on the grounds of Kyoto's Kitano Tenjin Shrine where centuries earlier Hideyoshi had hosted his legendary gathering. That same year, Kōzanji, a temple in the hills northwest of Kyoto, also sponsored a public tea in memory of its thirteenth-century founder, Myōe Shōnin, a monk credited with establishing tea plantations in the Kyoto suburb of Uji. These events, part of a movement to revive tea by reclaiming its roots and stressing public participation, were followed in 1880 by a re-creation of the Grand Kitano Tea.[6]

The publicity surrounding these large-scale tea gatherings and other similar events was so successful in renewing public interest in chanoyu and rekindling the art market that when the American zoologist Edward Morse, an avid collector of ceramics who had taught at Tokyo Imperial University in 1878–79, revisited Japan in 1882, he noted that "A quest for pottery showed unexpected conditions, for where formerly the bric-a-brac shops were filled with interesting pieces, now they are scarce; tea-jars, particularly, as the cult of the tea ceremony has been revived, and tea-bowls, tea-jars, and other utensils have come into use again."[7] Nor was this revival limited to Tokyo. An article that appeared in the *Yūbin shinchi* newspaper the following year noted a growing market for works of art associated with chanoyu in Kanazawa, seat of the Kaga domain and an important center of tea culture throughout the Tokugawa period. As evidence of the renewed interest in art, the newspaper noted the sale of a painting by Kano Tan'yū (1602–74) for 160 yen.[8] At a time when the average monthly salary of a carpenter or smith was 20–25 yen, of a local bank president 50 yen, and of a foreign technician 500–600 yen, this was indeed a large sum.[9]

Tan'yū's prestige at this time is noteworthy. As the first painter-in-residence to the Tokugawa shoguns, his painting had laid the foundations for the officially sanctioned styles and themes that would prevail throughout Tokugawa rule. Although he was a gifted and versatile painter, he was nonetheless the very embodiment of the feudal artistic system that had been dismantled and purportedly discredited following the Meiji Restoration.

◆ *Masuda Kokutoku and Kashiwagi Ken'ichirō*

Masuda credited his younger brother Kokutoku with first arousing his interest in combining chanoyu with art collecting.[10] In fact, Masuda Kokutoku did much more. He introduced his elder brother to collectors, dealers, and potential business associates, he designed teahouses for him, and he even served as his agent in the purchase of many works of art. Although he lacked his elder brother's business acumen, he too possessed an exceptional eye for art.

Born in Aikawa in 1852, Masuda Kokutoku's educational background and career were analogous to, if less spectacular, than his

elder brother's. He too began his "English" studies in Hakodate under Namura Gohachirō, by whom he was adopted. This adoption was later annulled, however, and by the time he enrolled as a student at Fukuzawa's Keio Gijuku Daigaku the boy had resumed the name Masuda. After graduation, the younger Masuda entered the Justice Ministry and was sent to Germany and the United States to study maritime law. Upon returning, he helped to compile Japan's maritime code, serving in the government for only a few years before joining the newly formed Tokyo Kaijō Hōken Kaisha, Japan's first marine insurance company, which was under the direction of Hachisuka Mochiaki (1846–1918).[11] Hachisuka, former daimyo of Awa domain (in modern Tokushima Prefecture), was a shrewd, Oxford-educated businessman with close ties to Inoue Kaoru.[12] Inoue no doubt played a role in Masuda Kokutoku's being hired by Tokyo Kaijō Hōken Kaisha.

Masuda Kokutoku began studying chanoyu soon after the Restoration, and through his teacher he joined Bincha, a club founded around 1873 that took its name from the iron kettle used to heat water for tea.[13] The club was guided by Kawakami Sō, a tea master of the Edo branch of the Omotesenke school. In the early Meiji period, when many men had been cut loose from their traditional social moorings, clubs like Bincha not only served to bring together those with similar cultural interests, but were useful links to politics and business. The members of Bincha were for the most part men of conservative tastes who had nonetheless made a successful transition to the new conditions of the Meiji era. For most the interest in traditional cultural practices was not limited to chanoyu. Some members are also known to have practiced *sencha*; others were interested in Kabuki; and still others in traditional music. The diverse membership of the club is striking. In addition to Masuda Kokutoku, it included a banker, Yasuda Zenjirō; a bureaucrat, Inoue Kaoru; a physician, Watanabe Ki; a journalist, Konishi Yoshihiro; and two art dealers, Umezawa Yasuzō and Yamazumi Rikizō.[14] Masuda Takashi did not belong to Bincha, but he later hosted and attended many gatherings with its members.

Although there are no records of the gatherings of this club, the guests at a "pottery party" attended by Morse in 1883 may well have included some of its members. The party was hosted by a tea master named Tanimura and included among its guests a student, a doctor, an editor of a daily paper, and a gentleman of leisure.

Morse's account of the event highlights the importance collectors attributed to the ability to discriminate among the many varieties of ceramics used in chanoyu. It also reveals the competitive play that was an integral part of chanoyu's appeal.

> Mr. Tanimura . . . has a meeting every month of men who are interested in old Japanese pottery. It is a guessing party, and each one brings a specimen of pottery difficult to identify. These are numbered and recorded in a list by one who does not take part in the guessing contest. The method is rather curious. The party sit around in a circle with candles in the middle, and each one has a lacquer cup with his name written on the bottom. A specimen of pottery, such as a tea-jar, bowl, or incense box is passed around, each in turn examines it, and then with a brush and India ink records his guess on the inside of the lacquer cup and places it downward on the mat. When every one of the party has marked his guess or opinion, the host records each name and opinion in a book. In this way we examined a number of old tea-jars, tea-bowls, and the like.[15]

Masuda Kokutoku began studying tea before his brother, but little is known of his taste or activities before 1884, when he hosted a chanoyu attended and recorded by Yasuda. For this gathering he hung in the tokonoma a calligraphic scroll inscribed by Seigan Sōi (1588–1661), the 170th abbot of Daitokuji. Seigan belonged to a circle of Kyoto tea men that included Rikyū's grandson Sen Sōtan, whom Seigan instructed in Zen. The utensils Masuda used in preparing tea—a Hakeme-style teabowl, a tea caddy in the style favored by Rikyū, and a tea scoop made by Sen Sōtan—suggest that his taste was relatively restrained and in keeping with Senke guidelines.[16]

Although Masuda Kokutoku was not as well-off as his elder brother, his sharp eye and contacts with dealers enabled him to make a number of exceptionally fine purchases for himself. Many of these works reflected his predeliction for wabi-style utensils. Two are now in the Gotoh Art Museum in Tokyo: an Old Iga vase with dramatic gashes down its sides, and the black Raku teabowl *Shichiri*, by Hon'ami Kōetsu (figs. 3-1 and 3-2).[17] Following his younger brother's death in 1903, Masuda Takashi purchased both these works from his estate.

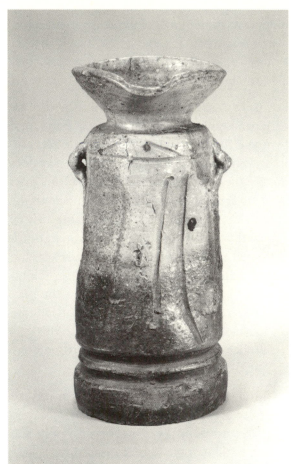

Figure 3-1. Old Iga
Flower Vase

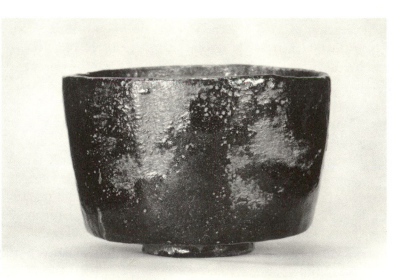

Figure 3-2. Black Raku
Teabowl *Shichiri*

Between 1896 and his death, Masuda Kokutoku was employed by the Mitsui Company and traveled extensively throughout Southeast Asia. Even while on business trips, he was alert to interesting articles that might be used in chanoyu. It was while in Bombay, for instance, that he discovered a strikingly patterned double ikat silk of a type called *patola* with a complex pattern including a cross formed from four heart-shaped leaves separated by lozenges and eight-pointed stars. *Patola* was woven in the Gujarat region of India chiefly for use in saris worn during weddings and other festive occasions. Its vivid colors and exotic pattern so appealed to Masuda Takashi that he used it for making protective and decorative cloth bags to enclose his favorite tewares. Small pieces of this fabric, which has come to be known as "Masuda Kantō" (Kantō refers to Canton, the Chinese port through which many textiles were traded), are now eagerly sought after by collectors (fig. 3-3).[18]

Masuda Kokutoku was also a talented designer of teahouses. Several of the teahouses on Masuda Takashi's estate, including his favorite, *Yūgetsutei* (Dim moon pavilion), were designed by him. (None of his designs survive, however.) Masuda Kokutoku no doubt came to his interest in and knowledge of the requirements of teahouse design through Kashiwagi Ken'ichirō (d. 1899), a collector, connoisseur, and art dealer who belonged to a family of architects once employed by the shogun. Since Western-style architecture was in vogue during the first decades of the Meiji era, there

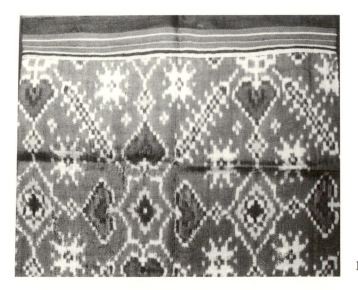

Figure 3-3. Masuda Kantō

was little demand for Kashiwagi's services as an architect. He is known to have designed a Women's Dormitory and Meeting Hall for the Mitsui Company, but beyond this most of his work was limited to private tea huts. Both Masuda and Shibusawa Eiichi had tea huts designed by him.[19]

None of the teahouses designed by Kashiwagi has survived, and discussions of architecture in the Meiji era are silent about him. For American zoologist and student of Japanese culture Edward Morse, however, he was a valuable informant about the traditional architectural styles and practices Morse was to describe in his 1885 publication *Japanese Homes and Their Surroundings*. Morse acknowledged his debt to both Kashiwagi and Masuda in his preface to this first Western study of traditional Japanese architecture.[20] More than a decade later, Ralph Adams Cram, a noted American architect and author of *Impressions of Japanese Architecture* would also find a kindred spirit in Kashiwagi, who, he claimed, "steadily refuse[d] to have anything to do with foreign architecture in any of its forms" and lived in a house "that was a faultless model of native architecture."[21]

In the 1870s and 1880s Kashiwagi made his living both as a consultant to the Tokyo National Museum and as an art dealer. (This was not, and still is not, considered a conflict of interest in Japan.) He was such a knowledgeable connoisseur of lacquer, ceramics, and old paintings that, together with fellow art dealer Ninagawa Noritane (1835–82), he was known as one of the Guardian Kings (Tennō) of Tokyo National Museum.[22] Edward Morse described Kashiwagi as "the pleasantest man I have met in Japan." And of his connoisseurship he said, "He is not afraid to say he doesn't know when some questions are asked of him, and does not approve of Ninagawa's method of trying to tell the exact age of an object."[23]

Kashiwagi's discriminating eye, together with his wide network of government and private connections, enabled him to acquire many exceptional works of art. In addition to Masuda, he was consulted by Edward Morse, William Bigelow, and Ernest Fenollosa. Masuda acquired from Kashiwagi a section of the twelfth-century illustrated scroll of *The Tale of Genji*, a work exemplifying the courtly themes and pictorial styles that art historians call Yamato-e (pl. 3). Later this scroll would be regarded as the most important painting in his collection. Kashiwagi had purchased it

for forty yen from Ninagawa Noritane, who had bought the scroll from the Hachisuka family for seven yen.[24] The price Masuda paid is not known.

Although the precise dates of Ninagawa and Kashiwagi's transactions are unknown, the low prices they paid for the Hachisuka family's scroll of *The Tale of Genji* leave no doubt that Yamato-e handscrolls, of which this, together with another section in the Tokugawa Art Museum in Nagoya, is today the most celebrated, were not greatly sought after by collectors of the early Meiji period. These prices, low as they may seem by modern standards, are in line with those paid for other handscrolls. In 1876, for instance, Tokyo National Museum bought a two-scroll set of *Fukutomi zōshi* (The story of Fukutomi) for forty yen, and a fifteen-scroll set of *Kasuga Gongen reigenki* (The Kasuga Gongen miracles), for five hundred yen. By contrast, that same year, 4,143 yen of the museum's total budget of 5,957 yen went toward the purchase of four glass window panes from England.[25]

The low esteem for handscrolls reflected their status in the Tokugawa period, when they were created chiefly for the amusement and edification of women and children and therefore were not considered suitable for display in the reception halls where official guests were received. *The Story of Fukutomi*, an illustrated version of which Masuda acquired some time before 1903, is a case in point (fig. 3-4). It relates the sorry but amusing tale of a man who, like the French performer Le Péteur, hoped to achieve fame

Figure 3-4. *The Story of Fukutomi* (detail)

and wealth by breaking wind before an audience.[26] The reappraisal of this and other narrative handscrolls was a by-product of late Meiji cultural nationalism, which held that Yamato-e gave expression to a uniquely Japanese pictorial style.

Kashiwagi also owned four other exceptional handscrolls later acquired by Masuda: a fragment of the *Chōjū giga* (Frolicking animals scroll), two versions of the *Jigoku sōshi* (Hell scrolls) and the *Yamai sōshi* (Scroll of diseases and deformities).[27] According to Masuda's grandson Yoshinobu (d. 1989), one of the *Hell Scrolls* came into his family's possession in a rather gruesome way. When the painting was offered to Kashiwagi, he did not have the money to pay for it, so he approached Masuda for a loan. Masuda agreed to the loan on the condition that upon Kashiwagi's death the scrolls would become his. Since Kashiwagi was considerably younger, he fully expected to outlive Masuda, but in 1899, while working on a teahouse for Shibusawa Eiichi, he was unexpectedly killed in a traffic accident.[28] This scroll, which was cut up after Masuda's death, is now divided among various collections in Japan and the United States. The section in the Seattle Art Museum, illustrated in figure 3-5, shows Buddhist monks who have tortured animals during their lives being driven into a fire by horse-headed demons. Both these fragments and a second, still intact version of the *Hell Scrolls* that also Masuda acquired from Kashiwagi, are still commonly referred to as the "Masuda scrolls."[29]

Although neither Masuda Kokutoku nor Takashi ever acknowledged his debt to Kashiwagi, it is likely that this urbane Tokyoite gave both a valuable artistic education by allowing them to handle and study the various works in his collection. In his *Japan Day by Day*, Edward Morse, who also benefited from Kashiwagi's expertise, describes the kind of congenial yet instructive gatherings that combined the functions of school, art gallery, and club room where aspiring men of tea developed their connoisseurship. Both Morse and Masuda attended a similar gathering hosted by Kashiwagi: "Seven or eight antiquarians were there, and it was delightful to talk with them and discuss pottery and other precious things which Kashiwagi brought out. . . . The appreciation of these old things is shown by everybody, and scholars meet to discuss subjects of every kind; it is one evidence among others of their long and high civilization."[30]

Figure 3-5. "Hell of Shrieking Sounds"

◆ *Yasuda Zenjirō and Inoue Kaoru*

The 1880s and early 1890s were Masuda's years of apprentice-ship. He attended many tea ceremonies as well as hosting some himself, but leadership in the world of tea was still in the hands of men such as Yasuda Zenjirō and Inoue Kaoru, who were older and wealthier than he (figs. 3-6 and 3-7). In many ways these two men, both equally devoted to tea, embodied two trends that had coexisted since the origins of chanoyu. While Yasuda especially relished the practice of tea, Inoue enjoyed the display of art that accompanied it. Masuda, who shared tea with both, would be more drawn to Inoue's than to Yasuda's style.

Yasuda, who made his fortune as a money changer (*ryōga-neya*) and later as a banker, was not among those first introduced to chanoyu and art collecting after the advent of the Meiji era. His father was a peasant who had bought samurai rank and the accompanying right to officiate at the teas held in his domain.[31] These family connections had given Yasuda a taste for tea and the arts associated with it at a relatively early age. His childhood friendship

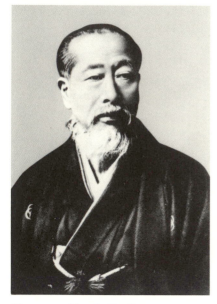

Figure 3-6. Yasuda Zenjirō

Figure 3-7. Inoue Kaoru

with the family of Osaka antiquarian Yamanaka further sparked his interest in art collecting.

Despite his long-standing interest in chanoyu, Yasuda's real dedication to its practice began only in 1880, the same year he founded the bank bearing his name that would be the basis of a vast business and financial empire rivaling that of the Mitsui family. It was in 1880 that Yasuda began to keep a tea diary that provides the basis for much of what is known about the dynamics of tea and art collecting during the early Meiji era.[32] Between 1880 and 1890 alone, Yasuda attended 95 teas, 17 of them his own. By 1911, the year of his final entry, he had attended 350. Like earlier tea diaries, Yasuda's records the date and location where the tea was held, the identity

of the host and guests, the works of art displayed in the tokonoma, and the utensils used in the preparation of tea. If the tea was accompanied by a meal or followed by musical entertainment, this too was recorded. Although the diary does not always convey a sense of the artistic flair or social interaction that animated each event, it is a remarkable who's who of the tea world as well as a unique and reliable record of the fluctuation in artistic taste.

Yasuda's diary for the 1880s is sprinkled with the names of the dominant personalities in the still restricted world of art collecting. Of course not all Japanese art collectors practiced tea, but all those who collected traditional Japanese and Chinese art were inevitably drawn into it. It was a small, close-knit world where everyone knew one another. Not surprisingly, the same names appear time and again. Businessmen and bankers are in the majority, but former daimyo also appear with considerable frequency. Professional connoisseurs, art dealers, and artists also figure occasionally as both hosts and guests. Many were men with whom Masuda would also become involved.

A typical diary entry describes a tea hosted by Masuda Takashi at his Gotenyama estate on March 26, 1882. There were four guests, Yasuda and industrialist Okura Kihachirō among them. In the tokonoma, Masuda hung a letter written by fourteenth-century Zen monk Chūgan Engetsu that had been mounted as a hanging scroll. Maiden flowers and wisteria were arranged in a single-level bamboo container of the style favored by shogunal tea master Katagiri Sekishū. The tea utensils included an Ashiya kettle, a Seto tea caddy, a Daitokuji Goki teabowl, and a tea scoop made by Shūsetsu.[33] Following the tea, the guests retired to the adjoining room where they were entertained by Masuda's instructor in Noh chanting, his brother Kokutoku, and "Hachisuka."[34] The latter was probably the former daimyo Hachisuka Mochiaki.

Hachisuka Mochiaki's name does not often appear in Yasuda's diary, but that of Matsuura Akira (1840–1908), another wealthy former daimyo, does. Matsuura, who was the heir to a large and distinguished art collection, was deeply concerned about the preservation of traditional cultural values, especially chanoyu. An avid practitioner of tea, he would be a founding member of an exclusive club of sixteen tea devotees known as the Wakeikai whose stated purpose was "to bring together for their mutal enjoyment courtiers

and daimyo, soldiers and doctors, industrialists and students, and even merchants of rice and lacquerware." Like Yasuda and himself, most of the members of the club, were affluent men born in the 1840s for whom the practice of tea had been a way of life long before the fall of the Tokugawa regime. As the hereditary master of the Chinshin school, a branch of the Sekishū tradition founded by his ancestor Shigenobu (d. 1708), Matsuura also had a personal stake in promoting chanoyu among the younger generation. A strong advocate of its practice by women, he became an influential tea instructor in the female division of Gakushūin, the Peers' School.[35]

Yasuda's diary also reveals that he and fellow collectors were well acquainted with Ryōchū and Ryōsetsu, two members of the Kohitsu, a hereditary line of calligraphy connoisseurs with close ties to the tea world. The Kohitsu, whose name means old brushwork, had made their livelihood during the Tokugawa period by authenticating works of art and by serving as agents in the sale of painting and calligraphy. Matsudaira Fumai, for instance, had purchased a scroll with a poem inscribed by Fujiwara Teika from a member of this family.[36] Their specialty, however, was albums with writing samples from different periods, often created to serve as models for calligraphy students. To compile these anthologies, the Kohitsu often cut sections out of Buddhist scriptures or other scrolls and removed pages from books. These fragments were then pasted into albums that were arranged both chronologically and in keeping with the social status of the writers.

Members of the Kohitsu family continued to practice their profession after the fall of the Tokugawa regime, often displaying their works of art both in formal art exhibitions and in informal chanoyu at which they were hosts or guests. Nor was calligraphy the only art form they sold. Occasionally they dealt in teawares and even Buddhist art. Their clients included Americans Morse and, later, Charles Freer, as well as Japanese collectors such as Masuda.[37]

Masuda acquired from Kohitsu Ryōchū the *Kanbokujō*, an album of 311 calligraphic fragments inscribed by noted calligraphers from the Nara to the Muromachi periods (fig. 3-8).[38] Now classified by the Japanese government as a National Treasure, the *Kanbokujō* contains one of the oldest surviving transcriptions of a poem by Ki no Tsurayuki, the compiler of the *Kokinshū*:

Figure 3-8. "Kōya-gire" in the Kanbokujō Album of Calligraphy

> When night gathers
> the waters are but dimly seen—
> at dawn once more I'll
> view Twice-seen Bay glittering
> like a jeweled box as day bursts open[39]

Since this fragment was once part of a calligraphic scroll preserved in a temple on Mount Kōya, it is commonly known as a "Kōya gire," literally, Kōya cutting. Inscribed in fluid yet measured *kana*, it is attributed to Tsurayuki himself, but it probably dates to the mid-eleventh century.

Despite Yasuda's deep involvement in chanoyu, the dearth of anecdotes about the ceremonies he hosted suggests that he did not have any special quirks or particular flair. Nor, despite his phenom-

enal wealth, does he appear to have spent a great deal of time or money on the acquisition of art. He was notorious for his frugality. What he did acquire suggests that his tastes were rather conservative. He was among those collectors who preferred to buy "safe" works widely acknowledged to be of artistic merit. A flower and bird composition by the Southern Sung academic master Ma Yuan, which he displayed in the first chanoyu recorded in his diary, is typical of this tendency. Paintings by Chinese artists of the twelfth or thirteenth century were the equivalents of Old Master paintings in the West, whose aesthetic merit was unquestioned, and whose ownership signaled that one belonged to the exclusive club of major collectors. Their enduring popularity in tea circles rested as much on the prestige that came from their ownership as on their undeniable visual appeal and their small scale, which made them especially well suited to the tearoom.

The patterns of display and use during the first twenty years covered in Yasuda's diary reveal that the tradition of daimyo tea was still strong. Yasuda and his friends were especially fond of works associated with or in the taste of Kobori Enshū. Ink monochrome paintings and calligraphy by Enshū's student Shōkadō Shōjō were well represented.[40] So too were calligraphic scrolls by seventeenth-century monks of Daitokuji, Kōgetsu Sōgan and Takuan Sōhō, both of whom belonged to tea circles frequented by Enshū. Calligraphy by court calligraphers of the Heian and Kamakura periods, such as Fujiwara Teika, whom Enshū had especially admired, were also displayed with considerable frequency.

Yasuda's tea diary also attests to the enduring popularity of Chinese-style ink paintings by masters of the Kano school. Paintings by Kano artists were displayed at sixteen of the ninety-five teas Yasuda recorded between 1880 and 87 (the same number of times works by Shōkadō Shōjō were shown) and at twenty of the eighty-five recorded between 1890 and 1901.[41] During this second period, the popularity of Kano painting was matched only by that of calligraphy by courtiers of the Heian and Kamakura periods.

The fondness for Kano painting was also in keeping with daimyo tea taste. Members of this hereditary school of artists had enjoyed the patronage of the Tokugawa rulers, so their compositions, which drew inspiration from the artists and styles popular among the Ashikaga shoguns, were displayed at official tea gatherings. Small hanging scrolls especially by Kano Tan'yū , who was an

enthusiastic devotee of chanoyu as well as a gifted and versatile painter, had also been used since the seventeenth century for less formal teas hosted or attended by merchants.[42] Paintings by members of the Kano school as well as other artists who had adopted ink painting styles and motifs of Chinese inspiration continued to be esteemed by collectors of the eighteenth and early nineteenth centuries. The collection of Matsudaira Fumai included compositions by sixteenth-century ink painters Sesshū and Sesson as well as works by Kano Motonobu and Eitoku.[43]

The frequency with which Kano painting was displayed at gatherings hosted by Yasuda and his friends belies the widely held belief, popularized by American collector Ernest Fenollosa as well as by Japanese art historians writing in the Taishō era, that it was disdained by Meiji collectors and connoisseurs.[44] While it is not clear to what extent other collectors shared this fondness for Kano painting, there is little question that artistic tastes among men of tea were not abruptly altered by the political changes that occurred in 1868.

Tastes in tea utensils are more difficult to determine, but domestic wares were clearly the most prevalent. Among teabowls, Karatsu and Ido were especially popular. Karatsu wares, first fired in large quanitities in Kyushu by potters who had immigrated from Korea in the late sixteenth century, had been especially favored by tea master Furuta Oribe. Later, however, the taste for them fluctuated.[45] Ido bowls, which were imported from the Korean peninsula where they had served as rice bowls, had been used in wabi tea throughout the Tokugawa period. Tea utensils with overglaze enamel decor made by the Kyoto potter Nonomura Ninsei were also frequently used (fig. 2-11). Many varieties of tea caddies were used, but those of the square-shouldered (*katatsuki*) type produced at the Seto kilns in imitation of Southern Sung imports seem to have been especially popular (figs. 2-2 and 3-11). The majority of tea scoops and bamboo flower containers were made by tea masters of the Tokugawa period such as Sen Sōtan.

Karamono of the Sung and Yuan periods and meibutsu associated with Nobunaga and Hideyoshi are strikingly absent from Yasuda's tea diary. These and other treasures had not been lost. They were, however, unavailable to these early Meiji collectors, since most of the former daimyo and merchants who had inherited them remained wealthy enough to hold on to them. Although it is

widely assumed that all daimyo, deprived of their domains, were left penniless, many were generously pensioned, so that in addition to social prestige, they still had substantial private incomes. In 1876 Hachisuka Mochiaki, who sold many works of art during the first decades of the Meiji era, had an annual income of thirty-six thousand yen. Even as late as 1901, members of the Maeda, Mori, Sakai, Shimazu, Mori, Matsuura, and Tokugawa, all former daimyo families, had annual incomes of over fifty thousand yen, making them among the 500 wealthiest men in all Japan.[46] Therefore, art sales by most former daimyo probably were motivated not by poverty but by their desire to divest themselves of assets that could be more profitably invested in industry and banking.

Some meibutsu no doubt did change hands during the first decades of the Meiji era, but their sale was conducted privately and not widely publicized, as would be the case in later years. Moreover, their new owners seem to have hidden these treasures in their storehouses. In light of the then still precarious state of the national economy, most collectors recognized the ostentatious display of such valuable assets to be in poor taste. Inoue Kaoru's failure to comply with this unwritten rule was probably one of the many factors that contributed to his unpopularity among fellow collectors.

At a time when most of his peers were seeking to revitalize chanoyu by rejecting, nominally at least, the excesses with which it had been associated during Japan's feudal past, Inoue promoted lavish gatherings and art exhibitions in the grand tradition of the Momoyama era. If Inoue's actions smack of self-promotion and showmanship, they are nonetheless evidence that tea and art collecting remained an integral part of the nation's cultural tradition.

Inoue, who served as foreign minister from 1879 to 1887, was an astute, even brilliant, politician whose repugnant personality often overshadowed his many positive contributions. He had a notoriously violent temper that led to his being called Kaminari-san, "Mr. Thunder." He was overly concerned with self-aggrandizement and was avaricious to a point that astounded even his friends. Fellow collector Kido Takayoshi recorded a particularly blatant instance in his diary. In 1870 Inoue had given Kido a set of two paintings by the literati artist Tanomura Chikuden. Kido thought they were a gift, but the following year Inoue started a quarrel, claiming that he had neglected to pay him. To end the disagreement, Kido offered Inoue forty yen, double the amount Inoue had paid for

them the previous year.[47] These personal qualities, combined with his outspoken promotion of Westernization at a time when he was in charge of delicate treaty negotiations with the West, made Inoue a frequent target of censure.

Although Inoue was described by one Western acquaintance as a man "who has adapted himself to Western civilization and habits more perfectly than any of his compatriots," he was at the same time a man with an abiding interest in traditional cultural pursuits, including tea and art collecting.[48] In 1887, despite deepening resentment of foreigners, Inoue, together with Home Minister Itō Hirobumi, planned two very different cultural events. The first was a Western-style masquerade ball held in the Rokumeikan, a two-story brick structure designed by English architect Josiah Condor for the use of government officials when entertaining Western diplomats. This gala brought together members of the foreign community and members of Japan's government and business elite. Banker Shibusawa arrived in the guise of a mountain ascetic. His wife was dressed in a butterfly costume inspired by a chapter from *The Tale of Genji*. Industrialist Okura Kihachirō assumed the role of Urashima Tarō, the hero of a Japanese folk tale. Inoue himself was dressed as a legendary strolling musician.[49] The second event was held a week later, between April 26 and 29, on the grounds of Inoue's Tokyo estate. Inoue's gala featured Kabuki performances, a viewing of his newly restored teahouse, and an exhibition of his art collection. If the Rokumeikan ball was an effort at international public relations, these events were aimed at improving Inoue's image at home.

Inoue's party was ostensibly occasioned by the reassemblage on the grounds of his estate of Hasōan, a teahouse associated with tea master Murata Shukō that had originally been attached to the Shishōbō of Nara's Tōdaiji temple. Inoue had purchased the Hasōan in 1880, but some years passed before it was reinstalled in Tokyo.[50] Since the dismantling, removal, and reassemblage of a small wooden teahouse was a relatively simple matter, one must assume that the seven-year delay was due to Inoue's preoccupation with matters of state.

The Hasōan was just one in a long series of tea-related acquisitions Inoue made during the first decades of the Meiji era. His dizzying succession of government assignments involved frequent travel throughout Japan and abroad, and whenever the opportu-

nity arose he visited antique dealers where those who had not fared well following the Restoration often disposed of family heirlooms. As early as 1870, for instance, he had purchased for fifty yen a set of five Shonzui ware plates used for serving food in the meal accompanying tea.[51] Not all of his acquisitions were purchases, however. He was notorious for coercing his associates, as Hideyoshi had done earlier, to present him with their prize teawares. As Fujihara Ginjirō, a fellow industrialist and tea devotee, later recalled, " Mr. Inoue got a very bad reputation because it was said that he took teawares from other men. . . . Mr. Inoue [simply] offered praise, saying 'this is an especially fine tea utensil,' then looked at it longingly. Seeing this, [the owner,] hoping to humor Inoue, would present it to him."[52] It was in this way that Inoue is thought to have acquired from a former daimyo a celebrated painting of a radish by Mu-ch'i that had been part of a scroll in the Ashikaga shogunal collection.[53]

Inoue's interest in tea and art collecting went hand in hand with a love of other traditional pastimes. Chief among them was Kabuki, a dramatic art form much enjoyed by the samurai elite of the Tokugawa period despite criticism that its often promiscuous subject matter was inappropriate for the nation's leaders. Efforts to reform Kabuki—especially to expunge from it language and scenes considered too vulgar or obscene for mixed audiences—had begun in the 1870s, but no official action was taken until 1886 when a coalition of bureaucrats and influential industrialists led by Itō Hirobumi and members of the Chōshū clique formed the Engeki Kairyōkai (Society for the Reform of Theater). Members of the society included bankers Shibusawa Eiichi and Yasuda Zenjirō, journalist Fukuchi Gen'ichirō, industrialist Okura Kihachirō, and Inoue himself.[54]

Having gained the cooperation of fellow members, in April 1887 Inoue erected in his garden a temporary theater, lit by electricity, which had only recently become available in Tokyo. There, for four consecutive days, Danjurō IX, Kikugorō V, and other celebrated actors performed sanitized versions of popular traditional Kabuki dramas. The emperor, imperial princes, and government officials attended the first day; the empress, princesses, and wives attended the second; the diplomatic corps and relatives the third; the empress dowager and her entourage the fourth. Although the Meiji Emperor was far less remote from his subjects than had

been his predecessors, an imperial visit was nonetheless a rare honor. By their attendance, the imperial family helped to establish Kabuki as a legitimate dramatic form to which both men and women of all levels of society could attend, and by the same token, they gave Inoue himself what amounted to an imperial seal of approval.

The event was momentous enough to be commemorated in woodblock prints by various artists. All were no doubt inspired by newspaper accounts rather than first hand knowledge. The triptych by Hashimoto Chikanobu (1838–1912) illustrated in figure 3-9 features the performance of Kikugoro V (1844–1904) in *Tsuchigumo* (The monstrous spider), a drama created especially for him. The emperor and empress, both dressed in Western attire, are seated on a dais on the right, while the other guests are seated on chairs at ground level to the left.

Figure 3-9. Performance of Tsuchigumo by Kikugoro V at Inoue Kaoru's Mansion

During the intermissions, Inoue guided his guests through the historic teahouse. Although Inoue did not serve tea, the emperor was not unfamiliar with chanoyu since tea had been prepared for him at the Imperial Palace in Kyoto two months earlier by Rokurokusai, Gengensai's successor as grandmaster of the Urasenke tea school.[55] Inoue also used this opportunity to show off his extensive art collection, displaying it on the second floor of his mansion. The stars of the exhibition were Mu-ch'i's radish painting and its mate, an image of a white cabbage.[56] To make a good impression, Inoue, unbeknownst to his guests, had apparently borrowed the

latter from shipping magnate Kawasaki Shōzō. The two paintings had originally formed part of a single handscroll showing several vegetables, which had been separated and remounted as hanging scrolls. Inoue's decision to display these scrolls for the inauguration of his teahouse may have been prompted by historical precedent: the tea diary of Tsuda Sōtatsu records that paintings from this scroll were displayed at a tea ceremony held in the Shishōbō on the fifteenth day of the second month of the year 1562.[57]

When the empress dowager toured Inoue's art collection she so admired these two paintings that etiquette obliged Inoue to offer them to her. Upon her departure, however, the painting belonging to Kawasaki mysteriously disappeared. Since those in attendance were not aware of its true ownership, it was assumed that Inoue had simply refused to part with his treasure, and he was severely criticized for his bad manners. The painting was presented to the Imperial Household Collection later, however, presumably after Inoue had gained Kawasaki's approval.[58]

The imperial visit to Inoue's mansion was a cultural and political drama with precedents of which both Inoue and his contemporaries were doubtlessly aware. Few could have failed to make the connection between this visit and Emperor Hanazono's visit in 1437 to the palace of the eighth Ashikaga shogun Yoshinori, or Emperor GoYōzei's 1588 visit to warlord Hideyoshi's Jurakudai Palace. The similarities between these events are indeed striking. All were well-orchestrated spectacles lasting several days, to which all the nation's most powerful court and political personalities were invited. All centered on lavish theatrical entertainment and the display of art treasures. And all had as their objective the consolidation and legitimation of power through association with the emperor. Like the ambitious Hideyoshi and other would-be political potentates of premodern times, Inoue recognized that political and cultural authority went hand in hand.

Although Masuda was not yet influential enough to be included among the guests at this memorable event, he shared Inoue's grand vision of chanoyu . As he later noted: "Tea is one of the leisure arts I enjoy. At first I was indifferent toward it, but gradually, as I began to understand it, I found it more interesting. Nobunaga, Hideyoshi, and other heroes were impressed with this art and came to find it deeply rewarding. Since the Genki and Tenshō eras [1570–75], all great men have had a taste for tea."[59]

Records of the tea gatherings Masuda hosted during the first decades of the Meiji era give little hint of the creative adaptation of chanoyu that later would lead friends and foe alike to claim, no doubt with a mixture of admiration and envy, that he had developed his own "Don'ō style" of tea.[60] Masuda began his study of chanoyu under Takahashi Sōi, a master of the Urasenke school, and learned from him the principles guiding the selection of the scroll, flower, and other objects that are arranged in the alcove of the tea-room as well as the proper movements required in the preparation of tea. Later he also studied under a master in the tradition of Katagiri Sekishū, the seventeenth-century shogunal tea master credited with the formal introduction and diffusion of daimyo-style tea in the city of Edo.[61] Masuda, however, was too strong-willed and independent-minded to remain anyone's disciple for very long. Since he came to tea relatively late in life, he was less steeped in tradition than others who had from an early age cultivated its practice. Moreover, the social upheavals of the Meiji era had made it easier for him to call into question the norms of the past.

Dispensing with the customary relationship with a professional tea master, Masuda took inspiration for his activities from the great men of tea of the Momoyama and Tokugawa eras. The men he most admired were not tea masters in the tradition of Shukō and Rikyū, but merchants, warlords, and daimyo for whom the practice of chanoyu and art collecting was inseparably entwined with business and political authority. Masuda felt a special kinship with Kamiya Sōtan, who also had made his fortune in foreign trade, and whose diary so vividly records the lavish tea gatherings hosted by Hideyoshi and other great men of the sixteenth century. He also admired Matsudaira Fumai, the nineteenth-century daimyo whose connoisseurship had enabled him to assemble such an exceptional art collection. The man he admired above all, however, was daimyo tea master, architect, connoisseur, and collector Kobori Enshū.

Masuda's interest in Enshū developed early and was not simply a reflection of the influence of his style of tea and artistic taste in the first decades of the Meiji era. His special kinship with Enshū evolved from having lived, beginning in 1876, on the grounds of Tōkaiji, a temple whose garden, pond, and tea hut the seventeenth-

century tea master was believed to have designed.[62] It was at Tōkaiji that in 1636 Enshū had first served tea to his patron Iemitsu.[63]

Masuda liked the area around Tōkaiji so much that as soon as his finances allowed it, he bought land on nearby Gotenyama, a hill in Shinagawa that had been celebrated throughout the Tokugawa period for its cherry trees and view of Edo Bay. Masuda was not the first tea devotee to be attracted to the area: Matsudaira Fumai had also had a mansion in Shinagawa; it was there that in 1816 he held the grand tea gathering described in chapter 2. Although the area was no longer as beautiful—the famous cherry trees had been burned in 1863 by men protesting the presence of the British legation—it was convenient for commuters since it was not far from Shinagawa station, one of the stops along the newly completed Tokyo–Yokohama train line. There Masuda built the house that he named Hekiundai (Blue cloud villa), which incorporated his first tearoom. Although Masuda would in time have many independent teahouses of various styles and sizes on this and other estates, his first gatherings were held in this tearoom, which, in keeping with the practice promoted by Enshū, adjoined a larger room where guests could relax after the formal tea had been served.

The influence of Enshū's taste is evident from the very first tea gathering Masuda hosted on November 6, 1881, soon after the completion of his house. For this special gathering Masuda invited his brother-in-law Tominaga Toshishige, who was a dealer in teawares, the banker Yasuda Zenjirō, and Hiraoka Hiroshi, a teacher of traditional Noh chanting (*kokyoku*). The selection of guests from such diverse backgrounds reflected Masuda's business interests, family ties, and personal hobbies. The focal point of the tea was a scroll with a poem inscribed by the Zen monk Takuan Sōhō (1573–1645). It was a doubly appropriate choice since Takuan had been a friend of Kobori Enshū as well as the first abbot of nearby Tōkaiji. Although the other utensils used for this special occasion are not known, the painting or scroll in the tokonoma determined the character of the gathering, so they too must have been in keeping with Enshū's taste.[64]

The calligraphy by Takuan was only the first of many articles owned, made by, or associated with Enshū that Masuda would acquire. Masuda's respect for Enshū's discriminating taste would especially lead him to seek out works that had belonged to Enshū.

Figure 3-11. Old Seto Tea Caddy *Hirano* and Four Accompanying Brocade Bags

By the end of his life, Masuda would own a large number of the surviving items Enshū listed in the *Enshū kurachō*, the catalogue of his collection of tea utensils. His pride in this accomplishment is reflected in his compilation of a book with photographic reproductions of the works that had formerly belonged to Enshū. Ceramic and lacquer tea caddies predominate, but there are also many teabowls, paintings, calligraphies, inkstones, and even brushes. Masuda himself owned 75 of the 210 works reproduced in this book.[65] Notable among them were a tea scoop carved by Enshū himself and named *Kiyomigaseki* after the place (in modern-day Shizuoka Prefecture) where he had found the bamboo (fig. 3-10), and an unusually large Old Seto tea caddy, named *Hirano* after one of its early owners (fig. 3-11).

How and when Masuda purchased so many of Enshū's treasures is not entirely clear, but it is likely that quite a few came to him via fellow tea aficionado Watanabe Ki (1836–1892). Masuda may have met Watanabe through his brother Kokutoku since both men were members of Bincha. Watanabe had purchased two crates full of Enshū's treasures in 1886, for the astronomical sum of 4,000 yen borrowed, it was rumored, from Yasuda Zenjirō. Watanabe died only six years later, however, and his collection was sold. Masuda acquired one of the finest items, a calligraphic scroll by Ch'ing-cho

Figure 3-10. Bamboo Tea Scoop *Kiyomigaseki*, Kobori Enshū

Cheng-ch'eng (Seisetsu Seichō in Japanese), a revered Chinese Zen monk who had come to Japan in 1326. The scroll was inscribed with the two large Chinese characters, *p'ing hsing*, meaning impartiality or equanimity. For this alone he paid two thousand yen—half the price of the entire lot purchased by Watanabe in 1886! Masuda no doubt coveted this scroll because Enshū was thought to have received it from his patron Iemitsu after performing tea at Gotenyama.[66]

Masuda was so taken by this scroll that he displayed it on many occasions, often with other articles associated with Enshū. For a tea held at his Gotenyama estate in 1910, for instance, he used it with a kettle that had belonged to Enshū and a bamboo flower container made by Enshū himself.[67] In his later years, Masuda also inscribed these two characters on several scrolls that he presented to friends.[68]

Matching the items once owned by Enshū with extant works was facilitated by the detailed annotations and drawings contained in the record of the contents of his storehouse, as well as by the extensive body of information concerning provenence and authenticity generally preserved along with treasured teawares. This system of pedigrees was not always reliable, however, and some of the articles Masuda believed to be from Enshū's collection were later copies and even forgeries. Masuda prided himself on his connoisseurship, but he was not infallible. As a friend remarked after Masuda bought a Raku bowl he incorrectly believed to be the work of Kōetsu, "occasionally even monkeys fall from trees."[69]

The problems of attribution Masuda and fellow collectors faced are highlighted by an incident involving a Ming period tea caddy listed in Enshū's catalogue.[70] Masuda was especially fond of this small lacquer container, decorated with a sprig of flowering plum inlay made of mother-of-pearl, and used it often. For fear of damaging it beyond repair, he secretly commissioned Hasegawa Sukeji, a noted lacquermaker, to made an exact copy. Copying or replacing a favorite tea utensil was a time-honored practice in the tea world.[71] Such copies were not considered forgeries—since they were not intended to deceive—but, after having been transferred from one collection to another, they were sometimes mistaken for originals. The copy complete, he held a tea, to which he invited various connoisseurs. All examined the lacquer caddy without real-

izing that it was a modern replica. Only when Masuda showed them its new box did they realize their mistake.

Masuda's prank highlights his conviction that chanoyu, while valuable as a means of instilling social and ethical values, could also be an amusing and entertaining experience. This view was antithetical to that espoused by the orthodox tea establishment, as represented by Gengensai, but well within the tradition of daimyo tea of which Enshū had been an exponent. Masuda's test, reminiscent of the "pottery party" described by Morse, also reveals the importance he attributed to connoisseurship. Like Enshū before him, Masuda's authority in the world of tea would derive in large part from his exceptional eye for art.

Masuda's purchase of a calligraphic fragment by the ninth-century monk Kōbō Daishi (Kūkai: 774–835) was the impetus for his inauguration on March 21, 1896, of an annual tea ceremony called the Daishi kai held on the grounds of his Gotenyama estate. The Daishi kai revealed Masuda's growing self-confidence as a man of tea—a self-confidence buoyed, no doubt, by his growing wealth and reputation as a businessman.[1] Given the surge of national pride that followed Japan's victory in the Sino-Japanese War of 1894–95, Masuda could not have chosen a better time to celebrate one of the nation's great culture heroes. Although there was a tradition of holding large commemorative tea gatherings, the Daishi kai was novel in that it honored a monk of the Shingon sect with no ties to the world of tea. The Daishi kai also broke with tradition by featuring Buddhist paintings and statues whose aesthetic and spiritual values had been considered inappropriate to chanoyu. Masuda and his friends had been collecting Buddhist art for some time, but by displaying devotional painting and statues at his gatherings, he contributed to far wider appreciation of their artistic and historical value. The precedent he set also stimulated others to collect and study Buddhist art.

◆ *Traditional Attitudes toward Buddhist Art Collecting*

The development of Buddhist art collecting was part of the process through which art was for the first time separated from belief, and its devotional qualities subordinated to its aesthetic ones. Buddhist icons used as the focus of ritual and devotion by sects other than Zen had not been the objects of art collectors' interest before the Meiji period. There were, to be sure, vast quantities of Buddhist sculpture and painting in temples and shrines, and most families also owned many icons, but these images were not bought and sold as were teawares or Chinese paintings. Buddhist statuary was generally commissioned directly from sculptors and, upon

completion, permanently installed on temple altars. Buddhist polychrome painting, commissioned or purchased ready-made from artists who specialized in religious subjects, was typically displayed only for the duration of specific rites. When not in use, it was rolled up and stored away. Buddhist icons were occasionally transferred from a main temple to a branch temple or from one family member to another, but commerce in Buddhist art was virtually unknown.

Although there is little writing on the subject, it would appear that trade in Buddhist art was considered sacrilegious in premodern Japan. The diary of a twelfth-century courtier describes a scandal that arose in the capital because a monk was profiting from the sale of Buddhist art. Selling a religious icon, the writer argued, is like selling one's mother and father.[2] As this analogy suggests, sacred images were thought to be imbued with qualities that required their being handled with special care. Although Buddhist teachings clearly differentiated between the deity and its representation, this distinction was not clear in the minds of many devotees. Tales about images that came to life, often with dire consequences, were widespread. So too were those describing the divine wrath that might be befall parishioners who neglected to care for the images in their local temple or shrine.[3] By the end of the Tokugawa period, there were no doubt many among the educated elite who saw such icons as the objects of superstitious belief, but for the vast majority of the population they were objects of deep reverence and even fear.[4]

Despite the government's efforts to eradicate beliefs it considered embarrassingly backward, these traditional attitudes continued to prevail well into the Meiji era. When Kido Takayoshi visited Nara in May 1869, he remarked on the "steady stream of worshippers, old and young, men and women" on their way to visit the Kannon statue in Tōdaiji's Nigatsudō.[5] Makimura Masanao, vice-governor of Kyoto, scandalized the city when he displayed in the prefectural offices a "secret image" (*hibutsu*) never intended for public viewing, and even as late as 1884, when Ernest Fenollosa sought to examine the now famous statue of Kannon in Hōryūji's Yumedono (Hall of Dreams), the priests "resisted long, alleging that in punishment for the sacrilege an earthquake might well destroy the temple."[6]

Another obstacle to trade in Buddhist art may have been its association with death. Many Buddhist paintings and statues were

created to serve in the funerary and memorial rituals that were an important function of Buddhist temples. Paintings of the Buddha Amida in his Western Paradise or descending to earth to greet the deceased, for instance, were commonly hung by the deathbed. Memorial services performed on the anniversaries of the day of death also required special images. Many images inspired by the *Lotus Sutra*, the most popular scripture of East Asian Buddhism, were created for use in such memorial services.[7]

Because of their subjects and styles, as well as the context in which they had first been created and appreciated, paintings associated with the Zen sect were viewed quite differently by collectors. Zen Buddhism had replaced the vast pantheon of deities that figured in the painting of other sects with a more limited number of deities and historical figures whose representations were intended as exemplars for Zen adepts. The spiritual and intellectual climate of Zen Buddhism had also fostered the creation of paintings of flora and fauna that gave symbolic expression to basic Zen ideals. In representing these themes, artists—who included both professionals and amateurs, monks and laymen—generally eschewed the the bright mineral pigments and gold and silver ubiquitous to Buddhist icons, relying instead on black ink with occasional touches of color. Many of their paintings, moreover, were copied from or inspired by those of the Chinese painters of the twelfth and thirteenth centuries whose works had been so eagerly sought after by the Ashikaga shoguns. These "Zen" paintings were among the first in Japan to be studied and appreciated in terms of style as well as content.

Commerce in Buddhist art began as a direct result of the Meiji government's decree of 1868 ordering the separation of Buddhist temples and Shinto shrines, which had traditionally functioned as unified cultic centers. In accordance with this decree, which was part of an effort to undermine Buddhist influence and establish Shinto as a state religion, Buddhist priests were ordered to relinquish their posts and return to lay life. Furthermore, Buddhist images in Shinto shrines and Shinto images in Buddhist temples were ordered removed. In the nationwide anti-Buddhist outburst resulting from this decree, temples and shrines throughout the country were abandoned and plundered, with damage varying from one region to another.[8]

In Japan, as in postrevolutionary France, the impulse to collect and restore religious monuments followed on the heels of a

brief but violent period of destruction. Although it is impossible today to determine the number of Buddhist and Shinto images lost, the recent discovery and identification of many works of art from temples dismantled during the early years of the Meiji era suggests that the extent of the damage may have been overestimated. Some icons were saved by being hidden, others by transfer to remote branch temples in regions where there was less antagonism toward Buddhism, and still others by being taken by defrocked priests who later sold them to the scores of antique dealers who opened shops in the vicinity of old temples.[9]

During the Meiji era, Nara alone had five dealers specializing in Buddhist art. The Tamai family, the source of many of Masuda's Buddhist treasures, maintained a shop near Hōryūji. (Their relationship was so close that, as discussed in chapter 6, several members of the Tamai family were hired to work in the Tamonten, an antiques shop in Tokyo established by Masuda Takashi and headed by his younger brother Masuda Eisaku.) A letter of 1907 addressed to the American collector Charles Lang Freer referring to the availability of a rare wooden statue of Jizō stolen from Hōryūji that had been hidden for many years indicates that even some of the works sold at the Tamai's Hōryūji shop were acquired under questionable circumstances during the chaotic early years of the Meiji era.[10]

Since so many transactions were clandestine, tracing the movement of Buddhist and Shinto paintings, statues, and related works of art in the early Meiji era is difficult. However, some clues about how they came to be transferred from religious institutions to private hands in the aftermath of the anti-Buddhist outburst can be found in the diary of Ninagawa Noritane. Ninagawa, one of the art dealer-connoisseurs who helped Morse form his collection of ceramics, participated in the first survey of temple and shrine treasures carried out under the auspices of the Meiji government. On July 30, 1872, the survey team visited Eikyūji, a temple formerly affiliated with Isonokami Shrine.

> Proceeding four or five blocks south of [Isonokami Shrine], we visited Eikyūji. We went to see the antiquities at Mr. Fujii Takao's.
> Wooden statue of Ono no Komachi; very old and beautifully carved; about one *shaku* in height; truly an exceptional image

> Eight Shingon patriarchs; four *shaku*; silk; very old; painted by Shinsen; fine works
> Record of the activities of the same [eight patriarchs]; painting by Mitsunobu; this is also a fine work
> Dual World Mandala; painted by Takuma
> [Wakan] rōeishū; four scrolls; by Gyosei
> It is said that one must not eat the fish or herbs in the Eikyūji Pond. Although the monastic orders have been abolished, sneaking into the Buddhist halls and elsewhere is forbidden.[11]

Ninagawa's account indicates that while many buildings were left standing, their contents had been removed to the home of Mr. Fujii, the secular name adopted by the former priest of Eikyūji. Although the whereabouts of most of the images Ninagawa saw is not known, quite a few works belonging to Eikyūji have survived. The Museum of Fine Arts in Boston owns a set of thirteenth-century panel paintings depicting the Four Guardian Kings that were acquired by Fenollosa, who described them as treasures from Tōdaiji.[12] The Berlin Museum acquired a set of paintings of the eight Shingon patriarchs, possibly the ones referred to by Ninagawa, but they were destroyed during World War II. At least two temples, Tōdaiji in Nara and Setagayasan Kannondō in Tokyo, have in their possession statuary originally from Eikyūji. Still other images are in the Tokyo National Museum, the Seikadō Foundation, and the MOA Museum in Atami. The owner of the largest number of treasures from Eikyūji, however, was the Osaka industrialist collector Fujita Densaburō. Records in the Fujita Museum, founded by his son, reveal that most of these works were purchased from Mr. Fujii, the former priest visited by Ninagawa.[13] The role of Mr. Fujii and other former priests in this and similar transactions, conducted at a time when it was unclear whether or not they had the right to dispose of devotional images from the temple formerly in their care, may help to explain why so many images were declared lost or damaged in the years after anti-Buddhist iconoclasm had swept the country.

◆ *Emile Guimet and Machida Hisanari*

When traditional Buddhist art began to enter the market in the 1870s, buyers were still few. Collectors were unaccustomed to

looking at Buddhist painting and sculpture as works of art rather than as religious icons, and they may have had scruples about handling and displaying images that might be associated with sickness and death. Some collectors also may have been deterred by uncertainty about its investment value. Western collectors and members of Japan's Museum Bureau, however, were not bound by such attitudes. The former were attracted to Japanese Buddhist art because of its exotic subject matter and ethnographic interest, while the latter saw its preservation and display chiefly in historical and commercial terms.

Emile Guimet (1836–1918), who went to Japan in 1876, was the first Western visitor to Meiji Japan to assemble a representative collection of religious art. One of the more sensitive Western observers of this period, Guimet was chiefly interested in Buddhist art as a reflection of Japanese religious traditions. His observations about the resurgence of popular religion suggest that the government's efforts to eradicate Buddhist beliefs had had just the opposite effect. "Popular religion," he wrote, "was one of the first things the progressive innovators had hoped to destroy; but their efforts in fact resulted in a revival of popular beliefs and forced the clergy to reorganize and perfect themselves."[14]

With the help of Kūki Ryūichi, the acting minister of education, who was himself a collector, Guimet was able to visit temples and shrines throughout the country. Wherever he went, he observed rituals, questioned priests about religious beliefs and practices, and purchased images illustrating them. He returned to France with three hundred religious paintings and six hundred statues of divinities, intending to install them in a museum in Lyons that would contain representations of "all the deities of India, China, Japan, and Egypt."[15] Guimet's selection was guided by the data on Buddhist divinities and their iconography that had been compiled and published by von Siebold in 1851 as part of his vast study of Japan.[16] Since Guimet was more interested in religious iconography than artistic quality, something he was in any event unqualified to judge, he did not hesitate to acquire copies of famous paintings or statues that are of negligible artistic interest by today's standards. One of his prize acquisitions was a set of wooden statues, purportedly modeled after the ninth-century lacquer figures arranged in the form of a mandala in Tōji's Lecture Hall. Guimet was apparently so impressed by the Tōji arrangement

that he commissioned copies from Kyoto sculptor Yamamoto Sai-suke at a total cost of 626 yen. The ornate, gilded figures Yamamoto sculpted, however, bear less resemblance to those in Tōji than they do to iconographic drawings contained in printed model books of the Edo period. This set of statues was among the selections from Guimet's collection displayed in the Paris International Exposition of 1878.[17]

Machida Hisanari (1838–97), the first director of what was to become Tokyo National Museum, was among the Meiji officials responsible for promoting recognition of Buddhist art as part of the national cultural patrimony.[18] A cultivated man, noted for his skill in traditional cultural pursuits and for his fine private art collection, Machida had a keen interest in Buddhist art and practice. When he resigned from the museum in 1887, he took Buddhist vows and moved to Miidera, a Tendai sect temple in the foothills of Mount Hiei, northeast of Kyoto.

Machida had been awakened to the importance of protecting traditional art during his two years in Europe. When he was in England as a student in 1865, the South Kensington Museum (today's Victoria and Albert Museum) had just been founded for the express purpose of promoting fine craftsmanship, and Gothic art and architecture was enjoying a surge of popularity that had prompted the restoration of many of Britain's many medieval churches. France, which he visited in 1867, had begun taking measures to preserve historical and cultural treasures even earlier. Romanesque and Gothic sculptures salvaged from monasteries demolished during the revolution or during city remodeling projects were being exhibited already in the 1820s, and by 1834 the government had established a Commission des Monuments Historiques to safeguard and restore monuments.[19]

Machida, influenced no doubt by what he had seen in Europe, was one of the leading advocates of the creation of a national museum that would be a repository for works illustrating the artistic achievements of the past. Although Japanese officials had expressed interest in museums since 1860, when a Japanese mission visited the Smithsonian Institution in Washington, their interest centered chiefly on museums of natural history rather than art.[20] Consequently, despite Machida's efforts, the museum that was eventually built in 1882 was not devoted solely to traditional Japanese and Chinese art, but rather was a museum of science,

technology, and history. Modeled after London's Kensington Museum, its primary objective was to promote commerce, not artistic sensitivity.

Commerce was also a motivating force behind the first government survey of temple and shrine treasures conducted in 1872 under Machida's direction. Although this undertaking signaled the start of the Meiji government's effort to identify important cultural property, the survey's aim was not strictly cultural. The survey team also hoped to locate examples of traditional art that could be sent to the International Exposition scheduled to be held in Vienna the following year as well as models for artists preparing contributions for sale at subsequent fairs.

The importance the government attributed to this project is evident from the constitution of the research team, from the number of institutions visited, and, perhaps most of all, from the fact that the group was accompanied by a photographer. In addition to Machida, the group included two noted connoisseurs, Ninagawa and Kashiwagi, an emissary from the Imperial Household Ministry, and even Western-style oil-painter Takahashi Yūichi (1828–94). After spending four months examining the holdings of temples and shrines in Tokyo, Nagoya, Ise, Kyoto, Nara, Wakayama Prefecture, Osaka, and Shiga Prefecture, the team presented a report listing items of historical interest, such as temple chronicles, private diaries, and arms and armor, as well many famous works of Buddhist art.[21] While economic dictates rather than preservation may have been the primary motivatation for the survey, the mere fact that government officials had been sent to examine the contents of old temple and shrine storehouses sent a signal that the wanton destruction of the past would no longer be tolerated. It also alerted owners to the potential economic value of traditional Buddhist paintings and statuary.

Although Japanese officials may have been inspired by British and French efforts to safeguard and register historic monuments and their contents, the 1872 survey was probably patterned after one conducted at the end of the eighteenth century at the order of Tokugawa Regent Matsudaira Sadanobu. For that survey, carried out at a time when antiquarianism was at its peak, artist Tani Bunchō (1763–1840) had visited many of the same temples and shrines later visited by the Meiji team. His purpose had also been to uncover ancient works illustrating Japanese history that could

serve as authoritative models for contemporary artists and craftsmen. In fact, the Meiji team may have hoped to trace some of the famous paintings, statues, calligraphy, arms and armor, and mirrors that are reproduced in the *Shūkō jisshū*, a printed book that records the results of Bunchō's survey.[22] Ninagawa's diary indicates that the team saw at least one of the treasures of Eikyūji illustrated in this publication—the statue of Ono no Komachi.

Growing recognition of and interest in Buddhist art primarily for its aesthetic and historical qualities is also reflected in the exhibitions sponsored by the Museum Bureau that were held in Tokyo's Yushima Seidō, a former Confucian temple, beginning in 1872. Initially none was devoted specifically to Buddhist art, but examples of religious painting and statuary from private collections were included. The exhibitors of Buddhist art at an exhibition held in the winter of 1872 included both Machida and Ninagawa, former daimyo Matsuura Akira, and members of the Kano, Tosa, Sumiyoshi, and Kohitsu families. The latter group, all of whom belonged to hereditary schools of painting and connoisseurship, would be especially active in the sale of Buddhist art during the first decades of the Meiji era. The articles displayed, and possibly offered for sale, at this exhibition ranged from handscrolls illustrating the biography of the thirteenth-century monk Ippen, to scriptures written by monk Myōe Shōnin, to gilt bronze statuary.[23]

Since the Meiji government created and staffed its Museum Bureau long before there was a permanent museum building, Machida made few acquisitions during the 1870s. The first purchases, made in 1873, were archeological artifacts excavated from Funeyama Kōfun, one of the many mounded tombs in Kyushu associated with Japan's early emperors. The first examples of Buddhist art, a group of ritual objects from Kōfukuji, were not acquired until 1876, and the first Buddhist painting, a depiction of Fugen Bosatsu from an unidentified temple, not until 1878.[24]

The government sponsored its first exhibition of Buddhist art in February 1877 in the cloisters around the Great Buddha Hall of Nara's historic Tōdaiji. Even the emperor attended this vast exhibition of more than one thousand items, including treasures from the Shōsōin and painting and sculpture from Hōryūji, the temple just outside Nara said to have been founded by Prince Shōtoku, the "father" of Japanese Buddhism. Kido Takayoshi, who was also among the visitors, was especially impressed by two items in the exhibition: a ninth-century statue of the Buddha Yakushi from Hō-

ryūji's Golden Hall and the seventh-century Tamamushi Shrine, an exquisite personal shrine in the shape of a miniature temple decorated with the shimmering wings of a beetle called *tamamushi* in Japanese.[25]

In February of the following year, 319 items, ranging from ancient textiles and ritual utensils to paintings and gilt bronze statues, were sold by Hōryūji temple to the Imperial Household. Many of these objects had only been recently transferred to Hōryūji from temples in the Nara region that had been abandoned or destroyed in the first years of the Meiji era. Although this transaction has been described euphemistically as a "donation," Hōryūji received ten thousand yen to maintain and repair its wooden buildings. Because of the unprecedented nature of this transaction, government officials had considered Hōryūji's offer for several months before accepting the collection and determining appropriate reimbursement, which was disbursed from a temporary budget of the Ministry of the Imperial Household. Since the government did not yet have adequate storage facilities, Hōryūji's treasures were deposited in the Shōsōin. They remained there until 1882, when Japan's first national museum, situated in Tokyo's Ueno Park, was completed.[26]

The Nara exhibition and transfer of treasures from Hōryūji, which was reported in several newspapers, is evidence of the evolution in the government and the public's attitude toward Buddhist art between 1868 and 1878.[27] While the exhibition helped to promote the sense that Buddhist art was of value chiefly for historic and educational reasons, the transfer gave tacit approval for the sale of temple treasures and indirectly helped to weaken the stigma attached to handling Buddhist art. Henceforth exhibitions and sales of temple treasures would become the chief means of safeguarding the survival of temples and shrines throughout the nation.

◆ *Ernest Fenollosa*

The process of reevalution of Buddhist art was already well under way when Ernest Fenollosa (1853–1908), the man widely credited with promoting the appreciation of Buddhist art in Japan and the West, arrived in Japan in the fall of 1878. Fenollosa had been invited, reputedly at the recommendation of Edward Morse, to teach philosophy at the new Tokyo Imperial University despite the fact that at twenty-six years of age, and barely four years after grad-

uating from Harvard University, he was hardly an established scholar. However, his prestige as a government official, his bravado, and above all his potential as a conduit for the sale of art abroad would open many doors to him.[28]

Fenollosa began collecting Japanese art soon after his arrival. A recently discovered record of his painting acquisitions reveals that between 1880 and 1889 he purchased 263 hanging scrolls and handscrolls, representative of nearly every school of Japanese painting. His annotated list, including provenance, attributions, and other pertinent information gleaned from various authorities, ranges from painting in the Yamato-e style, to works by Chinese-style painters active in Nagasaki, to Buddhist devotional icons. The gem of his collection was the *Buddha Śākyamuni Preaching on the Vulture Peak*, which was not then recognized to be a rare example of eighth-century Buddhist painting (fig. 4-1).[29] Until the Meiji era,

Figure 4-1. Buddha Śākyamuni Preaching on the Vulture Peak

Japanese connoisseurs had had little experience examining painting predating the Heian period, and errors of judgment involving such works were not uncommon. Just as it required the Napoleonic plunder of Italy for European collectors to discover the beauty of pre-Renaissance painting, so too it required the plunder of temples and shrines following the Meiji Restoration for Japanese collectors to discover the beauty of Buddhist painting and sculpture of the Asuka, Hakuhō, and Nara periods.

While Guimet's interest in Buddhist art was largely ethnographic, Fenollosa's was more aesthetic, reflecting the new trends in Western art history to which he had been exposed as a student. The almost rhapsodic tone of some of his commentaries on Buddhist art, however, also suggests a strong personal response to themes that most of his Western contemporaries still found too exotic. His entry on a large polychrome painting of White-robed Kannon by Kano Motonobu (fig. 4-2) is noteworthy in this respect.

Mr. Kano said that Motonobu's portrait of Buddha sold by Shosen to Okurasho has been considered the best of Motonobu; but this can now be said to be better, therefore the greatest Motonobu in existence. It is not a copy from Godoshi [Wu Tao-tzu] as some supposed. An original work. M's best in both color and drawing. The Kanos in Tokio have a copy of this by Taniu; and they have been studying and copying this design for ages, without ever having seen the original, or knowing where it was. A greater work than the colossal Nehanzu of Mot. at Miokakuji, Kioto. For so old a picture on silk, this is well preserved. Has noblest feeling. Kano calls it the finest picture in my collection. The execution of the rocks is considered by Kano to be unsurpassed. The whole effect nearly rises to the simple grandeur of Godoshi. The stary [*sic*] effect of the white would not have been noticeable when new. The double halo is effective and original. Lines in drapery most powerful. The calm unearthly grandeur grows on one. Matsuura offered me 150 yen for it. It formerly belonged to the daimyo of Hachisuka of Awa. The touch in the rocks of this is absolutely uncopiable. In this Motonobu's style is merely the clearest form of expressing his idea of rocks, instantaneous, inspired, not a manner. Of Motonobu's middle period. Kashiwagi said it was the finest picture in my collection. Yamanaka sold me this cheap thinking it or calling it

Figure 4-2. White-Robed
Kannon, Kano Motonobu

Cho Densu. Taniu's copy of this afterward (1883) sold in
Tokio for 350 yen. Has now become a celebrated work in
Tokio having been several times exhibited.[30]

This and other entries in the catalogue also provide valuable
evidence of the wide network of contacts on which Fenollosa relied
for advice and purchases. He knew two former daimyo collectors,
Matsuura Akira and Hachisuka Mochiaki. He was acquainted with
Kashiwagi Ken'ichirō as well as with art dealers Yamanaka Sadajirō
(1865–1936) and Wakai Kenzaburō of the Kiritsu Koshō Kaisha. He

also had dealings with Kano Eitoku (d. 1890) and Sumiyoshi Hiro-chika, two professional painters and connoisseurs who also sold traditional paintings. That Fenollosa crossed paths with so many collectors and dealers is evidence that the market for traditional art was already very active by the time he began collecting. Clearly, Fenollosa, far from teaching the Japanese people to know their own art, as Mary Fenollosa would later claim in her introduction to *Epochs of Chinese and Japanese Art*, was totally dependent on Japanese dealers and connoisseurs for both his information and his acquisitions.[31]

Masuda was acquainted with many of the men whose names are recorded in Fenollosa's catalogue and, given his knowledge of English, may well have met the American in the 1880s. There is no evidence, however, that Fenollosa influenced Masuda in any way. Despite their common interest in art collecting, the two men moved in very different circles since Fenollosa never took up chanoyu. Why Fenollosa, unlike Morse, remained so aloof from tea and apparently ignorant of its the influence in the development of Japanese taste is puzzling. (His *Epochs of Chinese and Japanese Art* makes no reference to it at all.) One possible explanation is that Fenollosa was less interested in appreciating Japanese art according to native aesthetic and decorative guidelines than he was in promoting his own approach to Japanese art history. Another is that, given the cliquish nature of chanoyu and growing resentment toward Westerners in Japan during this period, Masuda and his friends were not eager to include Fenollosa in gatherings where works of art were displayed, discussed, and, afterward, often purchased by one of the participants (see chapter 6).

That competition might have been a factor in Fenollosa's exclusion from the circle of connoisseurs to which Masuda belonged is suggested by Masuda's account of the history of a twelfth-century painting of Eleven-headed Kannon that he acquired in 1905 from Inoue. This painting, still in a private Japanese collection, had come into the possession of Hōkaiji, a small temple in Nara Prefecture, following the 1868 decree separating Buddhist and Shinto institutions. Inoue bought it from Hōkaiji some time in the 1880s for three hundred yen, only after Fenollosa, who had agreed to buy the painting from the temple for two hundred yen, failed to make payment.[32] Although Masuda's account was written years after the event, other evidence confirms that by the 1880s Japanese collectors were keenly interested in collecting Buddhist devotional art.

Although Masuda himself would become a leading collector of Buddhist art, his writings do not reveal when he made his first acquisition. His interest probably dates, however, from the same period when two close business associates, Inoue and Dan Takuma (1858–1932), began collecting. Whereas Inoue was considerably older than Masuda, Dan was younger and owed his job at Mitsui to Masuda.

Inoue seems to have had a special penchant for the imagery of the Shingon sect of Esoteric Buddhism. One of his early acquisitions was a painting representing Kujaku Myōō, which he is thought to have purchased around 1880 from the governor of Osaka Prefecture (fig. 4-3). The large scale and rigid frontality of

Figure 4-3. Kujaku Myōō

the seated deity, whose name Kujaku derives from his peacock mount, typify the style of painting associated with the Shingon sect. The painting had originally belonged to a temple on Mount Kōya, the monastic center of the Shingon sect founded by Kōbō Daishi. Inoue also owned ten paintings representing Fudō Myōō, a ferocious-looking deity, who protects believers against evil forces.[33] His taste for this type of painting must have been well known, for an adviser to the empress recommended he be given a painting of Fudō Myōō attributed to Kōbō Daishi himself as a reward for hosting the 1887 Kabuki performances discussed in chapter 3. This work, whose present whereabouts is unknown, was purchased by the imperial family from the Kongohōin, a venerable Kyoto temple, expressly for presentation to Inoue.[34]

Inoue was not alone in his fondness for images of Fudō Myōō. His taste was shared by Dan Takuma, a young protégé of Masuda's who also began collecting Buddhist art in the 1880s. Dan, born to a samurai family in northern Kyushu, had traveled to the United States in 1871 on the same ship as Masuda's younger sister Nagai Shige, remaining there until 1878, when he graduated from Massachussetts Institute of Technology with a degree in mining engineering. Unable to find employment as an engineer when he returned to Japan, he was forced to teach English, first in Osaka and later in Tokyo. During this period, he occasionally served as interpreter for Fenollosa. His interest in art collecting, Buddhist art in particular, he later wrote, was first aroused when he accompanied Fenollosa on his tours of Kyoto and Nara temples in 1879. He did not begin collecting seriously, however, until after 1884 when he was hired by the Ministry of Public Works to supervise operations at the Miike Coal Mines in Kyushu's Fukuoka Prefecture.[35]

The Meiji government had inherited from the shogunate most of the country's coal mines, but these enterprises required such heavy capital investment that in the 1880s it began to sell them off. When the Miike Coal Mines were auctioned in 1888, the two chief bidders were Mitsui and its rival, the Mitsubishi company. Mitsubishi, which dominated shipping at the time, was expected to win the mines, but when the secret bids were opened, Mitsui, bidding only at Masuda's insistence, and possibly tipped off by Inoue on what to offer, had won by a slim margin. Masuda, it was said, had urged Mitsui to bid for the mines after learning of the extent of the coal deposits there, the largest in Japan, from Dan. Extract-

ing the coal, however, was problematic due to frequent cave-ins, explosions due to seeping gas, and flooding as new and deeper shafts were dug under the bay.[36] As Dan later wrote:

> When I was in a state of terrible anxiety during the drilling of new drainage canals—a turning point in both the Miike Mines' and my own future—I happened to acquire a painting of Fudō Myōō during a trip to my hometown of Fukuoka. This painting helped to bring me peace of mind during the drilling.
>
> My interest in art had already been aroused through the influence of the appreciation of art shown by Fenollosa, a professor of philosophy at Tokyo Imperial University, and I enjoyed buying old paintings whenever I left Miike for Fukuoka, but until I bought the painting of Fudō, I had never been struck by such a feeling of inspiration. . . . Despite the fact that the painting was so soot-blackened that it was indistinguishable, I could make out from the box inscription that it belonged to Kōzanji [a temple in Fukuoka, not the famous one in Kyoto]. I guessed that it was several hundred years old, and after a glance, despite the difficulty of seeing the composition, I was impelled by the sense that it was my karma to help revive the temple's fortunes. I bought the painting on the spot and, when business took me to Kyoto, I entrusted it to a restorer for cleaning. . . . One month later, after the painting had been partially washed, when I saw Fudō's appearance—standing majestically amidst the water and fire, holding a sword in the right hand and a noose in the left—I was overjoyed. . . .
>
> At the time, having no idea what kind of Buddhist deity Fudō was, I had no intention of worshipping him, but as we struggled against a succession of floods in the tunnels under the harbor and fires in the coal mine shafts, I had the impression that we were being protected by Fudō Myōō, majestic amidst the water and fire.[37]

Although Dan claims that his interest in Buddhist art was first aroused by Fenollosa, it is noteworthy that the impulse to buy this painting was less aesthetic than spiritual. This account suggests that old beliefs and practices persisted to some extent even among

some modern leaders of Meiji Japan. Although his reverence seems to have been exceptional, it is noteworthy that Masuda, like both Dan and Inoue, was also drawn to the powerful imagery of Esoteric Buddhism.

◆ The Daishi Kai (I)

Masuda already owned numerous examples of Buddhist painting and sculpture by 1896, when he inaugurated the Daishi kai, but the catalyst for what would become an annual tea gathering held at his Gotenyama estate was the purchase of an exceptional sixteen-character calligraphic fragment inscribed by Kōbō Daishi in a highly ornamental, cursive style. The text was part of the *Tsuo yu ming* (*J. Zayu no mei*), a moralistic work by the second-century Chinese scholar Ts'ui Tzu-yu. Kōbō Daishi, who was considered one of the finest calligraphers of his day, may have copied it from an anthology by the T'ang poet Po Chu-i. The complete one-hundred-character handscroll had originally belonged to the Hōkiin, a subtemple of Kongobūji, the Shingon monastic center founded by Kōbō Daishi on Mount Kōya.[38]

The section acquired by Masuda in 1896 had been cut from the Hōkiin scroll around 1670, in lieu of a two-thousand-*ryō* payment due Kano Tan'yū for painting the walls of the temple's Golden Hall. Since Tan'yū is known to have emulated Kōbō Daishi's calligraphic style, he no doubt acquired this scroll as a model for his own practice, rather than for its edifying content. This interest in style rather than content is reflected in the fact that the fragment he acquired does not represent a continuous passage, but a ten-character section from the beginning and another ten-character section from the middle of the text. By the time Masuda acquired the scroll, two characters were missing from each section, but the passage's overall meaning remained relatively clear. The first admonishes the reader to be restrained in his conduct toward others but to forget about restraint when receiving alms, while the second suggests that the sun will shine on one who is warmhearted, but that being too softhearted is ineffectual.

Sometime before 1906 Masuda acquired another fragment of the scroll that had been preserved in a calligraphic album like the *Kanbokujō*.[39] This fragment featured on one side two cursive char-

acters, read "Nanzo itaman" in Japanese, and on the other a passage from a Buddhist scripture, also copied by Kōbō Daishi (pl. 4). When Masuda had this fragment mounted as a hanging scroll, he had the two inscriptions separated and mounted side by side. For the mounting, he used two rare and exceptionally beautiful pieces of fabric dating from the eighth century that he is said to have acquired from Hōryūji. The dominant fabric framing the calligraphy has a stenciled figures of large birds, flowers, and other fauna resembling those found on textiles in the Shōsōin. Taken out of their original context, the two characters, which could be interpreted to mean "Why such suffering?" took on Buddhist connotations not intended by their Chinese author.

Since Masuda was too much of a pragmatist to be a deeply religious man, it is likely that he intended the Daishi kai primarily to honor Kōbō Daishi for his contributions to Japanese culture. In addition to being an outstanding calligrapher, Daishi was credited with the invention of the *kana* syllabary, the sytem of writing that led to the flowering of prose and poetry during the Heian period. He also had a profound influence on the development of the visual arts of that period. The Shingon teachings he introduced from China led to many innovations in pictorial subject matter and style, most notably the mandala, a diagrammatic image that shows relationships among the many divinities in the Shingon pantheon. The popularity of elaborate rituals often requiring painting, statuary, and sacred implements arranged in mandalic form contributed significantly to the aestheticism that was a distinguishing feature of Heian court culture.

Masuda's inauguration of the Daishi kai the year after Japan's victory in the Sino-Japanese War also reflected widespread national pride and renewed interest in Japanese heroes. In the last decades of the Meiji era, the search for modern Japan would increasingly include the search for its past. Efforts to glorify and rewrite the past were certainly not new, but they were now undertaken with a greater self-confidence that was often accompanied by criticism of the West. The link between past and present was a dominant theme in the writings of Tokutomi Sohō (1863–1957), an influential journalist who wrote for *Kokumin no tomo*, one of the most widely read newspapers of the day. Writing during the Sino-Japanese War, he declared: "If we succeed in this great venture, our three thousand years of history will become living truth. Our historical heroes

will become living heroes. But if we lose, we shall not only bring disaster on our ourselves, we shall efface our history and betray our heroes."⁴⁰ Elsewhere he offered a list of heroes, singling out Kōbō Daishi as one of the men who best personified the national character.⁴¹

The Daishi kai represented a startling departure from traditional chanoyu in many ways, but none more so than in the expanded scope and character of the arrangement in the tokonoma and adjoining shelves. At the first gathering, Masuda's display included the *Zayu no mei* handscroll; a book of iconographic drawings used to guide artists in preparing a painted mandala; Kōbō Daishi's will (*yuige*), copied by Kano Tan'yū; a painted mandala; a censer from Hōryūji; a copy of the *Lotus Sutra*; and lotus flowers arranged in a scripture case.⁴²

Masuda's decision to display the *Zayu no mei* in the tearoom was a creative departure from tradition that opened up a whole new range of possibilities for tokonoma arrangements. Until the late nineteenth century, it had been customary to display writings by Chinese and Japanese Zen monks, poetry brushed by noted court calligraphers of the Heian and Kamakura periods, and writings by practitioners of tea. Despite the fact that many men of tea had been influenced by Kōbō Daishi's calligraphic style, works by him had not been shown in the tearoom. While rarity may have been a factor, the most likely explanation lay in the reluctance to display works of art associated with monks who did not belong to the Zen sect. A further inhibiting factor may have been the dearth of writings treating themes appropriate to the tearoom inscribed by monks of the Shingon or other older schools of Buddhism. Masuda was no doubt aware that he was breaking with tradition by displaying the writing of a ninth-century Shingon monk, but he eased acceptance of his innovation by selecting a Chinese text whose didactic tone echoed that of the writings of Kobori Enshū as well as later men of tea.

From the *Zayu no mei* it was only a matter of time before many new forms of religious writing came to be displayed in the tearoom. Masuda subsequently acquired a commentary on the *Kongō hannyakyō*, one of the central scriptures of Shingon Buddhism, also inscribed by Kōbō Daishi. As it was not suitable for hanging in the tokonoma he had it cut and remounted as a hanging scroll.⁴³ Another noteworthy example of calligraphy from the late

Figure 4-4. Passage from
Commentary on the *Sutra of
Golden Light*

eighth or early ninth century was a commentary on the *Konkōmyō
saishōōkyō* (*Sutra of Golden Light*) attributed to Emperor Saga (786–
842), with glosses written in red, attributed to Kōbō Daishi. This
fragmentary work was known as the "Iimuro-gire" (Iimuro cut-
tings) after the temple on Mount Hiei where it had been preserved
(fig. 4-4).[44] At some point the fragments had been mounted on
screens, but when Inoue Kaoru acquired them early in the Meiji
period, he restored them to their original handscroll format. When
Masuda purchased the handscrolls in 1926, he altered their format
again by cutting them into sections, which he had mounted as
hanging scrolls.[45]

Figure 4-5. The Five Esoteric
Ones (Gohimitsu) Mandala

The display of the *Zayu no mei* also set the precedent for the
use within the tearoom of a whole new range of pictorial, sculp-
tural, and decorative arts. Masuda often displayed at the Daishi kai
paintings like the Gohimitsu Mandala, created for use in specific
Shingon rituals (fig. 4-5). While this work's religious content must
have been remained a mystery to Masuda and his guests, they no
doubt appreciated this work for its subtle coloring and, above all,
for the sense of latent power conveyed by the five deities seated
within a womb-like halo.[46]

Masuda also contributed to the popularization of icono-
graphic drawings, a rich body of material that had been totally ig-
nored by earlier collectors. These drawings, dating for the most
part from the twelfth through the fourteenth centuries, included

Figure 4-6. Iconographic Drawing of Daiitoku Myōō

works in handscroll format executed by Shingon monks as part of their spiritual training as well as larger drawings on multiple sheets of paper used as models for polychrome paintings. A huge drawing of the deity Daiitoku Myōō astride a kneeling bull acquired by Masuda exemplifies the latter type (fig. 4-6).[47] This exceptionally detailed drawing even includes notations indicating the colors to be applied to the finished painting. Masuda and his peers no doubt found such drawings appealing because they were painted in ink with only occasional touches of color, giving them a superficial resemblance to the ink monochrome paintings long favored in the tearoom. Iconographic drawings, moreover, often have an individuality that was suppressed in most polychrome imagery painted by professional Buddhist artists.

Buddhist and Shinto sculpture was another area in which Masuda was a pioneer collector. He first exhibited a statue of Jūichimen Kannon at the Daishi kai of 1898.[48] In later years he also exhibited figures of Shinto deities, including Hachiman, a syncretic god to whom large Shinto shrines were dedicated at Kamakura, Usa, and Otokoyama, a hill south of Kyoto. Masuda's special fondness for wood sculpture from the Nara and Heian periods may reflect his predeliction for three-dimensional objects with strong and sharply contoured surfaces.

Masuda's enthusiasm for Buddhist art extended to temple paraphernalia such as altar tables, ornamental metal pendants (*keman*) suspended above the altar, gilt bronze trays for holding ritual implements, and musical instruments used in the dramatic performances that were part of the annual ritual cycle at many temples and shrines. And, with characteristic flair, Masuda found a use for all of them within the tearoom. In one ingenious tokonoma arrangement he used a damaged eighth-century drum core from Tōdaiji as a flower container.[49] For Masuda, as for the great men of tea before him, articles of artistic or historical interest, even if broken, could be recycled for use in chanoyu.

Masuda's catholic taste and skill in creating novel yet harmonious tokonoma arrangements is illustrated in a photograph taken to commemorate a tea the frail-looking octagenarian held in the large tearoom (*hiroma*) of his residence at his country estate in Odawara (fig. 4-7).[50] The spare yet elegant tokonoma arrangement is dominated by three lacquer plaques that originally formed the outer panels of a Buddhist shrine. The one in the center features an image of Tamonten, the Buddhist guardian of the north, and the two flanking panels feature regal lotus flowers and passages from a Buddhist text (pl. 7). Standing on a low table resting on the shelf beneath them is a Chinese bronze ritual vessel. On the ledge beneath the window to the left is an album of calligraphic fragments from Buddhist texts. The low, two-panel screen that frames the brazier and other tea utensils incorporates a large circular gilt-bronze temple pendant (*keman*) with a dazzling floral motif.

Masuda, who saw beauty in so many objects overlooked by his peers, may have been the first industrialist collector to devote special attention to the Buddhist art of the Asuka (552–645), Hakuhō (645–710), and Nara periods (710–794). Pre-Meiji collec-

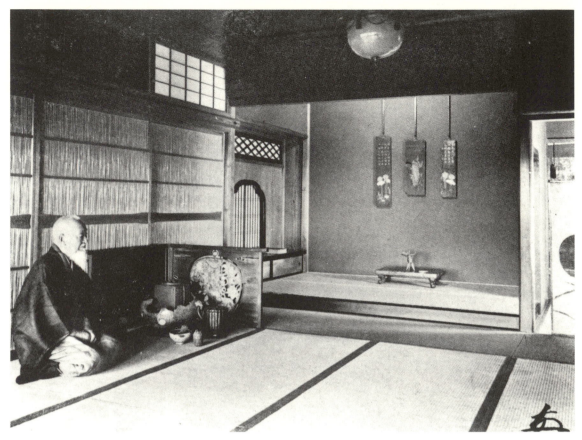

Figure 4-7. Masuda in
Tearoom of His
Odawara Estate

tors had considered the Heian period the dawn of Japanese art;
anything earlier was considered suitable only for use in temples or
shrines. In the 1890s, when Masuda first began acquiring objects
from this period, even professional art dealers had had little experi-
ence with works of art of such antiquity. When the Osaka dealer
Yamanaka was first shown a fragment of the *Illustrated Sutra of
Cause and Effects, Past and Present*, a scroll illustrating episodes
from the life of the Buddha Sakyamuni that had been accidentally
given to a rag dealer by a temple on Mount Kōya, he was unable to
identify its style or date. Only after consulting several dealers in
Nara did he learn that it was in fact an eighth-century painting.[51]
(For another version of this scroll, see plate 8.) Now, of course, this
scroll and others like it that were later discovered are known to be
the oldest surviving Japanese narrative handscrolls.

On another occasion, a Nara art dealer showed Masuda a landscape painted in ink monochrome on hemp also purporting to date from the eighth century. Since Masuda could find no frame of reference for this unusual work, he asked Kashiwagi Ken'ichirō to look at it. When Kashiwagi saw it, he immediately bought it on Masuda's behalf.[52] Since Kashiwagi had participated in the 1872 national survey of temples and shrines, he may have recognized this work to be similiar in style to two eighth-century landscapes, also painted on hemp, that were in the Shōsōin.

When and how two wooden figures representing a heavenly musician and an imaginary bird from Hōryūji came into Masuda's possession is not clear. These works, among the oldest and most treasured examples of Japanese wood sculpture, were originally suspended on a wooden canopy above the figures in the temple's Golden Hall (pl. 5, 6). Chances are that he acquired them around 1905, when the canopies and the figures were being repaired under the direction of sculptors from the Tokyo Art School, and four of the originals were replaced with copies. Since Masuda was a close friend of the abbot of Hōryūji, it is likely that he was presented these treasures as a token of appreciation for a large contribution toward the restoration work. The transaction is unrecorded, however, and the circumstances that led to Masuda's acquisition of these masterpieces of Japanese sculpture may never be known. Not surprisingly, Masuda took great pride in their ownership and displayed them often.[53]

By the turn of the century, so many of his peers were collecting Buddhist art that Masuda began inviting them to display examples from their collections at his annual Daishi kai. These displays, often focused on images of a particular deity or period, were designed to foster comparative study. In 1905, for instance, there were four examples of ritual implements from the eighth century and four paintings depicting Jizō Bosatsu.[54] They also offered Masuda, however, an opportunity to study interesting or newly discovered paintings that he was eager to acquire for himself. Indeed, many works of art changed hands following their display at the Daishi kai. Although Masuda may have known about the the Gohimitsu Mandala (fig. 4-5) since 1894, when the painting was illustrated in the art journal *Kokka* (National culture), he acquired it from Katano Satohirō only after it was shown at the 1907 Daishi kai.[55]

Figure 4-8. Fukūkenjaku
Kannon

Since the Daishi kai was only held once a year, it provided
a showcase for only a fraction of Masuda's Buddhist holdings.
Although it was illustrated and discussed in *Kokka*, a unique
thirteenth-century painting depicting Fukūkenjaku Kannon seated
on a rocky promontory with the guardian deities Shukongōjin and
Bishamonten standing at its base, for instance, was never exhibited
(fig. 4-8). Perhaps Masuda himself had some doubts about the au-
thenticity of this work, whose iconography puzzles scholars even
today.[56]

Although the seventy-five-year-old Masuda ceded leadership
of the Daishi kai to fellow industrialists Hara Tomitarō (1868–1937)
and Nezu Kaichirō (1860–1940) in 1922, he continued to foster

interest in Buddhist art through chanoyu until the very last year of his life. The most memorable of these efforts was a large-scale gathering commemorating the three-hundredth anniversary of the monk Shōkadō Shōjō held at Masuda's Odawara estate only months before his death in 1938. Shōkadō Shōjō (1564–1639), a leading disciple of Kobori Enshū, had been a much admired man of tea and owner of a notable collection of tewares, as well as an accomplished ink painter and calligrapher known for his emulation of Kōbō Daishi's writing style. He was also a Shingon sect monk with a hermitage in the vicinity of the Otokoyama Hachiman Shrine, just south of Kyoto. Although neither Shōjō's contemporaries nor his later admirers could have been unaware of his religious status or his ties to the Hachiman Shrine, Masuda was the first to hold a commemorative tea gathering that fully expoited these personal and topical affiliations.

Masuda's tea not only made use of many Hachiman meibutsu, as the tea utensils that had belonged to Shōkadō Shōjō had come to be known, but brought together an extraordinary array of close to fifty paintings, sculptures, and ritual implements from temples and shrines in Japan and even the continent. While the majority of the objects exhibited were from Nara temples, including Tōdaiji, Kōfukuji, and Hōryūji, a good number also came from from Shingon temples in Kyoto and the Otokoyama Hachiman Shrine.[57] Two unusual sculptures now in American collections were among the articles exhibited on that occasion: one is a figure of Tobatsu Bishamonten, Divine Guardian of the North, standing on the shoulders of the earth goddess Chiten (fig. 4-9); the other is a wing from a small portable shrine showing a seated Buddha and attendants (fig. 4-10).[58] This event, the culmination of Masuda's long career, dramatically illustrates the extent to which the shift from temple to tearoom had expanded the parameters of art collecting in Japan.

If Masuda's incorporation of Buddhist art into the tearoom ultimately met with praise rather than criticism, it was because adaptation was central to the philosophy and practice of tea. His display of Buddhist art was seen as a creative adaptation rather than a transgression of traditional practices. Such changes had occurred frequently in the history of tea, often in response to changing social and economic conditions, but they were generally pioneered by professional tea masters, not by men like Masuda. Only those who had totally absorbed the essence of tea could question its rules and,

following their own instincts, explore beyond its traditional boundaries. To do so required both extraordinary natural artistic flair and force of personality. That both scholars and tea men today liken Masuda's role in the development of chanoyu during the modern era to that of tea masters Murata Shukō, Sen no Rikyū, and Kobori Enshū is testimony to the fact that he had these qualities in abundance.

Figure 4-9. Statue of Tobatsu
Bishamonten

Figure 4-10. Wing of a Portable
Wooden Shrine

During the first quarter of the twentieth century, when the personal fortunes of Japan's leading entrepreneurs reached new heights, art collecting for chanoyu became the sine qua non of membership in Japan's business elite, just as it had been centuries earlier among the nation's leading daimyo. Tea appealed to these new feudal lords for many of the same reasons it had appealed to the old. It provided a clearly defined framework in which men of varying levels within the same company or even different companies could socialize and display their personal cultivation. It created cohesion by reinforcing the interlocking patronage relationships essential in a society where business connections were based on personal affinity. It fostered lifelong friendships that were often cemented by arranged marriages between promising sons and daughters. And it provided an accepted outlet for playing out and resolving personal, political, or business rivalries that were not allowed to surface in the workplace. For the new daimyo, like the old, the often fierce competition for the acquisition of pedigreed tearwares was emblematic of the quest for economic power and social prestige.

Although the leaders of many of the nation's great industrial concerns amassed vast collections of Chinese and Japanese art, art collecting for chanoyu was especially popular among men employed by the Mitsui concern.[1] This mingling of art and business was not new, since members of the Mitsui family, long noted for their enthusiastic pursuit of tea, had routinely accepted valuable tearwares as collateral for or repayment of loans. Now, however, growing affluence and aspirations had enabled a new group of men, the salaried managers and shareholders of Mitsui's diversified enterprises, to enjoy this pleasurable but costly pastime as well. These men included Magoshi Kyōhei, Asabuki Eiji, Dan Takuma, Takahashi Yoshio, Fujihara Ginjirō, Nozaki Hirotarō, and Masuda's son Tarō. To a large extent, this younger generation of collectors patterned their activities after those of Masuda.

The exceptional popularity of art collecting for chanoyu among members of the Mitsui conglomerate during the first quarter of this century reflected Masuda's extraordinary success in making mastery of this art integral to the Mitsui way of doing business. One of his acquaintances recalled that, because tea gatherings were Masuda's preferred setting for discussions of business strategy (presumably after the formal tea drinking was over), no aspiring company executive could afford to be ignorant of chanoyu.[2] Masuda's promotion of tea among Mitsui's executives reflected his conviction that it was an aesthetic discipline and a form of entertainment that could also instill company values and reinforce the social hierarchy. This outlook was a legacy of the tradition of tea promoted by Kobori Enshū and practiced by daimyo throughout the Edo period.

If Masuda was the acknowledged leader of the new daimyo, it was as much a tribute to his authority within the powerful Mitsui conglomerate as it was to his artistic sensitivity. As director of Mitsui Trading Company from its founding in 1876 until 1901, he had overseen the transformation of what had been a small, faltering import-export business into a vast conglomerate that by 1914 was handling over a third of the nation's international trade and averaging nearly two billion yen a year in total business.[3] As director of the entire Mitsui Company from 1901 until 1913, Masuda oversaw its expansion from its base in banking, trade, and mining to cotton spinning mills, paper factories, electricity, and armaments. It was also during this period that Mitsui became deeply involved in Japan's colonial expansion, as one of the chief financial backers of the South Manchurian Railway. The Taitō Sugar Company, the most profitable enterprise on the island of Taiwan, which Japan had acquired in 1895, was also a Mitsui subsidiary. Founded by Masuda after the Sino-Japanese War, it was so successful that by 1920, when it was under the direction of his son Tarō, it had become a mini-conglomerate with thirty subsidiary companies.[4] This and other Mitsui enterprises in which he had equity were the basis for Masuda's vast fortune.[5]

So firm was Masuda's power base that he continued to guide company policy even after 1912, when forced to resign due to the Siemens scandal, in which employees of Mitsui Trading Company were found to have been bribing high naval officials to secure a lucrative government contract. Masuda remained a valued adviser

to Mitsui Hachirōemon Takamine (1857–1948), head of the main branch of the Mitsui family, until the latter's retirement in 1933. To promote his own interests he also used his personal ties with other members of the Mitsui family, particularly Mitsui Hachirōjirō (1849–1919), who was employed by Mitsui Trading Company and enjoyed chanoyu.

Masuda no doubt would have liked to cement these ties by arranging a marriage between one of his children and a member of the Mitsui family, but Mitsui intermarriage with managers' (*bantō*) families had traditionally been frowned upon. Indeed, it was only after lengthy family discussion that in the 1920s a marriage between a daughter of Mitsui Morinosuke, president of Mitsui Trading Company and a noted tea devotee, and Masuda's grandson Tomonobu was permitted. Although this was a love match rather than an arranged marriage, it nonetheless served to reinforce the elder Masuda's power and social standing.[6] A photograph of the elderly Masuda surrounded by all the female members of his family (their identities are not known) taken around 1930 testifies to the ongoing importance of marriage politics in twentieth-century Japan (fig. 5-1).

Masuda's far-reaching influence not only ensured the appointment of his protégé Dan Takuma as his successor in 1913 but, after Dan's death in 1932, contributed also to the choice of Ikeda Seihin as Dan's successor. When Ikeda retired from the directorship of Mitsui in 1936, a report in *Fortune* magazine noted that "Under this [retirement] plan, Mr. Ikeda moved out of the titular leadership of Mitsui Gomei Kaisha. It is generally suspected in Tokyo that he moved out of nothing else."[7] Much the same could have been said of Masuda.

◆ *The Battle for Art*

Fueled by the remarkable growth of their personal fortunes and by a yearning to surround themselves with the trappings of traditional culture, industrialists spent lavishly on all forms of art during the late Meiji and Taishō eras. Masuda himself, who by 1901 ranked among the five hundred wealthiest men in the nation, made more acquisitions during this period than at any other time.[8] Competition was intense, however. Masuda's early business associate Fujita Densaburō, who had benefited from his close ties with Inoue

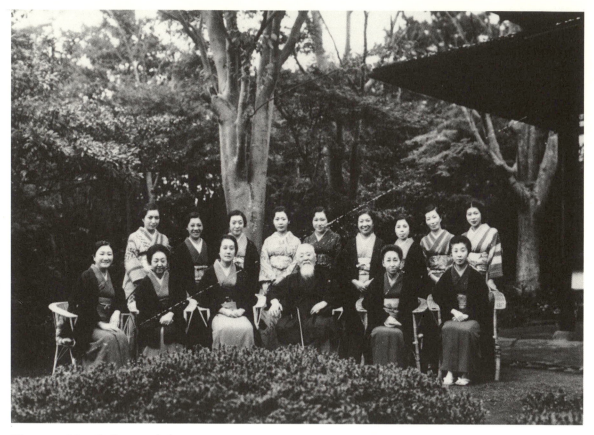

Figure 5-1. Masuda Surrounded
by Female Members of
His Family

Kaoru to build a diversified trading empire headquartered in
Osaka, was especially active in the art market. Inoue himself, who
in 1891, even while occupying a cabinet position, had accepted Mi-
tsui's offer to become the company's chief adviser, was also adding
to his art collection. The founders of Mitsui's rival concerns, Mi-
tsubishi and Sumitomo, were also building important collections.
And adding to their ranks were men behind other growth indus-
tries, such as shipbuilding and railway magnates Kawasaki Shōzō
and Nezu Kaichirō, and Hara Tomitarō, the adopted heir by mar-
riage to a great Yokohama silk fortune.

Competition among the swelling ranks of art enthusiasts
drove art prices to staggering new heights. The price and circum-
stances in which Masuda's young friend Hara Tomitarō acquired
in 1904 a twelfth-century painting of Kujaku Myōō heralded the
frenzied atmosphere that was to prevail in the Japanese art world
for the next decade and a half (fig. 4-3). That year, Takahashi Yo-

shio, who was an enthusiastic practitioner of tea as well as a journalist, arranged for Hara to visit Inoue's collection for the first time. When Hara saw the painting, he was so deeply moved that Inoue, perhaps half-jokingly, indicated that he might have it for ten thousand yen. Several days later, Hara sent Takahashi with the required sum, leaving Inoue no choice but to turn the painting over to him.[9] If fellow collectors were stunned by the unheard of sum offered for this Buddhist painting, they were even less prepared for the thirty-five thousand yen Masuda paid Inoue only a year later for a twelfth-century painting of Jūichimen Kannon. Inoue had bought this painting from a Nara temple in 1883 for three hundred yen.[10]

Although these prices were high, those commanded by Chinese paintings were higher still. The new daimyo were especially eager to own paintings by Mu-ch'i, Liang K'ai, Ma Yuan, and other Southern Sung painters. While Masuda acquired an exceptionally fine painting of a cat attributed to Southern Sung Emperor Hui Tsung, Inoue, master of one-upmanship, managed to acquire several works by him.[11] Among them was "Morning Dove on a Peach Branch," an exquisite work bearing an inscription dated to 1107, which is still widely accepted to be by Hui Tsung's hand (fig. 5-4). In 1913, when Nishi Honganji, the headquarters of the Honganji branch of the Jōdo Shinshū sect, auctioned a selection of its artistic masterpieces, Kawasaki Shōzō paid 50,000 yen, the top price at the sale, for a painting of Bodhidharma attributed to Mu ch'i. A quarter of a century later, when bankruptcy forced Kawasaki to part with it, the scroll would be resold for 123,000 yen.[12]

Although calligraphy by Chinese monks was much sought after, waka inscribed by Japanese courtiers, long admired by tea devotees, grew increasingly popular over the course of the late Meiji and Taishō eras. The rediscovery at Kyoto's Nishi Honganji in 1896 of the exceptional thirty-five-volume *Sanjūrokuninshū* (Anthology of the thirty-six immortal poets), inscribed by Heian courtiers on sumptuously decorated papers, did much to foster a wider appreciation of Japanese calligraphy. The anthology, which originally comprised thirty-nine books, is thought to have been commissioned in 1112 to celebrate the sixtieth birthday of Retired Emperor Shirakawa. By 1929, when two of the books containing poems by Ki no Tsurayuki and by Lady Ise were dismembered,

industrialist collectors including Masuda were eager to acquire pages of what had become the most celebrated example of court calligraphy (see fig. 6-11).

For the new daimyo, like the old, pedigreed karamono tea-wares continued to be much sought after. In 1912 Fujita Densaburō paid 90,000 yen for a ceramic incense container in the shape of a tortoise that had belonged to Matsudaira Fumai (fig. 5-2).[13] Predominantly yellow with brown and green markings, it was

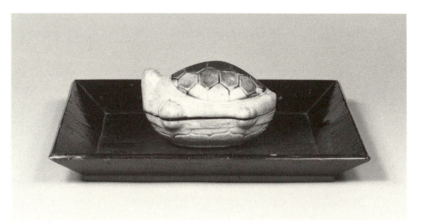

Figure 5-2. Kōchi Incense Container in Shape of a Tortoise

considered to be an exceptionally fine example of Kōchi ware. Its auspicious tortoise shape—the tortoise is a symbol of longevity—no doubt added to its appeal. Ceramic tea caddies, particularly those associated with the great warlords Nobunaga and Hideyoshi, were especially desirable. Mitsui Hachirōemon paid 159,200 yen for the Chinese *katatsuki* tea caddy, renamed *Kitano* after Hideyoshi had admired it at the Kitano tea gathering (fig. 1-5). In purchasing this caddy, the new head of the family was reclaiming the past, for *Kitano* had belonged to his eighteenth-century namesake. Hachiman meibutsu were also considered very desirable. *Kokushi Nasu*, a globular Chinese tea caddy that had been in the collections of Shōkadō Shōjō and later the Sakai family, was bought by Fujita Densaburō for 200,000 yen (fig. 5-3).[14] This price represented a hundredfold increase over the 2,000 yen it brought when the Sakai family had sold it in 1872.

Many art sales during the Meiji era were precipitated by bankruptcies or by failure to pay off loans. The Mitsui Bank was involved in two particularly celebrated cases, one involving an old

Figure 5-3. Tea Caddy *Kokushi Nasu*

merchant family and another involving Higashi Honganji, the Kyoto headquarters of the Otani branch of the Jōdo Shinshū sect. Nakamigawa Hikōjirō (1854–1901), who until his sudden death in 1901 was Masuda's chief rival for power within the Mitsui Company, was behind the Higashi Honganji sale.

The nephew of educator Fukuzawa Yukichi, Nakamigawa had been appointed director of Mitsui Bank on Inoue Kaoru's recommendation in 1897. His first task was to modernize and consolidate the bank's activities. The most notorious policy decision of his brief career was the effort to collect ten million yen, representing 5 percent of the bank's outstanding loans, from Higashi Honganji. For Nakamigawa, who had been profoundly influenced by his uncle's skepticism toward religion, nothing was sacred, and he threatened the temple that if the debt was not repaid within the year he would confiscate its main devotional image. The resulting nationwide campaign for donations and sale of temple treasures was so successful that it raised enough money to repay the loan and renovate the temple.[15]

Masuda and fellow collectors associated with Mitsui were equally ruthless when the lumber business of Kashima Seizaemon failed several years later. Like many traditional merchants, Kashima had used his art collection as collateral for a loan from Mitsui Bank, and when the loan was called in, Inoue Kaoru, Masuda, and Magoshi Kyōhei coerced him to sell his teawares at auction. The thirty-six choicest articles, which included Hui Tsung's "Morning Dove on a Peach Tree Branch," were acquired by the three industrialists (fig. 5-4).[16]

The Taishō era, especially the European wars years of 1914-18, when Japanese industry made huge profits from foreign trade, was the golden age of Japanese auctions. During this period auctions became the most popular method of disposing of large collections,

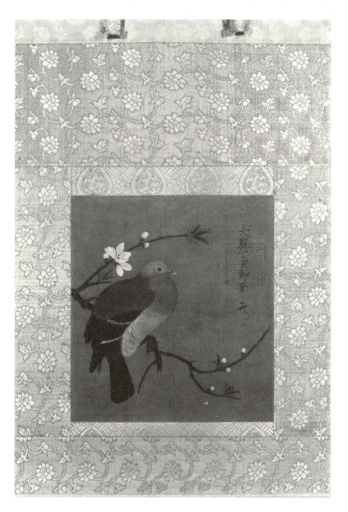

Figure 5-4. Morning Dove on a Peach Branch, Attributed to Emperor Hui Tsung

but Osaka and Kyoto, once unchallenged centers of artistic commerce, were eclipsed in importance by Tokyo, the headquarters of the Tokyo Bijutsu Kurabu, an association of art dealers founded in 1895. Although comparable organizations continued to hold auctions in Osaka and Kyoto, the shift in wealth made it essential for art dealers in those cities to join the powerful Tokyo group.

These Tokyo auctions were completely different from the lively, noisy affairs held at Druot, Christie's, or other European auction houses. Potential buyers could not submit bids directly, but had to do so through the intermediary of a dealer belonging to the association. Bidding, moreover, was in the form of ballots: when a potential buyer saw an item he wished to purchase, he advised his representative of the price he was willing to pay, and the latter submitted the bid in writing. Since bidding was secret, sometimes only a few yen separated the highest from the next highest bid. Masuda's associate Magoshi Kyōhei, for instance, acquired *Tamura Bunrin*, a noted Chinese tea caddy, with a bid only five yen above that of Mitsubishi's Iwasaki Yatarō.[17] The ten percent commission each paid the buyer's representative and the art dealers' association added substantially to the final cost.

Works of art, like anything that is bought or sold, are commodities with obvious commercial value. In the booming art market that prevailed during the Taishō era, the demand for fine teawares was so high that their value often doubled within the space of a single month, outpacing by a large margin the inflation that plagued Japan at the time. Nezu, shrewd businessman that he was, was one of many who bought art at auction, only to resell it at a huge profit a short time later.[18] The profits were used to finance the purchase of still more art. By 1916, Nezu admitted to having spent more than one-and-a-half million yen in the acquisition of the more than four thousand items in his collection.[19] Despite criticism of his speculative practices, all admired his collection, which included a unique thirteenth-century painting of Nachi Waterfall, a pair of six-fold screens depicting irises by Rimpa artist Ogata Kōrin (1661–1716), and a particularly fine fifteenth-century lacquer writing box with a design that incorporates pictorial motifs and Chinese characters alluding to a poem about cherry blossoms at Shirakawa. This box was among the rare examples of Japanese lacquer whose provenance could be traced to the Ashikaga shogunal collection (fig. 5-5).[20]

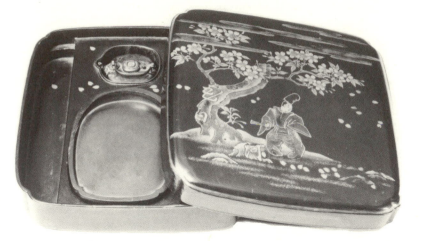

Figure 5-5. Lacquer Writing Box with Maki-e Design of Courtier under Cherry Tree

The most eagerly awaited auctions of this period were those of famous daimyo collections. Despite the popular perception that all the great feudal collections had been dispersed in the early years of the Meiji era, many former daimyo families had in fact managed to hold on to their heirlooms. When American art collector Charles Freer visited Japan in 1907, for instance, he visited the collections of Viscount Akimoto, Marquis Kuroda, Count Tsugaru, Marquis Hachisuka, and Count Date.[21] Over the course of the following two decades, however, all took advantage of the booming art market to sell many of their treasures at auction.

Among the most noteworthy auctions of daimyo collections that took place during this era was that of the Date, former lords of Sendai. Because of their generous patronage of the arts, their domain, located in northeastern Honshu, had been regarded as the northernmost outpost of metropolitan culture. Over the centuries, the flamboyant warrior Date Masamune (1566–1636) and his heirs had amassed a vast art collection that was particularly rich in utensils for chanoyu. The collection was so extensive that it had to be sold in two separate auctions.[22] The first, held in May 1916 under the auspices of the Tokyo Bijutsu Kurabu, raised more than a million yen, a new record. Japanese collectors were astonished. As Hara Tomitarō wrote to Charles Freer, "We were really surprised by the high prices which Marquis Date's sale brought in the art market. It was undoubtedly due to the prosperous condition in my country caused by the war [in Europe]. Since the time of the Date sale, there has been constant upward tendency in the market and

to-day the prices are something extraordinary."[23] Despite the high prices, Hara was among those who purchased items at the second sale, which was held later the same year. Among them was a painting attributed to Kano Motonobu (1476–1559) depicting the Chinese scholar Pai Ya playing the *ch'in* for his friend Chung Tzu-ch'i (fig. 5-6).[24] It is thought to have originally formed part of a series showing the "Four Accomplishments" of music, go, calligraphy, and painting, a theme often treated by artists of the Kano school.

Figure 5-6. Pai Ya Playing the Ch'in, Attributed to Kano Motonobu

Men from the Mitsui circle were among the chief beneficiaries of the three-part Akaboshi auction that took place in 1917. This extraordinary collection, especially rich in tewares, had been assembled by businessman Akaboshi Minosuke, but his thirty-year-old son, who did not share his father's enthusiasm for chanoyu, was easily persuaded to sell it. The most coveted work of art sold at the auction, a snowscape by Liang K'ai, later classified as a National Treasure, was bought by the Mitsui family through the Mitsui Club, a powerful front for business activities that was dominated by the eleven Mitsui families and directors of the company's various enterprises. The treasures Masuda bought included *Hirosawa*, an exceptionally handsome teabowl that featuring the distinctive blend of white and rust colors typical of Shino ware, and *Saruwaka*, a squat Seto ware tea caddy that had belonged to Kobori Enshū.[25]

One of the most active bidders at the Akaboshi auction was "Tamonten," the name by which Masuda's youngest brother Eisaku (1866–1921) was known.[26] Masuda Eisaku had been employed in various capacities by the Mitsui concern until his brother, realizing he was temperamentally unsuited to business, made him manager of the Tamonten, an art gallery he had established. The chief shareholders in this clubbish operation were Masuda's associates at Mitsui, Dan Takuma, Asabuki Eiji, Takahashi Yoshio, and Nozaki Hirotarō.

Tamonten was as noted for his artistic discrimination as for his high living. Something of a dandy, he dressed exclusively in black robes in winter and white ones in summer. So notorious was Tamonten's love of horse racing, gambling, sake, and geisha that when he planned a visit to the United States, the puritanical Charles Freer fretted that "he is a man accustomed to many luxurious habits."[27] A familiar presence at all the major auctions of this era, Tamonten not only bought many items for himself and his shop but handled many of his brother's transactions as well. This family connection to the art business no doubt gave Masuda Takashi an edge in the highly competitive art market.

Although prices for tea caddies, incense containers, and teabowls were high, the most sensational sale of the Taishō era was a set of two thirteenth-century handscrolls of the Thirty-six Immortals of Poetry attributed to court painter Fujiwara Nobuzane. These scrolls, with imaginary portraits of classical poets of the eighth through the twelfth centuries, each accompanied by a bio-

graphical sketch and sample poem, are the oldest surviving examples of this genre of painting. To distinguish them from the many later versions of the subject, they are called the Satake-bon, after the former daimyo of Akita in whose collection they had been.

The auction of over three hundred articles from the Satake family collection, including the Thirty-six Immortals of Poetry, was held in November 1917. The scrolls were acquired by shipping tycoon Yamamoto Tadasaburō for 353,000 yen, the highest price ever paid for a work of art. Two years later, however, Yamamoto went bankrupt and was forced to sell them.

The circumstances surrounding this sale and its aftermath demonstrate Masuda's prominence in the interlocking worlds of art and business. The month prior to the auction, representatives of the Satake family visited him to discuss the auction plans. Takahashi, who was present, recorded the details of this and subsequent meetings. The real reason for the visit, no doubt, was to determine whether or not the Mitsui Club or Masuda and his associates at Tamonten were interested in buying the scrolls, and if so, how much they would be willing to pay. This subject was not directly addressed, however. Instead, the wily Masuda raised the possibility that the scrolls might not sell because of their high price and might have to be cut into sections of one poet each. He also pointed out that the reserve price of 400,000 yen was too high since one of the poets was a seventeenth-century addition painted by Kano Tan'yū. Therefore, he suggested lowering the price to 350,000 yen. The eventual sale price, only 3,000 yen above that, was testimony to Masuda's keen sense of the art market.

Masuda intervened yet again in 1919, when bankruptcy forced Yamamoto to sell the Satake scrolls. After efforts to persuade members of the Mitsui Club to buy them had come to no avail, Masuda, with the cooperation of all the major art dealers in Tokyo, Kyoto, and Osaka, helped to coordinate their partition into thirty sevensections. (The extra section is a scene of Sumiyoshi Shrine that was appended to the end of the first scroll.) Before the scrolls were cut and remounted as hanging scrolls, he commissioned Tanaka Shinbi (1875–1975), a noted restorer and copyist of traditional Japanese painting, to paint exact copies of the two scrolls.

The sale of each of the Thirty-six Immortal Poets took place on December 20, 1919, at Masuda's Gotenyama estate.[28] Eleven of the thirty-seven fragments were bought by Masuda's friends, fam-

小大君

三條院東宮時女蔵人〱名やきち日眯 源
醍醐天皇終三世或ヶ世周敷王女母自儔
右女一条院御次

いそゝ一みするうさとー絶ぬto
するこ一Ｒト一きさし八又三年祥

Figure 5-7. Poetess Koigimi
from Satake Version of
Thirty-six Immortal Poets

ily, and business associates. Hara, for instance, acquired a particu-
larly fine portrait of the poetess Koigimi (fig. 5-7). Masuda himself,
however, acquired the section showing the poetess Saigū Nyōgo,
which is generally acknowledged to be the finest in the set.[29]

In the recession that followed the conclusion of World War I,
the art market began to decline. Hara was among the first to feel
the consequences of the postwar slump, for although the decline in
exports was widespread, the collapse of the silk market, formerly
one of the most profitable areas of international trade, was espe-
cially dramatic. The art world suffered even more acutely from the
earthquake of 1923 that laid waste to much of Tokyo and Yoko-
hama. This powerful quake not only left the economy in chaos, but
destroyed many of the art treasures in the collections of the nation's
industrial elite. The most devastating loss in Tokyo was the Okura
Shūkōkan, the museum of East Asian antiquities founded by
Okura Kihachirō in 1917. Although Okura's son later rebuilt the
museum, he was not able to fill it with works of art of comparable
quality. The earthquake also damaged Hara's Yokohama estate, the
Sankei'en, a veritable museum of traditional architecture that had

been open to the public since 1906. Despite the family's financial troubles, it too was restored.

The number of bankrupcies grew steadily in the increasingly unfavorable economic climate of the 1920s, but no single event shocked the nation more profoundly—and affected the art market more directly—than the failure of the Fifteenth Bank, popularly known, because its chief shareholders were members of the old nobility, as the Peer's Bank. The bank's collapse was due chiefly to bad loans extended to the Kawasaki Shipping Company. In an effort to recoup the bank's financial losses, Kawasaki Shōzō, founder of Kawasaki Shipping, Matsukata Iwao, president of the Fifteenth Bank, and his brother, Matsukata Kōjirō, president of Kawasaki Shipping, were forced to liquidate their personal assets, including their considerable art collections. All but the impressive collection of woodblock prints formed by Matsukata Kōjirō, a pioneer collector of a genre still little appreciated by his peers, were quickly auctioned off to other industrialist collectors.[30]

In the wake of the bank's collapse, Japan's wealthiest noble families were also forced to part with their collections.[31] The Imperial Household Ministry, which had made the bank the official repository of its funds, and former daimyo families including the Tokugawa, Shimazu, Matsuura, and Sakai suffered especially heavy losses. The Imperial Household alone lost 1.65 million yen, and the Shimazu family's fortune dropped from 6.5 million to 180,000 yen.[32] The sale of the celebrated art collections of the Tokugawa, Shimazu, Matsuura, Sakai, and other great noble houses signaled the final victory of the new daimyo over the old.

◆ *Art, Tea, and Company*

The exceptional popularity of tea and art collecting among members of the Mitsui conglomerate during the first quarter of the twentieth century reflected Masuda's conviction that the practice of chanoyu, by cloaking the new businessman in the trappings of culture, would help to enhance his power and prestige. Being a graduate of Keio University might gain an individual entrée into the Mitsui Company, but only one who had mastered the intricacies of chanoyu ever gained Masuda's complete trust. In his view, it was essential for an industrialist to combine business acumen with artistic taste. To be a man of taste required the cultivation of various

art forms, such as painting, calligraphy, chanting, and, of course, chanoyu.

Despite the abolition of the social hierarchy that had prevailed in the Tokugawa period and the contributions that entrepreneurs like Masuda himself had made to the nation's prosperity, class consciousness and prejudices against men engaged in commerce remained strong in Meiji-era Japan. For the most part, the Japanese public continued to adhere to the outlook voiced by Neo-Confucian scholars like Yamaga Sokō (1622–85), that to a man of moral fiber, "personal gain and a fat salary are more fleeting attractions than a snowflake on a hot stove."[33]

In 1884, when a German-style peerage of five ranks—prince, marquis, count, viscount, and baron—was established, for instance, no businessmen were awarded titles. Masuda was irate. "In recent years," he wrote, "those who advocate raising the nation through commerce and industry have steadily increased in number. . . . Nevertheless, if you consider how things really are in our country, you can see that it has not changed since pre-Restoration days. The men of commerce and industry . . . are not the equal of other classes in social prestige." He was equally disturbed in 1890, when only a handful of men representing the nation's business interests were elected to the Diet. Writing in *Jitsugyō no Nihon*, the business journal founded by his friend Shibusawa, he declared, "Power in this society is monopolized by the politicians, and men of commerce and industry have hardly any share in it. Although you would think that even a half-grown child would laugh at anyone who said that artisans and merchants should be placed beneath the samurai and peasants, in fact, even educated men have not yet cast off these feudal ideas."[34]

Masuda's dismay at the low standing of the Japanese businessman in Japanese society was shared by his long-time friend and business associate Shibusawa Eiichi, who combined a genuine talent for business with a seemingly incompatible faith in man's willingness to put community before individual interest. The idealistic Shibusawa was one of the first entrepreneurs to act upon the recognition that the new businessman, to gain respectability, would have to display the qualities traditionally associated with the samurai class that for over two centuries had represented the nation's social, intellectual, and cultural ideal.

Shibusawa's campaign to improve the public's image of those engaged in commerce began with the coining of a euphemistic new term, *jitsugyōka*, "one who does real work," to distinguish the new entrepreneur from the old-style merchant. Entrepreneurs eagerly adopted the new term, which soon became part of the standard lexicon.

The business ideal Shibusawa promoted stressed two qualities that were at the core of the Neo-Confucian teachings that had guided the samurai elite: education and social responsibility. Shibusawa did not advocate a strictly traditional education, however. He proposed combining traditional humanistic studies with training in practical matters, such as bookkeeping, that he thought were essential in the new business world. By social responsibility, he meant the subordination of the individual to communal needs: national welfare should come before personal profits. In his efforts to recloak old ideas in new garb, Shibusawa even went so far as to propose an audacious redefinition of *bushidō*, the moral code of the old samurai warrior, as "the way of the merchant."[35] As Masuda later claimed in a British publication: "Forty years ago the Japanese trader or man of business was looked down upon. He ranked as a member of the fifth class in our social scale; but now the best men of Japan are taking part in business and educating their sons for commercial careers, and the old tradition of clean-handed honor and valour, which the best of our race have shown in the field of battle, are now being developed in commercial life, and we are bringing 'Bushido' into business."[36]

Masuda's chief contribution to Shibusawa's campaign was in the cultural realm. Although Masuda belonged to his nation's entrepreneurial elite in his emphasis on the importance of Western technology and international trade, he remained a traditionalist in his espousal of the norms that for centuries had guided the activities of the ruling elite. Just as Neo-Confucian scholars had exhorted the samurai class to maintain a balance between the *bun* and the *bu*, the cultural and the martial arts, so too Masuda exhorted his subordinates at Mitsui to maintain a balance between culture and business. This emphasis on the value of culture was not intended solely to improve the *jitsugyōka*'s public image, however. It also had practical value.

This pragmatism was underscored when Laurence Binyon,

keeper of Asian Art at the British Museum, visited Masuda's Go-tenyama estate in 1929. As was customary when he received guests, Masuda served Binyon tea. Instead of displaying one of the many Japanese or Chinese scrolls from his collection in the tokonoma, however, he hung a map of the Roman empire. Puzzled, Binyon asked him why he had chosen this work. Masuda's somewhat rambling answer was as follows:

> The tea parties held in your country have neither scrolls nor [special] tea utensils. As a result, conversation inevitably turns to current events, which leads to politics and political factions, trade and business secrets, so naturally problems arise. But in Japan, where tea gatherings make use of scrolls and utensils, there is no need to talk about current events. Since the discussion centers on the scroll and utensils, neither politics nor trade secrets come up in the conversation. No matter who is present, all can converse without problems.
>
> Today I have hung this map . . . that a friend bought for me in England, because I can't read the Latin [inscription] and I hoped you would read it and tell me something about the Roman Empire. If I had an example of writing by Napoleon or Washington, I would have a fine mounting made for it so that I could use it in tea. But I would not only use the writings of men of the past, there are also many men alive today whose writings have merit.[37]

Masuda's explanation reflects his conviction that tea is common sense, *cha wa joshiki*. This was the response he often gave young Mitsui men when asked to explain why they should take up tea.[38] It was also a phrase he often inscribed on scrolls he presented to his friends and associates. Although he never offered an explanation of its meaning, it suggests that he saw the pursuit of chanoyu as a kind of training for life. Since its practice requires a sense of discipline, sensitivity to human relations, and strict adherence to formal decorum, it also made a man ideally equipped for the multifarious requirements of the business world.

Although Mitsui had assumed many of the formal trappings of a modern international corporation during Masuda's tenure as director, the internal workings of the company remained grounded in a traditional system of values that placed a high premium on personal loyalty. Masuda, like all entrepreneurs, was motivated by

the desire to make money, but he recognized that this goal could not be achieved at the expense of the personal relations and obligations that insured the smooth functioning of the company. Indeed, Masuda's extraordinary power within Mitsui owed in good part to his skillful cultivation of the chain of reciprocal obligations that were as important to the functioning of the Mitsui Company as they were to society at large.

Two incidents later recorded by Masuda's protégé Fujihara Ginjirō testify to the role that the exchange of valuable works of art played in maintaining personal and professional harmony among Masuda and his collegues.[39] The first incident, which occurred before Masuda had achieved supremacy within the company, involved Nakamigawa Hikōjirō, his most dangerous rival for power. When Nakamigawa was hired to centralize Mitsui's operations, one of the first administrative changes he undertook was to curtail Masuda's authority to run Mitsui Trading Company as if it were his personal feudal domain. This was followed by another decision that was equally offensive to Masuda: the ouster of Shibusawa Eiichi from the management of the Oji Paper Company, which he had founded and guided for over a decade. Nakamigawa also brought in many young graduates of his uncle's Keio University to infuse new blood into the company's management. One of these men was Fujihara Ginjirō (1869–1960), under whose direction the Oji Paper Company would become one of Mitsui's most profitable subsidiaries. The other was Nakamigawa's son-in-law Asabuki Eiji (1849–1918), a former Mitsubishi executive who was hired to run Mitsui's Kanegafuchi Spinning Mill. Both men would switch camps, becoming trusted business associates of Masuda's.

Although Asabuki owed Nakamigawa his job at Mitsui, he did not share Nakamigawa's view that business should come before personal relations. Like many within Mitsui, Asabuki was disturbed by the personal cost of Nakamigawa's draconian measures. However, since Nakamigawa was both his patron at Mitsui and his father-in-law, Asabuki could not openly admit his feelings. An enthusiastic art collector and tea aficionado, Asabuki took special pleasure in hunting out treasures at little-known dealers, especially in Tokyo's Hibiya district. One of his celebrated finds there was a Chinese tea caddy that had once belonged to Sen no Rikyū. Another was an imported bronze flower vase, *Seikaiha*, that had belonged to the Matsudaira branch of the Tokugawa family, which

Figure 5-8. Flower Container
Seikaiha

he had discovered at the shop of a Hibiya dealer specialized in old books (fig. 5-8).[40] The acquisition of this rare vase from such an unlikely source aroused both admiration and envy among fellow men of tea, but none more than Masuda. Although Masuda had repeatedly sought to buy the vase from him, Asabuki refused to part with his treasure. He finally offered it to Masuda as a gift two years before Nakamigawa's death. Its presentation was tantamount to a declaration of fealty.

Another celebrated instance of peacemaking through art involved the long-simmering rivalry between Masuda and Magoshi Kyōhei. Magoshi belonged to a merchant-class family who had apprenticed him at an early age to the Kōnoike, a wealthy Osaka fam-

ily of sake brewers with a celebrated collections of teawares. It was while he was in their employ that he first developed a taste for art and a desire to form his own art collection. Magoshi had first met Masuda in Osaka in the 1870s when he had been reduced to managing the inn where Masuda, who was then employed by the Mint, was staying. When both men were hired by Inoue a few years later, Masuda, though younger, was made manager while Magoshi was made his chief clerk at a miserable monthly salary of only four yen, sixty sen. This was increased to fifteen yen when Senshū Kaisha merged with Mitsui Trading Company, but eight years later, Magoshi recalled, he was still a clerk earning only thirty-five yen a month.[41] The disparity between their rank and salary was at the root of what would become a lifelong rivalry between the two men. It probably prompted Magoshi's decision to leave Mitsui Trading Company in 1892 to join Nippon Brewery, whose success (especially after its merger in 1905 with Sapporo Beer Company) enabled him to collect on a scale appropriate to his status as Japan's "Beer King." Magoshi's marriage to a granddaughter of Prince Takatsukasa and Mitsui Hachirōemon was a measure of his success.[42]

Despite the rivalry between them, Masuda and Magoshi often shared tea. And, in keeping with a practice common among men of tea, they occasionally exchanged teawares as well. When Masuda admired a handsome pair of screens of hawks by the sixteenth-century painter Sesson, Magoshi gave them to him as a gift (fig. 5-9).[43] Masuda, however, was at a loss as to what to give in return. Finally, at an auction of teawares being sold off to recoup the debt incurred when their owner defaulted on a loan to Mitsui Bank, Masuda bought a Kōchi ware incense container he thought would please Magoshi. Contrary to custom, Magoshi did not immediately make use of his gift, but waited for several years before celebrating its acquisition at a chanoyu to which he invited Inoue Kaoru and another Mitsui associate. When the two guests admired the incense container and asked its provenance, Magoshi explained that he had received it from Masuda. Expressing surprise that Masuda had parted with such a beautiful article, Magoshi suggested that at the time he had not recognized its true worth. This reply not only implied that Masuda lacked discernment but called into question the fairness of the exchange. Although the exchange of teawares was a sign of friendship among collectors, it was the unspoken rule

Figure 5-9. Hawks, Sesson
Shūkei

that the exchange be roughly comparable in value. After all, works of art could give their owners great personal satisfaction, but they also represented valuable, often hidden, assets. When word of this reached Masuda, he was incensed and retaliated by refusing to invite Magoshi to the Daishi kai the following year. Recognizing the consequences of such a feud in the small world of art collecting and tea, Tamonten urged Magoshi to apologize. Magoshi complied with this request. In addition, he presented Masuda Takashi with a peace offering: a vase in his collection that Masuda coveted because it had belonged to his late brother Kokutoku.

Writing about the sixteenth century, scholar Theodore Ludwig noted that "the value the use of chanoyu as a ritual process in the context of societal structuring was . . . an important element in

the sudden rise of this art. . . . Ritual, whether religious, quasi-religious, or secular, has essential public functions in societies: It communicates values and structures, it reduces conflict by affording a means of mutal recognition, and it dramatizes consensus regarding roles and thus motivates actions for healthy intragroup bonding."[44] Much the same could be said of tea as it developed within the Mitsui Company.

◆ *The Daishi Kai (II)*

As a man who preferred to express himself through deeds rather than words, Masuda's cultural leadership of the business world found its most eloquent expression in the Daishi kai. Whether he originally conceived it as an annual event or whether the success of the inaugural gathering of 1896 prompted him to repeat it is unclear. What is clear is that its character evolved considerably during the twenty years he hosted it. The changing character of the Daishi kai both shaped and reflected its host's growing reputation as an industrialist and a collector.

The Daishi kai was not at the outset a public relations vehicle for the Mitsui Company or for Masuda as the leader of the new daimyo. It was rather a gathering where Masuda, his two brothers Kokutoku and Eisaku (Tamonten), and fellow collectors could meet to study and discuss the works of art in their collections. This kind of gathering is recorded in a photograph taken around 1900 at Masuda's Gotenyama estate (fig. 5-10). All three brothers and two guests are present: the stout moustached Masuda Takashi and round-faced Kokutoku are seated on the right, while their younger brother Eisaku sits across from them, drinking tea. The other men may be dealers in teawares.

Masuda not only met often with dealers; he also invited them to prepare tea and display their latest acquisitions at the Daishi kai, a practice that no doubt served to stimulate art sales and to indebt the dealers to their host. This practice was not new, of course. Japanese collectors and dealers had long recognized the advantages of masking commercial activity under the guise of congenial cultural gatherings. Although Sen no Rikyū and the tea schools founded by his heirs sought to downplay its importance, trade in tea utensils had been a key factor in the popularity of chanoyu among merchants and daimyo of the Momoyama and Tokugawa periods.

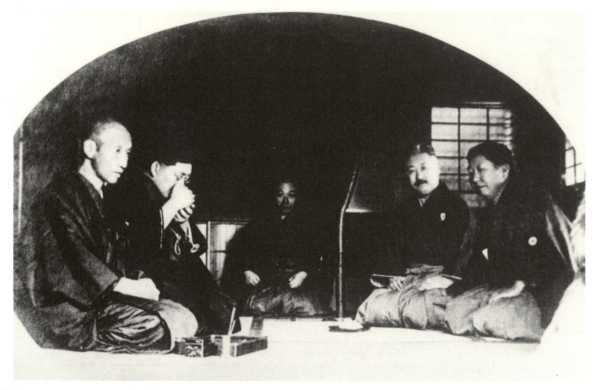

Figure 5-10. Masuda Takashi, His Brothers, and Two Guests at a Tea Gathering

With the exception of the various members of the Yamanaka family, who by this time had shops in Osaka, New York, Chicago, and Boston, nearly all the major art dealers of the Meiji and Taishō eras participated in the Daishi kai. The dealers whose names figure in records of the Daishi kai include men such as Wakai Kenzaburō and Kohitsu Ryōchū, who had helped Masuda in the early stages of the formation of his collection, but those who specialized in teawares, such as Yamazumi Rikizō, Umezawa Yasuzō, Nakamura Sakujirō (Kōkodō), and Toda Yashichi, appear with special frequency.[45] The Yamanakas' absence no doubt reflected the fact that they did not specialize in teawares, although Masuda did occasionally buy from them. Masuda purchased the teabowl *Dontarō* (see pl. 1) from Yamanaka's Osaka shop after he had learned about it during a visit to the Yamanaka's New York branch.[46]

Masuda's practice of inviting his friends and business associates to display objects from their collections at the Daishi kai became increasingly conspicuous after 1901, when he was appointed

director of Mitsui Company. Although Masuda, unlike Hideyoshi, did not use these occasions to coerce treasures from their owners, his contretemps with Magoshi, described above, suggests that he did use the Daishi kai to reward loyalty to him. He also used this cultural extravaganza as a mechanism to strengthen his personal relationships with business associates both inside and outside the Mitsui Company. In 1905, for instance, many men in Masuda's camp were invited to show treasured articles from their collection. Inoue brought out the painting of Fudō Myōō given him by the dowager empress in 1887; Mitsui Hachirōjirō and Magoshi showed Buddhist commentaries inscribed by Kōbō Daishi; and Hara, Dan, and Takahashi showed various scrolls depicting the Bodhisattva Jizō.[47]

The astonishing number of collectors who consented to display articles from their collections at the exhibition that accompanied the Daishi kai held two years later, the year of its host's sixtieth birthday, is evidence that Masuda had finally achieved the national prominence he so craved. This exhibition was unusual in that it featured, in addition to a large number of Buddhist paintings and statues, many examples of calligraphy by Hon'ami Kōetsu. Although the decision to display works by Kōetsu may have been motivated by the fact that his calligraphic style was influenced by that of Kōbō Daishi, it also reflected growing interest in him as a central figure in the seventeenth-century Kyoto revival of Japan's courtly tradition.

In addition to Masuda's many associates at Mitsui, many top government officials, including senior statesman Matsukata Masayoshi (1835–1924), displayed items from their collections. So did rival industrialists Yasuda Zenjirō, Okura Kihachirō, and Iwasaki Yatarō (1835–85) of the Mitsubishi conglomerate. The men whose treasures were most prominently featured at this Daishi kai, however, were the heirs to the great daimyo collections: Matsuura, Sakai, Maeda, Mori, Hachisuka, and even the Kii branch of the Tokugawa family.[48] This Daishi kai was clearly a personal triumph for Masuda.

The seventeenth annual meeting of the Daishi kai, held in 1916, is evidence that Masuda's retirement from Mitsui three years earlier had done little to change the blend of art and business characteristic of the event.[49] According to Takahashi's diary, only forty or fifty guests, fewer than usual, were invited since another grand

tea commemorating the centennial of Matsudaira Fumai's death was also planned for the same year.

As in the past, Masuda used this Daishi kai to display a recent acquisition, in this case, a second version of *The Illustrated Sutra of Cause and Effects*, which he had purchased from the Nara art dealer Tamai.[50] A tiny section of the handscroll that was cut and remounted as a hanging scroll after Masuda's death is reproduced in plate 8. It illustrates the Buddha being questioned by the three Kaśyapa brothers above the corresponding passage from the scripture. The character for ear missing from the text below is thought to have been cut out for talismatic purposes sometime before Masuda acquired the scroll.

By 1916, Masuda had on his Shinagawa estate thirteen tea huts or buildings containing tearooms, some built to his specifications by family and friends, and others bought and moved from their original sites. Today the Burmese (Myanmar) Embassy occupies much of the land that originally comprised Masuda's estate, and only the Ōkyokan, which Masuda donated to the Imperial Household in 1927, survives.[51] Built in 1742 as the *shoin* of Myōganin, a temple in modern Aichi Prefecture, the Ōkyokan gets its name from the sliding door paintings that decorate its interior. Painted in ink monochrome by Maruyama Ōkyo (1733–95) in 1784, they feature pines and bamboo, popular motifs in screen painting (figs. 5-11 and 5-12). Masuda had this structure dismantled and transferred to his estate in 1888. Because of its ample eighteen-mat interior, he used it for the exhibitions that accompanied the Daishi kai.

Since Masuda alone could not prepare tea for all his guests, a friend or business associate was appointed host in each of the tea huts or tearooms on his estate. Masuda himself prepared tea in the Yūgetsutei, a teahut for which he had a special fondness since it had been designed by his late brother Kokutoku. Inoue Kaoru prepared tea in the Ōkyokan. Mitsui Hachirōjirō, who though only a year younger than Masuda looked up to him as his mentor in chanoyu, reigned over the Yurakuan. Magoshi Kyōhei, Hatano Shōgoro (1854–1929), a director of Mitsui Bank, Tamonten, and Masuda Tarō also lent their assistence.

The names of three men stand out among the non-Mitsui affiliates who assisted Masuda in his preparations. They were were Oki Keiichirō, better known by his tea name Rōdō, Matsudaira

The New Daimyo ◆ 155

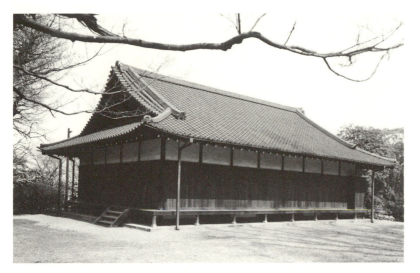

Figure 5-11. Exterior View of Ōkyokan

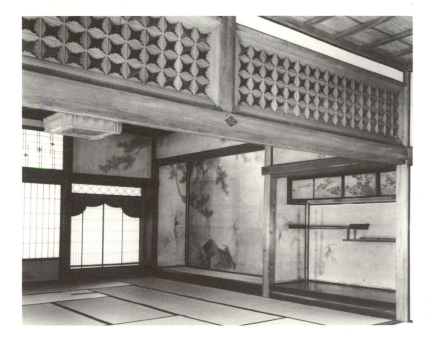

Figure 5-12. Tokonoma of Ōkyokan

Naosuke, and Hara Tomitarō. Rōdō was a noted architect, who enjoyed the patronage of many men within the Mitsui circle.[52] In 1916 Rōdō was in the process of building a teahouse of Masuda's design on the grounds of Gora Park in Hakone. Although the interior layout of Masuda's eight-mat teahouse, named Haku'undō

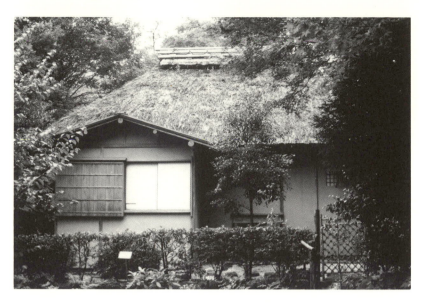

Figure 5-13. Haku'undō
Teahouse

(White cloud grotto), has been been altered, the exterior, distinguished by a steeply pitched thatch roof like that of a Japanese farmhouse, still reflects Masuda's original design (fig. 5-13). Attached to the Haku'undō is a hot-spring bath, one wall of which is formed from a colossal flat rock that was in situ when Masuda conceived this unusual architectural project.[53] In combining a tea and bathhouse, Masuda was recapturing the recreational spirit that had animated tea drinking before its formalization into chanoyu.

Matsudaira Naosuke was the heir to the collection of daimyo Matsudaira Fumai. Like many impassioned collectors, Fumai had identified strongly with his art collection and sought to achieve immortality by insuring that it remain intact after his death. "Even if my successors dislike chanoyu," he had written, "they should still take scrupulous care of these implements. In one generation I collected these things according to my own taste and made them treasures of the family. Therefore, taking good care of them after I die will be the performance of filial piety."[54] Filial piety or not, Fumai's heirs did manage to hold on to their legacy for over a century after the great collector's death.[55] Naosuke's presence at the Daishi kai was no doubt a tribute to Fumai as well as a prelude to the exhibition of his collection of *Unshū meibutsu* at Mitsukoshi Department Store the following year.[56]

Hara was one of the younger generation of industrialists who

had taken up chanoyu through Masuda's influence. The two men had first met in the 1890s through their involvement in the silk trade, and despite the twenty-year age difference they had become close friends. One reason for this friendship was Masuda's respect for Hara's eye for art. Although Masuda was not usually generous with his praise of rival collectors, he noted in his memoirs, that "Hara really knew painting."[57] This statement could have applied equally well to both Hara's connoisseurship and to his skill with the brush.

Hara's artistic talent, as well as the warmth he felt for Masuda, is evident from a whimsical handscroll he painted for him in 1931. The scroll, showing a typical day in the elderly Masuda's life, opens with a morning visit to the shrine on the grounds of the Odawara estate where he spent most of his time after his retirement from Mitsui. This is followed by a view of the portly but spry Masuda, dressed in Japanese-style robe, with basket in hand, feeding a flock of cackling chickens, a curious cow, and a few other barnyard creatures. By eight in the morning, he is off to survey the crops astride his pony, and by eleven he is home again about to prepare a morning tea ceremony. At four in the afternoon, Masuda is at the bustling entrance to the hospital for a medical checkup. Home by eight, he relaxes in his garden retreat before turning to his favorite evening pastimes of tea, painting, or calligraphy.[58]

Although painting was his true passion, Hara not only became an avid practitioner of chanoyu but, after the Daishi kai became a nonprofit foundation, chairman of the board, with Masuda, Nozaki, Takahashi, Dan, and Toda as directors. He also hosted the event in 1922, the first time it was not held at Masuda's Gotenyama estate.

The Sankei'en (Three valleys), Hara's seventeen-hectare Yokohama estate, beautifully landscaped in the manner of the strolling gardens of the great daimyo, provided an ideal setting for the Daishi kai. American collector Charles Freer's description of it in 1907 helps one to visualize its appearance before the 1923 earthquake. It also gives some sense of the flamboyant life-style of Japan's turn-of-the-century industialists.

The estate is large and exceedingly beautiful including over a thousand acres of land, less than one hundred of which are given over to agriculture. The balance is in iris fields, lotus

ponds, plum and cherry groves, forest—wild and cultivated—and garden and temple grounds—it has one shrine, one completed temple, another temple and pilgrims' rest house [and he] is now building, stables, several private houses, one public pavilion, a fire proof "go down" (warehouse) in which the magnificent art collection is stored, and the model residence in which I lived. . . .

My arrival at Sannotani at about nine o'clock in the evening when it was very dark was a sensation of charming delight. Throughout the valleys great bonfires were burning. The entire roadway throughout the estate along which I drove was lighted by coolies wearing white gowns and carrying huge white paper lanterns bearing Mr. Hara's crest in crimson. As we passed through the line of lantern bearers, they closed in column behind the carriage and followed. At the end of the driveway, begins a broad gravel path about an eighth of a mile long, ascending a steep hill at the top of which stands the "godown" and connected with it the lovely house to which I was destined and which was set aside for my individual use.[59]

When Freer visited the estate, which was then called Sannotani, Hara was just embarking on an ambitious program of building and landscaping that was largely complete when he hosted his first Daishi Kai in 1922. With eleven historic buildings representing religious and secular architectural styles from the fifteenth to the nineteenth centuries, the Sankei'en had become an architectural museum unique in Japan. Like Masuda, Hara had great admiration for the warlords of the Momoyama era, and several of the buildings he acquired were associated with Nobunaga and Hideyoshi. One of his first acquisitions was a Jutō, or Longevity Tower, built at Hideyoshi's order in 1591 on the compound of Daitokuji to commemorate his mother's recovery from illness. The Rinshunkaku, a complex of three adjoining buildings similar in style to the imperial villa of Katsura, was thought to have formed part of Hideyoshi's Fushimi Palace (fig. 5-14). (Recent research, however, has revealed that the building was in fact part of a villa dating to 1649 that was built on the banks of the Kinokawa River near Wakayama City.) The Shunsōrō, a three-and-one-half-mat teahut, is thought to have been designed by Oda Uraku (1547–1621), Nobunaga's younger

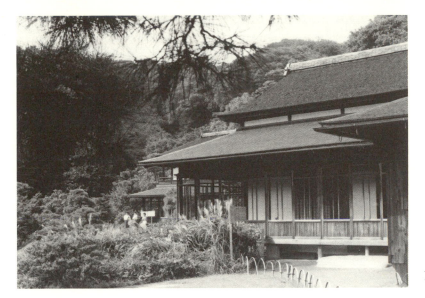

Figure 5-14. Rinshunkaku Villa

brother and a disciple of Sen no Rikyū. Hara had just completed reassembling this teahouse when he hosted the 1922 Daishi kai.[60]

Held the year before the great Kantō earthquake, the 1922 Daishi kai was the last of the private tea gatherings that came close to rivaling Hideyoshi's Grand Kitano Tea.[61] Over six hundred guests attended the event, requiring the use of seventeen buildings on the Hara estate. One building was devoted to a scholarly display of documents pertaining to Hideyoshi and his family. Another housed an array of Buddhist treasures on loan from Hara's friends and even from Tōji and Mount Kōya. In an unusual departure from tradition, another was devoted to paintings by eighteenth- and nineteenth-century literati artists Tanomura Chikuden, Yosa Buson, Rai Sanyō, and Watanabe Kazan, whose work Hara liked. Still others were given over to fellow collectors and dealers to arrange as they saw fit.

Despite his age, Masuda agreed to prepare tea in *Shunsōrō*. His selection of teawares, all from his personal collection, spanned the history of chanoyu. The calligraphic scroll by fourteenth-century Zen monk Ch'ing-cho Cheng-ch'eng and the Chinese bronze vase *Seikaiha* (fig. 5-8) were displayed in the tokonoma. For preparing tea, Masuda used *Nuregarasu* (Wet crow), an Old Ashiya iron-ware kettle featuring a large crow in shallow relief on its sides

(pl. 9). This unusually dramatic motif was thought to have been designed by fifteenth-century ink painter Sesshū. His tea caddy was *Reiki*, a meibutsu, which was placed on a square tray bearing Rikyū's seal. As a water container, he used a Dutch ceramic vessel. His teabowl was *Iwashimizu*, an Ido ware vessel whose name alludes to the shrine with which Shōkadō Shōjō was associated. *Omokage*, his tea scoop, had been made by or belonged to Kobori Enshū.

The evolution of the Daishi kai vividly illustrates the cultural power that was concentrated in the hands of Masuda and other plutocrats of his day. In the decades since Masuda had inaugurated it, the Daishi kai had grown to embrace nearly every form of artistic expression created in Japan, China, and Korea. Through their vast wealth and political clout, Masuda and his friends fostered the appreciation of the nation's rich cultural heritage. They also controlled and shaped the art market, and through it, the artistic perceptions of their age.

Following his retirement from Mitsui in 1913, Masuda added to his renown as a businessman and collector a reputation as a leader in the protection and promotion of Japanese art. The motivation for his involvement in such activities was a mixture of pride in Japan's artistic heritage, concern about the future of traditional Japanese art, and fear of the consequences of growing public criticism of wealthy industrialists. The dangers facing the leaders of the industrial conglomerates were underscored in 1921 when Yasuda Zenjirō was murdered by a young man seeking funds for a Buddhist charity. Eleven years later, Masuda's successor Dan was also assassinated amid charges of corruption and profiteering on the part of the Mitsui elite. Masuda's enlightened self-interest is reflected in an account written in the last year of his life, which describes when and why he began collecting.

> My appreciation of art began long ago, in 1879 [*sic*], when Japanese art objects were being sent by the government to an exhibition in France and Mitsui Bussan was ordered to handle the transaction. At that time I purchased the lacquer writing box that marked the beginning of my infatuation with art.

> Of course I collect art because I like it, but also because I believe that Japanese art is highly developed and we must take great care to preserve and study it in Japan. Therefore, I feel that I should do everything in my power to buy it. Carried away in large numbers by foreigners, its best examples will rapidly disappear.

> The modern world is tired of Greek and Roman art, and the number of people [in the West] who study Far Eastern art has increased. Now they have gone beyond Ukiyo-e and are even taking note of artists such as Kōetsu, Sōtatsu, and Kōrin. Americans like the late Charles Freer of the United States became totally carried away by the thought of Tosa painting. In Europe and the United States these days, women's clothing, personal belongings, and even home furnishings have been influenced by the Orient.[1]

Masuda was not alone in his fear that the nation's artistic patrimony risked being carried away by foreign predators. The sense that it was their personal responsibility to safeguard Japanese art was shared by many industrialist collectors. It was expressed in Inoue's and Hara's writings, as well as in the fervently nationalistic speech Okura delivered in 1916, the year before the opening of his art museum.[2]

> I first began to consider art collecting around the time of the Meiji Restoration when daimyo teawares were being sold for a pittance and lacquer tables, writing boxes, and even gold screens were being burned to extract the gold they contained. Seeing this dismal situation, I couldn't contain my indignation and determined, somehow, to insure their preservation. It was at that time, using my still limited financial resources, that I began to accumulate what would become the basis of my present art collection.
>
> Later, when the problem of Buddhist-Shinto synthesis arose, Shinto shrines were forced to sell the Buddhist painting and other articles belonging to them. I couldn't stand the sight of Americans like Fenollosa continually buying and carrying these [paintings] out of the country, so again I sought to buy as many as I could. Since even the sacred buildings of Zōjōji in Shiba and Kaneiji in Ueno had to be sold, I bought them too, and soon they will be rebuilt on the grounds of the Okura Art Museum.[3]

By such declarations, Masuda and his friends sought to channel the public's attention away from the private aspect of collecting, to emphasize that it was not a frivolous pursuit or a private aesthetic indulgence, but a noble, patriotic duty.

◆ *Art Collecting and Cultural Nationalism*

The conviction of Masuda and his peers that it was their mission to collect art, though self-serving, was not entirely unfounded given the limitations of governmental measures taken to protect the nation's artistic treasures. Although official surveys of temple holdings had been conducted several times since 1872, they had resulted in little more than national registration lists. Government recognition did not guarantee funds for the upkeep of ancient and

often fragile works of art, nor did it explicitly forbid the sale of registered items. As noted in chapter 4, since the government lacked the resources to buy or protect them, some of the works of art brought to light through these surveys were sold to private collectors in Japan and abroad. Only in 1897 was the government finally successful in enacting the Law for the Preservation of Old Shrines and Temples, insuring the protection of architecture, painting, sculpture, and applied arts in religious institutions through guarantees of funds for upkeep and restoration. This law also provided powerful psychological protection by designating important works of art for the first time as "National Treasures" (*kokuhō*). While the 1897 law was an important watershed in the development of national arts legislation, its scope was relatively limited since it applied only to those works of art in temples and shrines. It contained no provisions concerning the many treasures already in private hands, or the export of important works of art.[4]

Although the claims of Masuda and his friends that patriotism had prompted them to collect are suspect, there is no doubt that art collecting during the Meiji and Taishō eras had ideological overtones. Japanese government officials who had traveled to Europe in 1871–72 as part of the Iwakura Mission had recognized museums housing the cultural and technological achievements of the past to be valuable tools in building a modern nation. As the mission's report declared: "When one goes through a museum, the order of a country's enlightenment reveals itself spontaneously to the eye and heart. If one studies the basic reasons when a country flourishes, one learns it is not a sudden thing. There is always an order. Those who learn first transmit their knowledge to those who learn later. . . . There is nothing better than museums to show that order."[5] Years later, in his introduction to Takahashi's *Kinsei dōgu idō shi*, Masuda reiterated this idea. "As a rule," he wrote, "all enlightened nations have treasures handed down from the past."[6] And, he implied, private collectors had a role in preserving this cultural patrimony.

This correlation between national identity and artistic traditions was by no means new in Japan. The waves of Chinese influence that had swept its shores over the centuries had made Japan keenly aware of the traits that distinguished its culture from that of China. Recognition of the methods required to protect this cultural legacy, however, came about only with knowledge of

developments in Europe, where, in the wake of the Napoleonic in-
vasions, many states had begun to enact laws to safeguard their
heritage from damage by or loss to foreign armies. Cosmopolitan
businessmen like Masuda were also sensitive to the economic threat
brought about by the American surge of prosperity at the end of
the ninetheenth century. If even wealthy European collectors were
unable to prevent the sale of family heirlooms and religious treas-
ures from churches and monasteries to American millionaires will-
ing to pay any price to buy European culture, then what of their
Japanese counterparts?

Unlike Europe, Japan had not experienced the kind of artistic
looting that had fostered such powerful nationalistic sentiments in
nineteenth-century Europe. Artistic nationalism in Japan had its
roots in the fear of subservience to the West that followed the
opening of Japan's ports. Its first manifestations were the ambiva-
lent reactions to the West's admiration of its traditional crafts.
Because of the extraordinary favor they found in Europe and the
United States, lacquer, ceramics, and other crafts were among the
first commodities other than silk and tea for which the economi-
cally hard-pressed Meiji government found a foreign market. Sir
Rutherford Alcock, the British minister who assembled a selection
of Japanese art for the London Exhibition of 1862 that foreshad-
owed Japonisme in Europe, declared: "In their porcelain, bronzes,
their silk fabrics, their lacker, and their metallurgy generally, in-
cluding works of exquisite art in design and execution, I have no
hesitation in saying that they not only rival the best products of
Europe, but can produce in each of these departments works we
cannot imitate or perhaps equal."[7]

While some Meiji officials recognized that art might serve as
an effective agent for creating a more positive self-image, others
rejected this idea, believing it did not foster the image Japan
needed to project in order to gain the West's respect. The resulting
conflict between the respect for tradition and the desire for mod-
ernization pitted idealists against pragmatists. The issue was espe-
cially thorny since the sale of traditional crafts was essential to the
Meiji economy.

The way the arts mirrored larger economic concerns is vividly
illustrated in the public debate concerning the validity of calligra-
phy as an art form. Despite the fact that calligraphy traditionally

had been regarded as an important art form, the absence of any comparable genre in the Western tradition had led Meiji officials to exclude it from the annual government-sponsored art exhibitions. The issue came finally came to a head in 1882 when Koyama Shotarō, a leading spokesman for Western-style painting, published an essay in which he argued that calligraphy was merely a form of written communication like Western penmanship, with little merit because it was neither conducive to progress nor salable abroad. The widely publicized and successful rebuttal was authored by Okakura Kakuzō (1862–1913), a student of Ernest Fenollosa who would become a leading advocate of traditional Japanese art.[8] Okakura was one of the promoters of the government's efforts to register artistic treasures, as well as one of the founders of *Kokka*, an influential journal devoted to Asian art that was launched in 1889.

The pragmatists who believed that dignity for Japan would follow from modernization along Western lines were largely correct. The universal praise for Japanese art, while gratifying to some, did not necessarily imply either understanding of its aesthetic values or acceptance of Japan as an equal. On the contrary, the prominence of art in Japan's displays at the various international expositions contributed to the popular impression that the Japanese were a people as delicate and childlike as their art. As one reviewer of the 1876 Philadelphia Exposition wrote, the railings around the lily garden of the Japanese park were "about as stout as a sandalwood fan," adding that if this served as protection in Japan, then men and beast alike "must be as gentle as the lilies of the field."[9] Such an image was hardly bound to please a nation whose motto was "rich country, strong army" (*fukoku kyōhei*). Equally humiliating was the view, pervasive in the West, that artistic sensibility, based as it was on the simplicity of the Japanese mentality, was incompatible with scientific progress. As Percival Lowell wrote in *The Soul of the Far East*, "Artistic perception is with him [the Japanese artist] an instinct to which he intuitively conforms. . . . His perception of beauty is as keen as his comprehension of the common is crude, for while with science he has not even a speaking acquaintance, with art he is on terms of the most affectionate intimacy."[10] While the victory in the 1894–95 Sino-Japanese War and, even more surprising to the West, in the 1904–5 Russo-Japanese War won Japan new

respect, the vast differences in artistic perception remained an obstacle to an appreciation of Japanese art on its own terms.

By the late 1880s and early 1890s, greater economic stability and self-confidence vis-à-vis the West led many intellectuals to begin voicing their resentment of such patronizing attitudes. The association between art and the Japanese character that had earlier been a source of such embarrassment became a keynote of their writings. The two leaders of the movement, Miyake Setsurei (1860–1945), chief spokesman of the conservative camp, and Tokutomi Sohō (1863–1957), his progressive counterpart, were men of a new generation born on the eve or just after the onset of the Meiji era. Both were the beneficiaries of a modern, Western-style education that had provided them with sources of comparison necessary for the task of formulating a definition of the national character.

Members of the conservative faction led by Miyake shared a common goal: gaining self-respect for Japan through expressions of cultural nationalism. This goal was expressed in terms such as the "preservation of the national essence" (*kokusui hōzon*). Defining this national essence, however, proved difficult. For one of Miyake's followers, this meant Japan's unique aesthetic sensibility. "We have the writings of Murasaki Shikibu, the pictures of the Kano school, ceramics, lacquerware. . . . All of these have an artistic sense." For another it was rooted in the courtly tradition: "In Europe, culture arose from cities and villages, in Japan it rose from the Imperial Court."[11] All agreed, however, that preserving and developing Japan's cultural uniqueness was essential to achieving national pride.

Miyake himself elaborated on this theme in an influential booklet published in 1891. Entitled *Shinzenbi Nihonjin* (The Japanese: The true, the good, the beautiful), it articulated many ideas about Japanese culture that have since become widely accepted. Miyake urged his readers to take pride in the aesthetic quality of Japanese life, remarking that "even in poor households, one can see color prints affixed to the walls and vases in which seasonal flowers have been arranged . . . and in affluent households, there are scrolls hanging in the tokonoma and plaques above the transom. Even the iron kettle, the earthenware teapot, and the teabowl vie with one another in beauty, antiquity, and elegance. Moreover, all these decorative articles have in common an ingenious sense of design and

tasteful workmanship."[12] The richness of Japan's artistic tradition, Miyake argued, was all the more reason for the Meiji government to devote its national museum exclusively to Japanese art rather than to art from all over the world, as was then the case.[13]

Not all the young thinkers of the mid-Meiji shared Miyake's belief in the value of Japan's artistic heritage. For Tokutomi Sohō, the most radical and outspoken member of the progressive camp, Japanese arts and crafts were products of a decadent and wasteful society of little use to a modern industrial state. Deeply resentful of what he considered to be the West's patronizing attitude toward Japan's artistic achievements, in one article he fulminated, "What value has foreigners' flattery? These foreigners regard Japan as the worlds' playground, a museum. They pay their admission and enter because there are so many weird things to see." In another he argued, "Our country can never be preserved by the Tosa school of painters or by the architecture of Hōryūji or the Shōsōin or by sculpture or by the celebrated capitals of Nara and Kyoto."[14]

Despite their disparate outlooks, both progressive and conservative writings had a profound impact on the way the Japanese saw themselves and on attitudes toward the importance of protecting their artistic heritage. As art became inextricably associated with the national essence, it assumed a near mystical quality that provoked widespread concern about its export. These concerns, however, were all out of proportion to reality.

◆ *The Threat of Foreign Collectors*

Although Tokutomi Sohō complained that the West saw Japan primarily as a playground or museum, in fact the more dominant image of Japan was as a five-and-dime store. Allusions to the the rich assortment of cheap hand-made curios available in shops throughout the country were a sine qua non of all accounts of travel to Japan. When Emile Guimet visited Japan in 1876, he noted, "We had been told that Japan was the land of the knick-knack and novelty, but I never imagined that nine of ten shops would be antique dealers." Edward Morse concurred. "The collector of bric-a-brac," he wrote in *Japan Day by Day*, "finds Japan a veritable paradise, for wherever he goes, he finds second-hand shops, known as *furui doguya*, displaying old objects of every de-

scription. . . . In the smallest villages through which one rides, one finds some shop of this description with a modest assortment of old things."[15]

Further contributing to this image of Japan was the conviction, also widespread among Western collectors (perhaps because they drew analogies to the fate of aristocratic collections following the French Revolution), that all the great art collections belonging to daimyo households had been dispersed at the end of Tokugawa rule. In the view of these Western collectors, most of these treasures were being sold abroad because few people in Japan had the discretionary income to afford such art or an interest in traditional art. English collector James Bowes's remarks are typical. "Perhaps it may be, he wrote, that the future generations will have to study the best forms of their art in foreign countries, for there is no doubt that many of the finest examples have been sent abroad."[16]

While Western visitors may have believed that anything could be had for a price, Japan's most cherished art forms were protected by residual religious or family sentiment and, in most cases, were little appreciated abroad. Even after the 1927 crash of the Peer's Bank, when financial constraints did force former daimyo families to part with their heirlooms, the prize items were purchased chiefly by Japanese industrialist collectors.

The vast bulk of art exports during the Meiji era were articles made expressly for the foreign market. Chief among them were items made of coral, ivory, and lacquer, lanterns, porcelain and pottery, cloisonné, screens, and fans of the type purveyed by Mitsui Trading Company to Europe and the United States.[17] Although many Western consumers believed this bric-a-brac to be representative examples of Japanese art, most items were made specifically to suit Western taste. A screen awarded a prize at the 1878 fair is a case in point:

> At the last Paris Industrial Exhibition in 1878, one article, a lacquered three-winged screen (*biobu*) was prominent above all the other Japanese lacquer wares for the richness of its decorations—an exhibition piece, that even in the presence of the shields of Elkington, the bronzes of Barbedienne, and the beautiful Indian collection of the Prince of Wales, made a great impression on lovers of art. . . . A more beautiful ornamentation in raised gold lacquer work is scarcely conceivable

than the magnificently executed red and white paeony blossoms in gold and silver, the several chrysanthemums and other flowers with their leaves, which adorned this screen. The Prize Commissioners rewarded the exhibitor, Minoda Chojiro, a merchant of Tokio, with the gold medal, and an English amateur paid the sum of 60,000 frcs. for it.[18]

As this passage suggests, the acquisitions of many nineteenth-century Western collectors conformed to distorted notions of what constituted Japanese art. The screen described above, like many of the works of art displayed at the international expositions, was indeed "an exhibition piece" and would have been totally out of place in a Japanese residence. The screens prized by Meiji collectors were generally designed as pairs and decorated with landscapes or figures drawn from the Sino-Japanese tradition, executed in ink monochrome or mineral pigments.

One need only follow the heated debate between the American Edward Morse and the Englishman James Bowes (1834–99), both avid collectors of Japanese ceramics, to realize how limited the understanding of Japanese art was at that time. While Morse, based on his familiarity with chanoyu, argued that sober, undecorated wares were the most representative of Japanese taste, Bowes was convinced that it was the highly decorated wares of the Satsuma, Kutani, and Kiyomizu kilns.[19] Since tea taste incorporates both trends, each was only partly correct.

Although collectors in Europe and the United States admired Japanese ceramics, until the publication in 1906 of Okakura's influential *The Book of Tea*, the aesthetics of tea remained a largely a mystery. For most collectors, teawares were merely cute. Louisine Havemeyer's reaction in 1884 upon the arrival of a case of tea caddies is revealing: "I opened the case and was surprised to find it contained innumerable small boxes. I opened these small boxes and found they contained each another box inside. Upon opening the second box I found it had a silk bag and upon undoing the silk bag my little 'brownie' revealed himself to me. Like a child with a toy, I soon had rows of brownies about me, while the little boxes were in a heap upon the floor beside me. What pretty dainty things they appeared to me."[20]

Not all collectors were as open to the charm of tiny teawares, however. Many European collectors, Bowes and Burty (whose

reaction was quoted in chapter 1) among them, were extremely antagonistic toward chanoyu. Even one of the more sophisticated collectors of the day, Frank Brinkley (1841–1912), a British journalist, adviser to the Japanese government, and art dealer who was fluent in Japanese, found the world of tea inaccessible. The reasons for this were not simply aesthetic, however. His dislike of tea taste was partly rooted in the clubbish atmosphere that prevailed among tea devotees: "The Japanese themselves, strange to say, decline to admit foreign neophytes into the penetralia of their ideality. Open and good-natured as they are about other subjects, they preserve in respect of this an exceptional reserve. Nay, they are even insincere, for while they profess with the most engaging candour, to explain in detail the features of a rusty pot or a rustier bowl, they so contrive their explanations that the problem remains as inscrutable as ever to their hearers."[21]

Western collectors of traditional Japanese art (with the possible exception of woodblock prints) were generally more noted for their enthusiasm than for their knowledge. Unable to distinguish between old and new, many bought export goods that were passed off as antiquities. The production of outright forgeries was a thriving cottage industry whose effects are still felt in the world of collecting. Even collectors like Charles Freer, who prided himself on his aesthetic discrimination, were occasionally taken in by forgers. In a bitter letter of May 30, 1907, to his partner Colonel Hecker he complained:

> Since my arrival here I have kept away from the shops and have avoided unnecessary association with the dealers to an extent which has caused very much bitter feeling against me even in the minds of those whom for years I have been on rather intimate terms, viz. the Yamanakas, Ushikubu, the Kioto Matsuki, Kobayashi, Ekeda and others. This course of action I found necessary . . . to protect myself against contemplated conspiracies which I quickly discovered after my landing in Kobe were aimed in a big way, and most devilish, at my purse. Depletion of my purse as contemplated by the fiends, was bad enough, but they had other ambitions which to me and them were more important.
>
> I was determined to whip them in all of their long-laid plans and also to secure, at least, a few choice objects of art

without their assistance. The latter acquisition looked pretty hopeless but without causing me any alarm up to the day I wired asking the cable transfer of $10,000. That morning the doors of one of the temples here were thrown open to me and I was allowed to make selections from their treasures, but for ot [?] cash only. I looked the collection through hastily and found besides much rubbish, enough good to make me risk the ten thousand I first wired for, before I actually bought a piece. I realized the hazard both to my purse and reputation as a critic (the right of the priests to sell being made clear to me there was no risk of confiscation by higher authories of anything I might buy) which would naturally follow my going into such a game without an advisor like Prof. Fenollosa behind my back. I believed the game a big one and worth the risk of $10,000 . . . so I went at it as strongly as I could. I found ten thousand dollars would not satisfy my desire so I wired you for five thousand more and received it promptly. . . . Mighty little of the fifteen thousand is left and the "spoils" are mine. Some I shall always take aesthetic joy with, some will cater to a mean spirit within me, others will show the world some day the power of the Japanese as copyists today and during the last three centuries.[22]

With the exception of Fenollosa and other longtime residents of Japan, such as the British journalist Brinkley and the physician Dr. Anderson, most Western collectors purchased Japanese art through dealers such as the Yamanakas, who had shops in the major European and American cities. Consequently the range and quality of work available to them was quite limited. While woodblock prints, exotic enough to appeal, but not so exotic as to be incomprehensible, were well represented, many other forms of art were not. Unlike prints, whose themes and styles had already incorporated Western elements, many forms of Japanese pictorial art and calligraphy were simply too alien to all but the most adventurous collector. The most successful dealers recognized this and stocked their shops accordingly.

Dealers also had to take into account the prices the market would bear. Many European and American collectors had first turned to Japanese art because it was relatively cheap in comparison to Western art, and as long as it remained so they were willing to

buy. The French collector and connoisseur Edmond de Goncourt, for instance, recorded in a journal entry of 1875 his delight over the discovery of a newly imported Japanese bronze duck resembling some of the excavated bronzes in the Vatican Museum, but costing only five pounds instead of the four hundred the latter would have fetched.[23] Later, in 1907, when Charles Freer deemed the art prices in Japan too high, he turned his attention to Chinese and Korean art, which were considerably less costly. As he wrote Hecker, "All kinds of ancient pottery in Japan is now fearfully dear—old Chinese, old Corean and first class Japanese has doubled in price within twelve months."[24]

Although it is impossible today to determine the full scope or quality of the works of art that left Japan in the Meiji and Taishō eras, *Zaigai Nihon no shihō*, a survey of works identified by contemporary Japanese scholars as "treasures of Japanese art abroad," offers some indication of Western trends in Japanese art collecting.[25] Published in 1980, this ten-volume series covers all the major areas within the Japanese artistic tradition: Buddhist painting, narrative handscrolls, ink painting, screens, Rimpa, literati and other schools of painting, sculpture, woodblock prints, ceramics, lacquer, and other decorative arts.

A tabulation of the nearly one thousand works of art included in these volumes by collector or museum and approximate date of acquisition (see appendix A) reveals that the vast majority of Japanese art treasures entered Western collections *after* World War II.[26] (While acquisition dates rarely correspond exactly to the date of sale, they do provide a last possible date for the work's export.) In numerical terms, the three areas best represented among acquisitions made between 1868 and 1940 are Buddhist painting, ceramics, and lacquer. Twenty-seven of the sixty-seven Buddhist paintings included in the survey are part of the Fenollosa-Weld or Bigelow bequests in the Museum of Fine Arts in Boston. The bulk of the ceramics and lacquer is in European collections, such as the Victorian and Albert Museum in London, and consists of articles such as lacquer portrait panels, toilet cases, and portable altars made expressly for export. Their inclusion among the treasures of Japanese art abroad reflects their rarity in Japanese collections.

Numbers, of course, do not tell the whole story. Only seven of the seventy-eight narrative handscrolls included in *Zaigai Nihon no shihō* were acquired prior to World War II. Two of them, how-

ever, "The Burning of the Sanjō Palace" and "Minister Kibi's Journey to China," are works of exceptional artistic quality and historical importance. Both scrolls are in the Museum of Fine Arts, Boston. Similarly, although only thirteen of the sixty-five works by Rimpa artists were purchased during the Meiji era, they include "Waves at Matsushima" and "Ascending and Descending Dragons," two pairs of screens widely considered to be the finest works by Tawaraya Sōtatsu. Both screens were acquired by Charles Freer in 1905.[27]

A tabulation of the contents of *Zaigai Nihon no shihō* on the basis of distribution further reveals that most of the works of art acquired during the Meiji and Taishō eras that have stood the test of modern scholarship are in two American collections: the Museum of Fine Arts in Boston and the Freer Gallery of Art in Washington. Indeed, it was to a large extent the success of the two Americans who had acquired most of the treasures for these museums that caused Masuda and other Japanese collectors to feel so threatened.

◆ *Ernest Fenollosa and Charles Freer*

Masuda knew both Fenollosa and Freer, and through his many connections in the art world he no doubt followed their activities closely. When Masuda first met Fenollosa (fig. 6-1) is not known, but it is likely to have been in the 1880s. Since they had several friends in common it is possible that their paths crossed quite often. Both men knew art dealer and connoisseur Kashiwagi Ken'ichirō; both knew Dan Takuma; and both were acquainted with Matsuura Akira, Hachisuka Mochi'aki, and other former daimyo with extensive art collections.[28]

Although Fenollosa made most of his acquisitions during the period between 1882 and 1889, when Masuda himself was beginning to collect, there is no published record of any direct competition between them.[29] One reason for this may be that, except in the field of Buddhist art, their tastes differed. Fenollosa was chiefly interested in painting and never sought to understand the aesthetics of chanoyu. Fenollosa's activities as a collector, however, apparently did arouse resentment among other Japanese collectors. Evidence of this—though generally couched in terms designed to enhance the value of his acquisitions—can be found in a letter of September

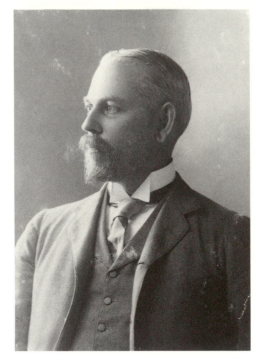

Figure 6-1. Ernest Fenollosa

27, 1884, that he wrote to his friend Morse: "Already people here are saying that my collection must be kept here in Japan for the Japanese. I have bought a number of the very greatest treasures secretly. The Japanese as yet don't know that I have them. I wish I could see them all safely housed forever in the Boston Art Museum. And yet, if the Emperor or Mombusho should want to buy my collection, wouldn't it be my duty to humanity, all things considered, to let them have it?"[30]

Two years later, a report published in the *Salem Gazette* noted: "We understand that Mr. Fenollosa has encountered the hostility of both conservatives and partisans of Western art. The old critics, connoisseurs, and artists resent the intrusion of the more vigorous ideas of a foreigner into the stagnating circle, while the radical young Japanese, who blindly regard everything Western as wholesome, look upon him as a sentimentalist and fanatic."[31]

Although these claims may have been exaggerated, comments in Fenollosa's catalogue concerning the painting of Kannon by Kano Motonobu ("Matsuura offered me 150 yen for it. . . . Kashiwagi said it was the finest picture in my collection. . . . Has now become a celebrated work in Tokio having been several times ex-

hibited") support the contention that men in Masuda's circle were aware and even covetous of some of his finer purchases. It is unlikely, however, that they knew the full scope of his acquisitions until after 1905 when Okakura Kakuzō became a consultant and later curator of Asian art at the Museum of Fine Arts in Boston. Between 1904 and his death in 1913, Okakura traveled frequently between Boston and Japan, where he maintained close ties with industrialist collectors, including Hara Tomitarō.[32] Moreover, it was only during his tenure that the collection of Japanese art Fenollosa had assembled was formally accessioned. The 1911 inventory of his acquisitions, officially known as the Fenollosa-Weld Collection since Weld had purchased it from Fenollosa, totaled nearly 17,000 items exclusive of prints. While swords and sword furnishings, netsuke and *inro* consituted the bulk, the two bequests included 4,733 Chinese and Japanese paintings.[33] Growing awareness among well-traveled Japanese industrialist collectors of the vast quantity of art housed in Boston may help to explain why Okura, in his 1916 speech, criticized Fenollosa, who had died eight years earlier, rather than Freer, who was still actively collecting.

If Okura's declaration reflected his effort to use nationalism to divert public attention away from his vast accumulation of wealth, Masuda's reflected concerns of a more personal nature. Freer began collecting Japanese art in the 1890s, just as Masuda had hit his stride as a collector, and there is considerable evidence of rivalry between them. The two businessmen met in 1895, during Freer's first visit to Japan. Unlike the genuinely warm friendship Freer later enjoyed with Hara and his family (Hara's son Zenichirō spent a year in the United States under Freer's guardianship), his relationship with Masuda seems to have been relatively formal (fig. 6-2). It was a relationship based on mutual respect rather than affection since Masuda's fiercely acquisitive nature precluded close friendships with his competitors. Moreover, Freer, for all his interest in Japanese ceramics, never developed an interest in or understanding of chanoyu, which played a central role in Masuda's aesthetic vision.

Freer made many fine acquisitions in spite of the fact that he was guided by an aesthetic vision quite different from that according to which the objects had been made or were appreciated in their own country. Indeed, his eye for art, his ample purse, and his many influential contacts in the Japanese art world combined to

Figure 6-2. Charles Freer
with Hara Tomitarō and
Family in Japan

make him a serious rival to Japanese collectors, Masuda included. The alarm they felt is obvious from Freer's correspondence during his 1907 trip to Japan.

> I spent this afternoon with Mr. Masuda the richest collector of Japan and he invited a few other Japanese collectors to meet me. It was an extraordinary little event. You should have heard their congratulatory remarks concerning the manner in which I bought the Ririomin Rakans from under "our feet" as they put it. The loss of these famous sixteen paintings to Japan created great excitement and now they stand ready to make great sacrifices to get them back again. Fortunately for America, I could not return them even if I wanted—they are in the Smithsonian lot.[34]

The paintings Freer was referring to are a rare set of paintings depicting the sixteen Arhats, disciples of the Buddha, now firmly attributed to the fourteenth-century Japanese ink painter Ryōzen

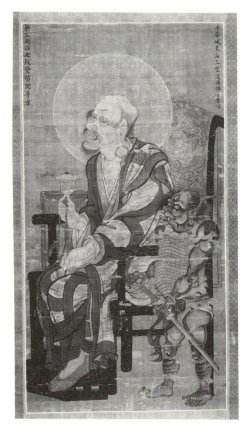

Figure 6-3. Arhat Kanaka-Bhāradvāja, Ryōzen

(fig. 6-3).[35] Their importance owes both to their high quality and their known provenance. They had belonged to the great lacquer artist Shibata Zeshin (1807–91), who had purchased them directly from Tōfukuji, the Zen temple in Kyoto where Ryōzen had worked.

Again, in letter written a month after the one quoted above, Freer announced:

> Today I have word that the great Kofukuji temple of Nara is considering selling a tremendously important set of sixteen paintings given to the temple centuries ago by Prince Konoe!!
>
> At Myoshinji in this city yesterday they made a large sale privately which is causing much talk today. Who the buyer is is unknown. I would have liked to have had a chance, but the authorities would not let me. As a consolation they told me they would soon sell some more of the famous set of Rakans of which I already possess two. The meaning of all these and other doings mystifies me.[36]

Although Freer was unaware of it at the time, "the authorities" were not alone in seeking to prevent him from buying important works of Buddhist art. Masuda and his friends were also instrumental in frustrating his efforts. In 1906 the need to raise funds for repairs had prompted Nara's Kōfukuji temple to sell seventy-seven items from its collection. The total asking price of over 300,000 yen was more than Masuda himself could raise, so with the cooperation of Nara dealers he formed a consortium to buy the lot. The principle members of the group—Masuda, Dan, Asabuki, Takahashi, and Nozaki—were all men in the Mitsui circle.

Since finding storage space for such a large number of images was a problem, Masuda set up a shop on Chuodori, a street in Tokyo's Nihonbashi district where many of Japan's most prominent art dealers still do business. Masuda's brother Eisaku was made director of the shop, called Tamonten after one the images acquired from Kōfukuji; Kohitsu Ryōchū, a member of the family of calligraphy connoisseurs, became the chief clerk; and Tamai Kyūjirō, a member of a family of Buddhist art dealers with a shop near Hōryūji, was his assistant. Members of the consortium had first choice of the finest items in the lot. As might be expected, Masuda himself bought the seventeen most desirable works. These ranged from a lacquer sutra box with a motif of lotus and waterfowl (pl. 10) to a number of small figures of the deity Shō Kannon that had originally stood in the Hall of the Thousand Buddhas on the Kōfukuji compound (fig. 6-4).[37] The remaining images were offered for sale at the shop, but only to selected customers such as Yasuda Zenjirō, Nezu Kaichirō, Inoue Kaoru, and Okura Kihachirō.[38] Although Freer visited the Tamonten four times during his 1907 trip to Japan, he made no purchases. After his final visit, during which he met with Masuda Eisaku and two other employees, he noted in his pocket diary, "Beware of the three."[39]

While Masuda's desire to control the art market and prevent his Japanese rivals from acquiring choice items was no doubt the chief motivating factor behind the creation of the Tamonten, a telling anecdote related by Tamai reveals that nationalism was also a factor. Among the treasures not initially sold to members of the consortium were a pair of eighth-century dry-lacquer statues representing the deities Bonten and Taishakuten (figs. 6-5 and 6-6).[40] Masuda wanted to buy them but was unwilling to pay the price Eisaku thought appropriate. To force his hand, Eisaku, in collusion

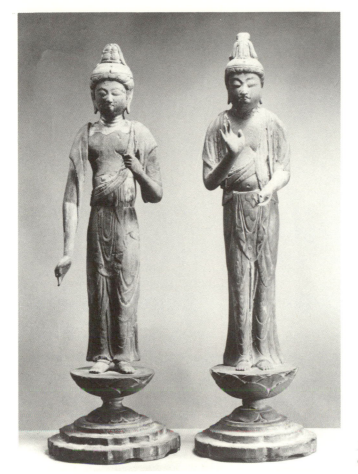

Figure 6-4. Standing Images of Shō Kannon

with Tamai, asked if they might offer the figures to the Boston Museum of Fine Arts. Masuda, outraged at the idea, paid the 25,000 yen asked by his brother.[41] Ironically, these figures, much restored due to the damage they suffered during the 1923 earthquake, did eventually find their way to the United States. They were purchased in 1954 by Avery Brundage and later donated to the Asian Art Museum of San Francisco.

In light of his relationship with Tamai, Masuda also may have played a behind-the-scenes role in hindering Freer's acquisition of an eighth-century gilt bronze statue. Freer apparently saw the figure during his 1907 trip to Japan and later sent his agent Nomura Yōzō to Nara to negotiate its purchase. After haggling over the price for some months, Nomura wrote to Freer, "I am sorry I have

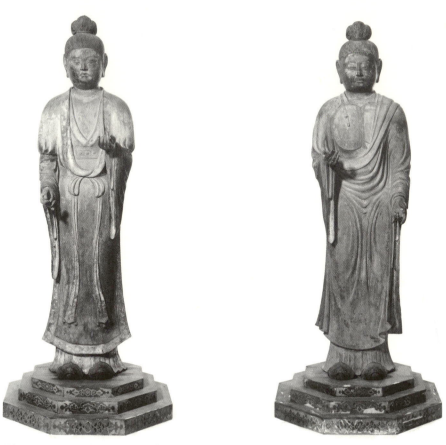

Figure 6-5. Standing Image of
Bonten

Figure 6-6. Standing Image of
Taishakuten

not yet settled with Tamai of Nara, as he is too stubborn and obsti-
nate. Now he says he would rather keep it [the statue] and won't
sell until he gets a little poorer. He is tantalizing me. He has found
out somehow that I am acting for you."[42]

Masuda apparently underwent a change of heart following a
trip to the United States he made in October 1907, during which
he saw Freer's collection for the first time. Masuda was both im-
pressed by its quality and appreciative of Freer's plan to donate it
to the Smithsonian Institution. Following his return to Japan, he
reportedly told Nomura that "as long as Japanese art is so carefully
protected and preserved as by you, Japanese collectors ought to
help Mr. Freer to get any thing he wants for the sake of the world's
goods [sic]."[43] This new attitude may have reflected the grow-

ing realization among Japan's more cosmopolitan industrialist col-
lectors that a museum housing examples of Japanese art in the
American capital might foster better understanding between the
two countries.

Masuda's more positive attitude toward Freer combined with
his desire to promote a greater appreciation of Japanese art in the
West also underlay his collaboration in one of Freer's pet projects,
a major exhibition of Japanese and Chinese art to be held in New
York. Masuda promised to assemble a collection of ancient Chinese
and Japanese objects from the collections of the emperor, former
daimyo, and other leading collectors of Japan, with the under-
standing that none was to be for sale. Although Freer worked tire-
lessly, discussing the project even with Theodore Roosevelt, the
exhibition was never realized, for many of the same reasons that
still plague organizers of international exhibitions: insufficient
funds to cover insurance, handling, and lectures.[44]

Despite the failure of their exhibition plans, Masuda and
Freer continued to correspond for many years. Kōetsu, an artist for
whom both collectors had a special affinity, was the subject of sev-
eral letters. In one handwritten note, Masuda argued that he could
"clearly prove" that the underpainting of the now-celebrated "Deer
Scroll," which was then in his collection, was the work of Sōtatsu
rather than Kōetsu (fig. 6-7). He concluded, "If you have any sug-
gestion kindly write to me."[45] In 1914, as a Christmas gift, he sent
Freer a jar used for waste water in chanoyu, a wine pot, and a tea-
bowl.[46] The water and wine pots were probably the work of Ono
Don'a, a potter employed by Masuda to make copies of his ceram-
ics as well as to make new wares for use in tea gatherings. The
Kōetsu-style Raku teabowl was one that Masuda had made himself.

In November 1927, as a tribute to the American collector's ap-
preciation of Kōetsu, Masuda held a memorial service in his honor
at the Kōetsuji, a temple on Takagamine, the hill northwest of
Kyoto where Kōetsu had lived from 1615 until his death. The occa-
sion was the annual Kōetsu kai, a tea gathering inspired by the
Daishi kai, which had been held there since 1915. In the speech he
delivered on the occasion Masuda concluded, "Mr. Freer truly in-
troduced Kōetsu to the world, and it is hardly an exaggeration to
say that it was in his enhancement of Kōetsu's reputation [abroad]
that he rendered his greatest service [to Japan]."[47] Three years later,
a stone monument to Charles Freer, with a dedicatory inscription

Figure 6-7. Deer Scroll (detail), Painting by Sōtatsu and Calligraphy by Kōetsu

Figure 6-8. Monument to Charles Lang Freer Dedicated by Masuda Takashi and Otani Sonyū

in English by Masuda and in Japanese by Otani Sonyū, the head of the Kōetsu kai, was installed on the grounds of Kōetsuji (fig. 6-8).

Like the Daishi kai, the Kōetsu kai's membership consisted chiefly of industrialist collectors and art dealers, all of whom loaned works of art by Kōetsu and his Rimpa school followers for the ex-

hibitions that accompanied the event. Like its Tokyo counterpart also, the Kōetsu kai was attended by Takahashi, who subsequently wrote newpaper columns about those in attendance, the utensils used in preparing tea, and the works included in the exhibitions.[48] As a result, the gathering played an important role in fostering interest in and study of Kōetsu and the circle of craftsmen around him. It also made Freer a familiar name in Japan. In commemorating the artistic taste of this American collector, the Kōetsuji monument served as a permanent reminder that if the Japanese public did not appreciate its artistic heritage, it would be lost to foreign collectors who did.

◆ Contributions to Cultural Causes

During the Taishō era, especially in the economic slump following the conclusion of World War I, the new enterpreneurial class that had grown up in the first decades of the Meiji era was beset by widespread public criticism due to its control over the nation's political life, its lack of concern for the welfare of the working class, and its extravagant life-style. To shake this negative image, many wealthy industrialists, Masuda among them, began to make contributions to a variety of social and cultural causes. Although some of these philanthropic activities had Buddhist overtones, their chief source of inspiration came from the United States, where embattled steel, oil, and railroad magnates had found that using their vast financial resources to assist projects of their choosing was personally satisfying, politically expedient, and tax deductible. It was in this problematic era that the Daishi kai came to serve as a vehicle for fund-raising.

Masuda's philanthropic efforts were more personal and limited in scope than those of his American counterparts. Unlike Freer or other American industrialist collectors, Masuda never considered the possibility of donating his collection to one of the three national museums. The notion of donating art to the nation, much less that of offering tax incentives to do so, was still alien to Japan. Of course, Masuda and other industrialist collectors did present important works of art such as the Ōkyokan (figs. 5-11 and 5-12) and paintings by Mu-ch'i to the Imperial Household, but presenting such treasures to an individual or family, rooted as it was in traditional gift-giving practices, differed from presenting them to an anonymous entity such as a state museum.

Unlike his friend Hara, who was an enthusiastic patron of contemporary painters, Masuda was a dyed-in-the-wool conservative in all artistic matters—whether drama, music, or art. (He strongly disapproved of his son Tarō's involvement in promoting Western-style musicals in Japan.) The only living artists who interested him were craftsmen who practiced traditional techniques and styles or who made copies of celebrated works from the past.[49] Masuda clearly expressed his views on the subject in his introduction to *Kinsei dōgu idō shi*: collecting treasures handed down from the past, whether works made in Japan or imported from China, was important because it provided craftsmen with models for their work.[50]

Masuda's rationale for preserving and protecting the national patrimony, while heretical to modern-day collectors, was not unusual in the nineteenth and early twentieth centuries. The Victoria and Albert Museum had been founded to provide a repository for arts that could serve as examples for modern industrial design. A similar commercial objective also underlay the establishment of the Tokyo National Museum, which grew out of Japan's displays at the international expositions and was intended to promote industrial progress, not aesthetic sensitivity.[51] Even the landmark 1897 Law for the Preservation of Old Shrines and Temples betrays a similar bias in its system of classifying objects on the basis of technical merit.[52]

Although Masuda's involvement in the export of Japanese arts and crafts no doubt contributed to this pragmatic perspective, the roots of his artistic views go far beyond the Meiji era. In traditional Japan, where the nature of the materials, the climate, and the frequency of earthquakes and fires all conspire to shorten the lifespan of both art and architecture, replication was an accepted means of insuring artistic preservation. The most celebrated manifestation of this practice is the rebuilding of Ise Shrine every twenty years in accordance with architectural plans and techniques dating to the eighth century, but the practice plays an important role in the tea world as well. In chanoyu, where objects acquire value only inasmuch as they have the power to evoke associations with people and places, making faithful copies of famous teawares in the style of a particular artist or to the taste of a particular tea master insures that traditional techniques are passed from one generation to the next, and, by the same token, that something of the spiritual aura of the original is preserved for posterity. Masuda's recognition that tradi-

tional craftsmen possessed valuable knowledge and skills that might be lost to industrialization foreshadowed the enactment, decades after his death, of government legislation to guarantee the livelihood of men and women popularly known as "Living National Treasures" (*ningen kokuhō*). Like the men patronized by Masuda, those first designated "Living National Treasures" in 1954 were predominantly craftsmen who specialized in articles that could be used in chanoyu.[53]

It was this spirit that informed Masuda's patronage of a group of craftsmen who specialized in utensils for use in tea. They included two lacquerers, Watanabe Saburō and Hasegawa Sukeji; a basketmaker, Ikeda Hy'ou; a metalworker, Miyazaki Kanchi; a potter, Ono Don'a; and a painter and restorer, Tanaka Shinbi. Although Masuda employed them chiefly to make copies of works in his collection for presentation to his friends, all were noted craftsmen in their own right.

In 1927, for instance, Masuda commissioned Ikeda to make seven copies of a sixteenth-century bamboo basket with a particularly distinguished pedigree (fig. 6-9).[54] The original basket, made from a variety of bamboo found in the foothills of Mount Fuji, had belonged to Sen no Rikyū. It had been made to hold fish, but Rikyū used it as a container for flowers, a practice followed by later men of tea. Rikyū gave the basket to his disciple Hosokawa Yūsai (1534–1610). Next it passed into the collection of Eisuke Hōin, the monk in charge of the Hasōan teahouse. Inoue acquired the basket

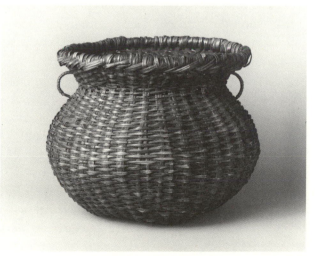

Figure 6-9. Bamboo Flower Basket with Two Handles, Ikeda Hy'ou

in 1888, when he bought the Hasōan. Masuda bought it at auction after Inoue's death.

Tanaka Shinbi was unquestionably the most acclaimed of the craftsmen associated with Masuda. Shinbi had trained under his father, a disciple of Reizei Tamechika (1823–64), an artist instrumental in the nineteenth-century revival of Yamato-e themes and styles. This training had given Shinbi a unique understanding of the arts of that period. Recognition of his talent came early. He was commissioned to copy scrolls illustrating *The Diary of Lady Murasaki*, belonging to the Hachisuka family, when he was eighteen and *The Tale of Genji*, belonging to Masuda, when he was only twenty-five years old.[55] Later he also copied handscrolls such as "Excellent Bulls" and books such as Nishi Honganji's "Anthology of the Thirty-six Immortal Poets." By the end of his life he had copied nearly every major example of twelfth- and thirteenth-century narrative handscroll painting as well as many scriptures and calligraphic compendia. Since many of these works were subsequently cut, remounted as hanging scrolls, and sold to collections in Japan and the West, Shinbi's copies provide invaluable records of their original appearance (figs. 6-10, 6-11).[56]

Shinbi's copies also served another, equally important purpose. Efforts to protect and promote appreciation of the nation's artistic patrimony had put considerable pressure on religious institutions to make their treasures available for public viewing. Although shrines and temples were ill equipped to handle and display fragile works of devotional art traditionally exhibited only once a year, the priests and monks in charge of many of these institutions, recognizing the need to adapt to changing times, determined that the solution to their dilemma lay in commissioning reproductions that could be displayed on a permanent basis.

This was the motivation that underlay the copying of the *Heikenōgyō*. A set of thirty-three scrolls donated in 1164 by Taira Kiyomori to Itsukushima Shrine, they epitomize the formalized and highly ornamental taste of the Heian court. Twenty-eight of the scrolls are inscribed with one chapter each of the *Lotus Sutra*, four of them with the texts of other Buddhist scriptures, and the remaining scroll with a dedication dated 1164 written by the donor himself. All the scriptural scrolls are preceded by illustrated frontispieces painted in the Yamato-e manner and inscribed in gold,

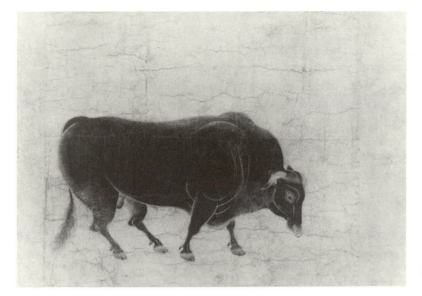

Figure 6-10. Black Bull

Figure 6-11. "Ishiyame-gire" from the "Anthology of Thirty-six Immortal Poets," Attributed to Fujiwara Sadanobu

silver, and mineral pigments on lavishly decorated papers. In sharp contrast to *The Tale of Genji*, which had suffered from frequent rolling and unrolling, the private and religious nature of the *Heikenōgyō* had insured its preservation in nearly pristine condition.

When the head priest of Itsukushima Shrine decided in 1920 to commission a complete copy of the *Heikenōgyō*, he contacted Tanaka Shinbi.[57] Because of the extraordinary cost entailed (Tanaka's estimate was 50,000 yen), however, shrine authorities approached Masuda to help raise the necessary funds. Masuda agreed to lend his support to the project, but on his own terms. On April 21, 1920, the day of his annual Daishi kai, five of the scrolls were sent from Itsukushima to Tokyo National Museum and then transferred to Masuda's estate where they were put on display in the Ōkyokan from 10 A.M. until 4 P.M. Alongside the display was a sixth scroll where visitors could pledge their support. By the end of the of day, the entire 50,000 yen had been pledged. Not surprisingly, the fifty-some donors consisted chiefly of Masuda family members, men from the Mitsui concern, fellow collectors, and art dealers—all of whom were indebted to Masuda Takashi in one way or another.

Tanaka Shinbi's contribution required far more time: five years and eight months, a good part of it spent studying the materials and techniques used in the original and making microscopic photographs of both the text and pictures to insure faithful reproduction of every detail. When Tanaka began his work, ten of the scrolls were secretly transferred from the shrine to his house. Fear of theft or unwanted requests to view the scrolls made secrecy absolutely mandatory. The risk of fire was also a consideration, so those scrolls he was not working on were kept in the fireproof storehouse of Takahashi Yoshio, one of the few men in on the secret. The completion of the scrolls coincided with the restoration of Tokyo National Museum, which had been damaged in the 1923 earthquake, so both were unveiled simultaneously on November 10, 1925.

What motivated Masuda to lend his support to this project? While there was no doubt the ever-present undercurrent of self-promotion, his involvement with the *Heikenōgyō* was in keeping with his appreciation of the aestheticism and elegance of the courtly tradition it exemplified and his admiration for the patron who had made its creation possible. Like Masuda himself, Taira

Kiyomori was a resourceful and audacious pragmatist and an early advocate of expanded trade with China. Like Masuda also, he was the leading representative of a newly wealthy class that was fast replacing the old aristocracy—a man who recognized that political supremacy required appropriation of the cultural symbols of the class he was seeking to supplant.

Masuda's fund-raising efforts on behalf of the Reihōkan Museum on Mount Kōya also had personal overtones since Mount Kōya was the monastic headquarters of the Shingon sect founded by Kōbō Daishi, whose memory Masuda honored at the annual Daishi kai. The desire to construct a museum on Mount Kōya, like the copying of the *Heikenōgyō*, came about in response to the demand for broader public access to its famous art treasures. The many temples scattered over Mount Kōya's slopes housed countless paintings, statues, and other ritual arts, many of them classified as National Treasures. Transferring them to a museum would insure their protection from the fires that periodically swept the forest-covered mountain and would provide a setting for their display to the many pilgrims who came to Mount Kōya annually to visit the graves of their ancestors.

Masuda was first approached for assistance by Saeki Yūjun following a lecture the monk had given in Tokyo on April 21, 1913, the date of the annual Daishi kai.[58] Saeki, with whom Masuda was already acquainted, was the abbot of Hōkiin, the temple that owned the *Zayu no mei* scroll inscribed by Kōbō Daishi. Despite the national prosperity during Taishō era, raising the funds for such an ambitious project must have been difficult. Although Masuda and his friends no doubt recognized the value of a museum of religious art, it was a novel idea that cannot have pleased more conservative devotees from whom the bulk of the funding was sought. Moreover, Saeki's solicitations coincided with efforts on the part of the authorities at Ise and Nikkō to build museums to houses their treasures.[59]

Since there was no precedent for a museum of the kind planned on Mount Kōya, there was as much discussion about the architectural style of the building as about what would be displayed. Ultimately, it was decided that the museum would combine elements of Heian-, Kamakura-, and Muromachi-style architecture and that the centerpiece of the installation would be a colossal twelfth-century Raigo painting. This painting, depicting the Bud-

dha Amida and his twenty-five attendant bodhisattva descending to earth to greet the deceased, had been confiscated by Hideyoshi from its original owners on Mount Hiei and presented to the monks of Mount Kōya as a reward for their support in his efforts to unify the country. Because of its extraordinarily large scale and recognition that it was a "world-class painting comparable in quality to the Dresden Art Museum's Madonna," an entire room was devoted solely to its display.[60]

Although details of Masuda's involvement in fund-raising for the museum are not available, newspaper accounts and photographs from the inaugural ceremonies, held in 1921, leave no doubt that he and his business associates contributed significantly to the project. Those in attendance included Masuda himself, his partners in the Tamonten, as well as other men, such as industrialists Magoshi and Nezu and art dealer Toda, who participated regularly in the Daishi kai. As might be expected, the event also featured a tea for which Masuda's friends had brought appropriate teawares.[61]

The profound social, political, and economic changes that occurred during the first quarter of the twentieth century had altered the free-wheeling artistic climate in which Masuda had begun collecting. While the importance of protecting the nation's artistic patrimony had been widely acknowledged during the Meiji era, government legislation had been limited primarily to Buddhist painting and statuary and other articles in temples and shrines. Moreover, since the principles underlying the system of classification were commerce and national glory, protection was determined chiefly on the basis of craftsmanship and historical importance. During the Taishō and early Shōwa eras, however, the dismemberment of masterpieces like the two scrolls of the Thirty-six Immortal Poets, the sale of daimyo collections following the crash of the Peer's Bank, and widespread fear of the loss of Japanese art to foreign collectors put pressure on the government to expand its definition of what constituted a National Treasure to include objects in private hands.

The issue sparked emotional debate.[62] While Masuda was supportive of efforts to protect and preserve the works of art owned by religious institutions, through both government ordinances and private efforts, he was extremely antagonistic toward governmental efforts to register works in private collections.[63] In his eyes, such legislation was unnecessary since private collectors like him-

self had both the means and the self-interest to maintain the works in their possession. He also believed it represented an infringement of property rights that would result in widespread artistic devaluation.

Despite opposition from collectors who feared that restricting the right to dispose freely of objects in their collection would hurt the art market, in 1929 the government enacted the Law for the Protection of National Treasures. This new law led to the registration of many works of art long esteemed by collectors but previously ignored by the government. Works newly classified as National Treasures ranged from *The Tale of Genji* scroll belonging to Masuda to works by literati painters Ike Taiga and Yosa Buson.[64] Under the provisions of the law, private owners of National Treasures were guaranteed subsidies for restoration or repairs, just as temples and shrines were, but unlike the latter they were entitled, upon approval from the Ministry of Education, to sell or use their treasures as collateral for loans. The new law also explicitly prohibited the export of National Treasures, and in so doing finally achieved the very goal that Masuda and fellow industrialist collectors had claimed to seek.

Although Masuda lived nearly a decade beyond its enactment, the 1929 law, with its presumption of state over individual artistic rights, brought to a close the golden age of art collecting in which he had played such an active role. If the broadened scope of arts legislation dampened the adventurous and sometimes irresponsible spirit that animated Japan's first generation of industrialist collectors, it also foreshadowed Japan's entry into the museum age. Despite the dispersal of Masuda's own collection, the impact of his artistic vision would endure through the private museums established by many younger industrialist collectors for whom he had served as mentor and model.

◆ Conclusion

Although it is generally acknowledged that the timetables of cultural and political change rarely coincide, it is widely held, both in Japan and in the West, that the Meiji Restoration of 1868 caused a radical transformation in Japanese artistic taste. This impression stems in large part from the reliance on accounts written, often a half a century or more after the events they describe, by men keenly sensitive to world opinion, who sought to emphasize the rapidity with which Japan had cast off its feudal past. Comments on the artistic situation in the first two decades of the Meiji era by men such as Masaki Naohiko, head of the Tokyo Arts School, published in 1909 in an English-language publication entitled *Fifty Years of New Japan*, both shaped and reflected this still pervasive outlook.

> [At the end of Tokugawa rule] all the lords yielded up their revenues to the Crown, and samurai were without the means of livelihood, and merchants and artisans who had lost their trades abounded everywhere, at such a time Art was bound to be entirely neglected, and in consequence precious works of Art and valuable paintings were prized no more than rubbish. Even when peace and quietness ensued, the people were too occupied with their immediate concerns and too busy adopting the material civilization of the West to attend to anything like Art.
>
> In those days, hereditary artists were reduced to such straits as defy description. The Kanō family were broken up with the downfall of the Tokugawa government, and their traditional art was no longer cared for, while the official artists of the Tosa school were relieved of their duties. . . . Almost every artist either changed his profession or barely lived on some vulgar handicraft.[1]

The activities of collectors Kido Takayoshi, Inoue Kaoru, Yasuda Zenjirō, and Masuda Takashi testify that the cultural situa-

tion was neither as grim nor as clear-cut as Masaki would have one believe. There was no wholesale rejection of the past, and if patterns of taste changed, they did so only gradually. These members of the bureaucratic and business elite, in defiance of such simplistic characterizations as "Westernized" or "traditionalist," fostered technological and industrial modernization while at the same time participating in tea gatherings and collecting the art forms popular during the Tokugawa period. Artists of the Kano, Tosa, and Sumiyoshi schools no doubt suffered loss of domestic patronage in the Meiji era, but some were able to survive and even flourish by producing crafts for the international expositions while others, relying on their connoisseurship and contacts in the art world, made a living by selling art. Indeed, to a large extent the modes of artistic production and consumption during the Meiji era continued to follow paths laid out during the 250 years of Tokugawa rule.

The recollections of Okura, Inoue, Hara, and Masuda concerning when and why they began collecting Japanese art, also written in the late Meiji or Taishō eras, are informed by a similar desire to stress change over continuity. Although national pride may well have contibuted to their interest in collecting Japanese art, their nearly identical claims that patriotic duty impelled them to collect reflect views current only after the Sino-Japanese War of 1894–95, when cultural nationalism became widespread. Their politically opportunistic slogans mask motivations for collecting that are more complex, personal, elusive, and, ultimately, more compelling.

Like collectors the world over, these men were not content to look, but had to possess. Some derived their greatest pleasure from the competitive quest for art, from "buying something from under the nose of a rival,"[2] others from the acquisition of objects that had belonged to great men of the past. As Frederick Baekeland noted in his study of the psychological aspects of art collecting, "It is as if merely by having them their current owner were imbued with the fame, riches, power or special ability of their former owner."[3] Still others were motivated by vanity, the desire for social advancement, or the recognition that fine art is a good investment.

The motivations, although similar in many respects, were not identical for all the collectors considered in this study. Nor were they necessarily the same for men at all times in their lives. Kido belonged to a generation of men of the samurai class who reached

maturity before the Meiji Restoration, for whom art collecting was already a well-formed and largely unquestioned habit born of social and educational circumstances. The same might be said of Inoue, who came from a similar socioeconomic background. And yet, for Inoue, who was not above using extortion to acquire objects he coveted, art collecting seems to have been the manifestation of an almost pathologically compulsive personality. Yasuda collected tea utensils, less out of interest in their intrinsic beauty than because they were essential for chanoyu, whose practice he had learned in his youth. Although he was a contemporary of Inoue and Kido, he came from a merchant-class family for whom the pursuit of tea had been emblematic of assimilation into samurai society. Little is known of Okura's early activities as a collector, but he seems to have been keenly aware of the value of art as an investment—an outlook rooted in the traditional merchant-class practice of using art as collateral for or repayment of loans. This approach to collecting was later overshadowed, however, by a more modern vision, no doubt informed by Western practices, of achieving immortality through the establishment of a museum named after his family.

For Masuda, who was a decade or more younger than these men, art collecting was a more self-conscious pursuit. We will never know precisely what prompted him to collect, but it is likely that his cosmopolitan education and work for foreign employers made him more sensitive to his cultural heritage than he otherwise might have been. Although he was first drawn to art through his professional activities, and the ties between art and business would remain strong throughout his life, he quickly developed a truly insatiable urge to collect. Masuda seems to have belonged to that class of collectors who might be described as having been afflicted by a disease over which they had little or no control. As Charles Freer, in describing his own growing enthusiasm for art, put it: "Oriental art is 'crawling through my innards,' so to speak, and whether it will prove a tonic or a tape worm is still an enigma."[4] For Masuda, as for Freer, art collecting clearly proved to be a tonic.

Despite the astonishing scope of his collection, Masuda was not an indiscriminate accumulator. In art as in business, he was wiley, aggressive, and willing to take risks. And just as he brought to his professional activities an instinctive business sense, so too he brought to collecting an instinctive eye for art of all periods, media,

and styles. It was this aesthetic sense that distinguished him from and gained him the respect of other collectors of his and later generations.

If the passion for collecting transcends national borders, it is nonetheless colored and conditioned by deeply ingrained national cultural values. Chanoyu remained central to art collecting in Meiji and Taishō era Japan because it provided industrialist collectors with time-honored aesthetic guidelines for their acquisitions as well as an enjoyable yet socially structured setting for their display. The requirements of chanoyu, more than any other single factor, determined the art forms Masuda collected as well as his vision of himself as a collector. For some, tea was a cultural touchstone that offered a measure of stablity in a period of difficult social, economic, and political adjustments, but for Masuda it became a means of self-expression. He enjoyed the challenge of discovering and combining diverse and often unusual works of art in novel ways, inspired by topical, seasonal, or personal associations. Time and again, he revealed his artistry by manipulating the cultural emblems of the past in response to the conditions of the present. Unlike most of his peers, he recognized chanoyu to be a practice that, for those who fully understood its spirit rather than merely its outer form, encouraged artistic creativity. His approach to chanoyu, with its blend of art, tea, and company, should be seen not as a struggle between old and new, but rather as evidence of his creative use of the forces and restraints of Japan's traditional heritage to promote his personal prestige, wealth, and power in an increasingly industrialized and modern nation.

TABLE 1. JAPANESE ART IN FOREIGN COLLECTIONS, DATES OF
ACQUISITION (based on works of art in *Zaigai Nihon no shihō*)

	Pre-1940	*Post-1940*	*Unknown*	*Total*
Buddhist painting	32	30	5	67
Narrative painting	11	64	3	78
Ink painting	13	60	4	77
Screen painting	15	36	7	58
Rimpa arts	16	43	6	65
Literati painting	9	62	5	76
Sculpture	17	56	16	89
Ceramics	50	55	8	113
Lacquer, metal, textiles	53	28	4	85

TABLE 2. DISTRIBUTION ABROAD OF JAPANESE ART ACQUIRED
BEFORE 1940

	BMFA[a]	*Freer*[b]	*Others*[c]	*Total*
Buddhist painting	27	2	3	32
Narrative painting	5	4	2	11
Ink painting	8	5	—	13
Screens	10	2	3	15
Rimpa arts	2	11	3	16
Literati painting	8	—	1	9
Sculpture	8	1	8	17
Ceramics	12	8	30	50
Lacquer, metal, textiles	13	—	40	53

[a] Museum of Fine Arts, Boston.
[b] Freer Gallery of Art, Washington, D.C.
[c] Other private and public collections.

Asabuki Eiji (1849–1918). Tea name: *Saian*. Born in Oita Prefecture. Studied at Keio University. Hired by Nakamigawa Hikōjirō as director of Mitsui's Kanegafuji Spinning Co. and later its Ōji Paper Co. Friend and associate of Masuda noted for his eye for art.

Dan Takuma (1858–1932). Tea name: *Rizan*. Baron, 1928. Born into a samurai family in Fukuoka Prefecture (Chikuzen). In 1871 traveled with Iwakura Mission to United States. Studied mining engineering at M.I.T. In 1884 was appointed chief engineer at the Miike Mines, and, after the mines' purchase by Mitsui, director of its mining division. Director of Mitsui Gōmei Kaisha after Masuda's resignation in 1912. Killed by a member of a right-wing organization in 1932. Enthusiastic collector, devotee of tea, and member of Masuda's inner circle.

Fujihara Ginjirō (1869–1960). Tea name: *Gyōun*. Born in Nagano Prefecture. Studied at Keio University, graduating in 1889. Worked as journalist before joining Mitsui Bank under Nakamigawa. Later transferred to Mitsui Trading Company, working under Masuda. In 1911 became managing director of Ōji Paper Co. An enthusiastic collector and man of tea with vivid recollections of Masuda's activities during late Meiji, Taishō, and early Shōwa eras.

Fujita Densaburō (1841–1912). Tea name: *Kōsetsu*. Baron, 1911. Born in Yamaguchi Prefecture (Chōshū), the son of a sake brewer. Moved to Osaka after the Restoration. Was a partner in Inoue's Senshū Kaisha but later founded his own highly successful trading company, Fujita-gumi. Spent lavishly to acquire prize teawares, which formed the basis of the collection in the Fujita Art Museum founded by his son Heitarō.

Fukuchi Gen'ichirō (1841–1906). Born to a samurai family in Nagasaki. Joined Iwakura mission to Europe and United States in 1871. Prominent journalist for *Tokyo nichi nichi*. Early friend and business associate who shared Masuda's fondness for tea and art collecting, though on a more modest scale.

Hachisuka Mochiaki (1848–1918). Former daimyo of Awa domain (Tokushima Prefecture). Studied in England. Played active role in Meiji industry and foreign affairs. Maintained close ties with Inoue Kaoru. Heir to a large art collection noted for its narrative handscrolls, including sections of *The Tale of Genji* and *The Diary of Lady Murasaki*, acquired by Masuda.

Hara Tomitarō (1868–1939). Tea name: *Sankei*. Born in Gifu Prefecture, son of Aoki Kyuei but later adopted into family of his wife. Modernized and expanded the raw silk business operated by Hara family, becoming one of the foremost businessmen in Yokohama. Avid art collector and gifted

amateur painter. Acquired many old buildings which were rebuilt at Sankei'en, his Yokohama estate. Took up tea through Masuda's influence and became active participant in Daishi kai as well as president after it became a nonprofit foundation in 1922.

Hatakeyama Issei (1881–1971). Tea name: *Sokuō*. Art collector and tea enthusiast influenced by Masuda's taste and activities. Promoter of Daishi kai after Masuda's retirement. Founder of the Hatakeyama Art Museum.

Inoue Kaoru (1836–1915). Tea name: *Seigai*. Count, 1884; Prince, 1907. Born into samurai family in Yamaguchi Prefecture (Chōshū). Sent to England to study in 1863, returning in 1864 to join in efforts to restore emperor to power and expel foreign traders. After 1868, served as minister of public works, public affairs, agriculture and commerce, finance, home affairs, and foreign affairs. Close ties with Mitsui Company. Avid art collector whose early interest in Buddhist art influenced Masuda.

Kashiwagi Ken'ichirō (?–1899). Born into a family of architects traditionally employed by the shogun. Became noted in Meiji era as professional connoisseur, art dealer, designer of teahouses, and consultant to Tokyo National Museum. Source of many works acquired by Masuda Takashi.

Kawasaki Shōzō (1837–1912). Born in Kagoshima Prefecture (Satsuma), son of a family in charge of domain finances. Pioneer in shipbuilding. Closely allied with government official Matsukata Masayoshi and his family. Amassed extensive art collection in Meiji and Taishō eras that was auctioned following his bankruptcy in 1927.

Kido Takayoshi (1833–1877). Born into samurai family in Yamaguchi Prefecture (Chōshū). Together with Inoue, played important role in Meiji government through posts as state councillor and education minister. A skilled calligrapher, patron of the arts, and enthusiast of both *sencha* and chanoyu.

Magoshi Kyōhei (1844–1933). Tea name: *Keshō*. Born in Okayama Prefecture. Joined Inoue's Senshū Kaisha in 1873, remaining there after it became Mitsui Trading Company. In 1892, intensely jealous of Masuda's professional success, left to become president of Nippon Brewery. Enthusiastic tea devotee and owner of a noted collection of teawares.

Masuda Eisaku (1865–1922). Tea name: *Tamonten*. Masuda's youngest brother. Social gadfly. Director of Tamonten, Tokyo art gallery specializing in antiquities set up by Masuda and his Mitsui associates. Collector in his own right as well as agent for his brother.

Masuda Kokutoku (1852–1903). Tea name: *Mui'an*. Masuda Takashi's younger brother. Trained in marine law and employed by Tokyo Marine Insurance Company. Took up practice of tea in the 1870s and prompted his brother to do so as well. Noted for his eye for art and small but fine collection of teawares, many of them reflecting wabi taste.

Masuda Takashi (1848–1938). Tea name: *Don'ō*. Baron, 1918. Born on Sado Island, son of shogunal official. As a youth worked for Townsend Harris. Traveled to Europe on shogunal mission in 1864. After Restoration, worked for Walsh, Hall & Co. and Senshū Kaisha before becoming director of Mitsui Trading Company in 1876. Appointed director of Mitsui Company in 1901. Retired in 1912 following Seimens scandal. Celebrated art collector and man of tea who influenced the activities and taste of many of his contemporaries as well as younger industrialist collectors.

Masuda Tarō (1875–1953). Eldest son of Masuda Takashi. Studied at Keio University and later in London and Antwerp. Director of Taiwan Sugar Manufacturing Company. Heir to his father's art collection, but was more interested in modern theater for which he wrote numerous plays under pen name Tarō Kaja.

Matsuura Akira (1840–1908). Tea name: *Shingetsu*. Former daimyo of Hirado (Nagasaki Prefecture). Active in early Meiji tea world and in education. Instructor to Akinomiya (Emperor Taishō). Heir to fine collection of teawares.

Nezu Kaichirō (1860–1940). Tea name: *Seizan*. Born in Yamanashi Prefecture. Amassed fortune in Tōbu Railway Co., warehousing, gas, cement, and insurance enterprises. Collected avidly and widely during Taishō era. Founder of Nezu Art Museum in Tokyo's Aoyama district. One of younger generation of collectors influenced by Masuda Takashi.

Ninagawa Noritane (1835–1882). Professional connoisseur, art dealer, and consultant to Tokyo National Museum. Participated with Kashiwagi in 1872 government survey of temples and shrines. Particularly knowledgeable in ceramics. Guided Edward Morse in the formation of his collection.

Oki Keiichirō (?–1941). Tea name: *Rōdō*. Noted designer of tea huts patronized by Masuda and men in Mitsui circle. Architect of *Sunkaraku* teahouse now in Philadelphia Art Museum.

Okura Kihachirō (1837–1928). Tea name: *Tsuruhiko*. Baron, 1915. Born into merchant family in Niigata Prefecture. Made fortune first as arms dealer and, after traveling to Europe in 1871–72, in foreign trade. Founder of diversified conglomerate similar to those of Mitsui, Mitsubishi, Sumitomo, Yasuda, and Fujita. Amassed huge collection of antiquities that became basis for holdings of Okura Shūkōkan.

Shibusawa Eiichi (1841–1931). Baron, 1900; Viscount, 1920. Born into wealthy farming family in Saitama Prefecture. Became shogunal retainer and went to Europe in 1867–68. Employed with Inoue in Finance Mininstry from 1868 to 1873, but later refused government posts. Became banker, promoter of Western-style business practices, and socially responsible businessman. As adviser to Mitsui Company, collaborated with Masuda in many business enterprises but only mildly interested in chanoyu and art collecting.

Takahashi Yoshio (1861–1937). Tea name: *Sōan*. Graduate of Keio University. Worked as journalist before joining Mitsui Bank and later becoming director of Mitsukoshi Department Store. After retiring, returned to journalism, writing regular columns chronicling tea gatherings hosted by and for industrialists tea for *Kokumin no tomo*. Noted connoisseur, man of tea, and confidant of Masuda Takashi.

Tanaka Shinbi (1875–1975). Trained by his father, a disciple of Reizei Tamechika. Noted restorer, copiest of narrative handscrolls and other arts of Heian period. Enjoyed patronage of Masuda, whose scrolls he copied.

Wakai Kenzaburō (1834–1921). One of founders of Kiritsu Kōshō Kaisha. Art dealer with special interest in teawares, active in both Japan and the West. Maintained close ties with Masuda.

Yasuda Zenjirō (1838–1921). Tea name: *Shōō*. Born in Toyama Prefecture to peasant family who had bought samurai rank and the right to officiate at domainal tea gatherings. Founder of Yasuda Bank and later a diversified

conglomerate with investments in railroads, insurance, real estate, electricity, and gas that rivaled Mitsui's, Mitsubishi's, and Fujita's. Devoted man of tea and author of tea diary covering Meiji and Taishō eras.

◆ *Notes*

CHAPTER I. THE LACQUER WRITING BOX

1. Unless otherwise indicated, all information about Masuda's life and activities in this chapter is derived from Masuda Takashi, *Jijō Masuda Takashi ō-den*, ed. Nagai Minoru (Tokyo: Private printing, 1939). (Hereafter abbreviated as *Jijōden*.)

2. Francis Hawke, *Narrative of the Expedition of an American Squadron to the China Seas and Japan* (New York: Appleton & Co., 1854), p. 498.

3. Ibid., p. 502.

4. Toshio Yokoyama, quoting the diary of Kojima Matajirō, in *Japan in the Victorian Mind: A Study in Stereotyped Images of a Nation, 1850–80* (London: Macmillan, 1987), p. 64.

5. Miyoshi Masao, *As We Saw Them: The First Japanese Embassy to the United States (1860)* (Berkeley: University of California Press, 1979), p. 26.

6. The other was Nakahama Manjirō, a fisherman who, after a shipwreck, spent ten years in the United States. James Huffman, *Politics of the Meiji Press: The Life of Fukuchi Gen'ichirō* (Honolulu: The University Press of Hawaii, 1980), p. 23.

7. Letter of condolence to Masuda Tarō from American Ambassador Grew following Masuda Takashi's death, reproduced in Yokoi Yau et al., eds., *Daichajin Masuda Don'ō* (Tokyo: Gakugei Shoin, 1939), pl. 2. The political tensions during this period are described by Grew himself in *Turbulent Era: A Diplomatic Record of Forty Years: 1904–1945* (London: Hammond, Hammond & Co., 1953), pp. 2:987–1034. A photograph of Masuda, Grew, and others at the dedication of the Harris monument is reproduced in the Mitsukoshi exhibition catalogue, *Masuda Don'ō ten* (Tokyo: Nihon Keizai Shinbunsha, 1983), unpaginated.

8. The saddle is reproduced in *Masuda Don'ō iai meihin-ten* (Tokyo: Hatakeyama Kinenkan, 1983), pl. 33.

9. Basil Hall Chamberlain, *Things Japanese: Being Notes on Various Subjects Connected with Japan* (Rutland, Vt. and Tokyo: Tuttle, 1971), p. 1.

10. *Fukuzawa Yukichi's "An Encouragement of Learning"*, trans. David Dilworth and Umeyo Hirano (Tokyo: Sophia University Press, 1969), p. 65.

11. Katsunobu Masuda, *Recollections of Admiral Baron Sotokichi Uriu* (Tokyo: private printing, 1938), p. 42.

12. Ibid., pp. 39–40.

13. For Masuda's own account of the situation, see Takashi Masuda, *Japan and Its Commercial Development* (London: Sisley's, 1908), pp. 45–46.

14. John Roberts, *Mitsui: Three Centuries of Japanese Business* (Tokyo and New York: Weatherhill, 1973), pp. 109–10.

15. Ihara Saikaku, *"The Japanese Family Storehouse" or "The Millionaire's*

Gospel Modernised": Nippon Eitagura or Daifuku Shin Chōja Kyō (1688), trans., G. W. Sargent (Cambridge: Cambridge University Press, 1959), pp. 28–29.

16. "Pine Trees in Snow," a National Treasure, widely regarded as one of Ōkyo's finest screen compositions, was among the works in the collection of the Mitsui family. This work is reproduced in the exhibition catalogue *Ōkyo and the Maruyama-Shijō School of Japanese Painting* (St. Louis: Saint Louis Art Museum, 1980), fig. 21 and pl. 74.

17. The catalogue of teawares belonging to the Kōnoike merchant family, compiled sometime in the Edo period, for instance, lists the price adjacent to each item recorded. See *Kōnoikeke dōguchō* in *Chadō*, ed. Iguchi Kaisen (Tokyo: Sōgensha, 1937), 14: 699–754. The practice of including the estimated value of tea utensils in family records was by no means limited to merchants, however.

18. Roberts, *Mitsui*, pp. 64–84.

19. Kozo Yamamura, "General Trading Companies in Japan: Their Origins and Growth," in *Japanese Industrialization and Its Social Consequences*, ed. Hugh Patrick (Berkeley: University of California Press, 1976), pp. 169–71.

20. Clara Whitney, *Clara's Diary: An American Girl in Meiji Japan* (Tokyo and New York: Kodansha International, 1986), p. 185.

21. *The Diary of Kido Takayoshi*, trans. Sidney DeVere Brown and Akiko Hirota (Tokyo: University of Tokyo Press, 1983–85). On their meetings, see entries for August 9, September 20, and September 25, 1876, 3:348, 353–54, and 367.

22. Masuda also admired San'yō. An entry in an unpublished ledger book indicates that in 1875 he bought a painting by San'yō for six yen, five sen. This purchase, which Masuda later forgot or chose to forget, would have antedated that of the lacquer writing. Shirasaki Hideo, *Don'ō Masuda Takashi* (Tokyo: Shinchōsha, 1981), 1:86.

23. Translator's introduction, *The Diary of Kido Takayoshi*, 1:xxiv.

24. Ibid., July 9, 1871, 2:40; October 10, 1876, 3:374; and September 4, 1871, 2:70.

25. Ibid., January 1, 1875, 3:136.

26. Ibid., April 1, 1872, 2:145; and March 2, 1872, 3:39–140.

27. Ibid., May 13, 1873, 2:329–33.

28. Ibid., March 3, 1869, 1:187; July 29, 1868, 1:66–67; December 6, 1868, 1:298.

29. Sir Ernest Satow, *A Diplomat in Japan* (Rutland, Vt., and Tokyo: Tuttle, 1983), p. 270.

30. For amusing anecdotes about Kyōsai's talents as a performance artist, see Emile Guimet, *Promenades Japonaises* (Paris: Charpentier, 1880), pp. 179 and 192.

31. *The Diary of Kido Takayoshi*, January 23, 1968, 1:166.

32. Ibid., November 23, 1868, 1:138.

33. Ibid., February 21, 1875, 3:136.

34. *Le Japon à L'Exposition Universelle de 1878*, published under the direction of the Japanese Imperial Commission (Paris, 1878), pp. 1–3 and 64–81.

35. The review was reprinted in the journal published by Siegfried Bing. See Philippe Burty, "Japanese Pottery," *Artistic Japan* 3, 17 (1889): 210.

36. Peter van Dam, "Wakai Kenzaburō, the Connoisseur," *Andon*, no. 18 (1985): 37.

37. Ōtsuka Eizō, *Magoshi Kyōhei ōden* (Tokyo: Makoshi Kyōhei Ōden-ki Hensankai, 1935), p. 359.

38. Mitsui Zaidan Hōnin Mitsui Bunko, comp., *Mitsui jigyō shi* (Tokyo: Mitsui Bunko, 1980), 2:286–87.

39. Imaizumi Atsuo et al., ed., *Kyoto no rekishi*, vol. 8: *Kyoto no kindai*, ed. Hayashiya Tatsusaburō (Kyoto: Gakugei Shorin, 1975), pp. 124–30.

40. Although Japan's first national museum has been known by different names, for the sake of clarity its modern designation, Tokyo National Museum, will be used throughout this study. See the chronology of museum's acquisitions in *Museum*, no. 262 (January 1973): 30. For other objects acquired at the same time, see Tōkyō Kokuritsu Hakubutsukan, comp., *Tōkyō Kokuritsu Hakubutsukan hyakunen shi*, (Tokyo, 1973), 1:156.

CHAPTER 2. ART COLLECTING AND CHANOYU

1. On the early history of tea drinking in Japan, especially the contributions of Murata Shukō and Takeno Jōō, see *Chadō shūkin*, vol. 2: *Chanoyu no seiritsu*, ed. Murai Yasuhiko. For an overview in English, see Murai Yasuhiko, "The Development of Chanoyu: Before Rikyū," trans. Paul Varley, in *Tea in Japan: Essays on the History of Chanoyu*, ed. Paul Varley and Kumakura Isao (Honolulu: University of Hawaii Press, 1989), pp. 3–33.

2. On the practice of naming and classifying tewares, see Tokugawa Yoshinobu, "Meibutsu-ron," in *Chadō shūkin*, vol. 10: *Cha no dōgu 1*, ed. Hayashiya Seizō, pp. 250–56.

3. For an account of its acquisition, see *Jijōden*, pp. 375–77.

4. Since all these texts are known only through later copies, their interpretation is subject to much scholarly discussion. The shogunal catalogue is reproduced and discussed in Tani Shin'ichi, "Gyomotsu on'e mokuroku," *Bijutsu kenkyū* 58 (1936): 439–47. The *Kundaikan sayu chōki* is reproduced in Sen Sōshitsu, ed., *Chadō koten zenshū* (Kyoto: Tankōsha, 1956), 2:281–322. The *Muromachi-dono gyōkō okaraziki* is reproduced and discussed in Nezu Bijutsukan and Tokyo Bijutsukan, comps., *Higashiyama gyomotsu: zakkashitsuin ni kanshin shiryō o chūshin ni* (Tokyo, 1976), pp. 146–97. The latter publication is the catalogue of an exhibition of extant works from the Ashikaga collection.

5. This painting is discussed briefly in Nezu Bijutsukan and Tokyo Bijutsukan, comps., *Higashiyama gyomotsu*, p. 199.

6. *Zusetsu chadō taikei*, vol. 5: *Cha no bijutsu to kōgei*, ed. Noma Seiroku and Koyama Fujio (Tokyo: Kadokawa Shoten, 1964), pp. 55–60. See also Tanaka Takeo with Robert Sakai, "Japan's Relations with Overseas Countries," in *Japan in the Muromachi Age*, ed. John Whitney Hall and Toyoda Takeshi (Berkeley: University of California Press, 1977), pp. 159–79.

7. *Cha no bijutsu to kōgei*, p. 56.

8. See *Kundaikan sayu chōki*, in *Chadō koten zenshū*, 2:313. The prices are given in *hiki* (rolls of silk), but I have converted them at the then exchange rate of 100 *hiki* to 1 kan.

9. On Nobunaga's famous treasure hunts (*meibutsu gari*) and confiscation of art treasures, see *Zusetsu chadō taikei*, vol. 2: *Cha no bunkashi*, ed. Haga Kōshirō and Saiyama Matsunosuke pp. 123–131. On Matsunaga, see Kuwata Tadachika, *Bushō to chadō* (Tokyo: Jinbutsu Ōraisha, 1964), pp. 46–69.

10. For two instances of this practice, called *dōgu soroe*, see *Tennojiya kaiki: Tsuda Sōgyū chanoyu nikki*, Tenshō 11/9/16 and 11/11/14, in *Chadō koten zenshū*, 7:397–400, 402.

11. *Jijōden*, pp. 264–68. This tradition may have been inspired by a gathering on Tenshō 15/6/25. See *Sōtan nikki*, in *Chadō koten zenshū*, 6:230.

12. On paintings of this theme and their influence in Japan, see Richard Stanley-Baker, "Mid-Muromachi Paintings of the Eight Views of Hsiao and Hsiang," Ph.D. dissertation, Princeton University, 1979.

13. This tradition is based on sixteenth-century painter Hasegawa Tōhaku's *Notes on Painting*, but the scrolls may in fact have been cut by later collectors. See Hasegawa Tōhaku, *Tōhaku gasetsu*, ed. Minamoto Toyomune (Kyoto: Wakō Shuppansha, 1963), p. 7.

14. Yonehara Masanori, "Sengoku bushō to chanoyu," in *Chadō shūkin*, vol. 3: *Sen no Rikyū*, ed. Murai Yasuhiko (Tokyo: Shōgakukan, 1985), pp. 114–15.

15. Cited in Michael Cooper, "The Early Europeans and Tea," in *Tea in Japan*, pp. 114–15.

16. Account dated 1565 by Alameida, cited in ibid., pp. 112–13.

17. Kobori Enshū, *Kobori Enshū kakisute bumi*, in *Chadō koten zenshū*, 11:137.

18. This rationalization was used by Matsudaira Fumai. See Paul Varley, "Chanoyu from Genroku to Modern Times," in *Tea in Japan*, p. 179.

19. For discussion and reproduction of works in Enshū's taste (*konomi*), see *Chadō shūkin*, vol. 4: *Oribe, Enshū, Sōtan*, ed. Kumakura Isao, especially pp. 104–8 and 133–42.

20. See Haga Kōshirō, "The Wabi Aesthetic through the Ages," in *Tea in Japan*, pp. 195–230.

21. Nanbō Sōkei, *Nanbōroku*, in *Chadō koten zenshū*, 4:10–11. The *Nanbōroku* (also read *Nanpōroku*) is a problematic text. Said to have been "discovered" one hundred years after Rikyū's death, it is generally acknowledged to be a work of the late seventeenth century.

22. This tradition is based on Yamanoue Sōji, *Yamanoue Sōjiki*, in *Chadō koten zenshū*, 6:72.

23. Nanbō Sōkei, *Nanbōroku*, p. 10.

24. Nagashima Fukutaro, "Picture versus Word: Trends in Tokonoma Display," *Chanoyu Quarterly* 35 (1983): 12.

25. See Louise Allison Cort, *Shigaraki, Potter's Valley* (Tokyo and New York: Kodansha, 1979), p. 132, and Cort, "Gen'ya's Devil Bucket," *Chanoyu Quarterly* 30 (1982): 31–40.

26. The author of this criticism was Dazai Shundai. Cited in Varley, "Chanoyu from Genroku to Modern Times," p. 175.

27. On Enshū's courtly taste, generally termed *kirei sabi* (refined rusticity), see Kumakura Isao, "Kan'ei Culture and Chanoyu," in *Tea In Japan*, pp. 142–49.

28. Konishi Jun'ichi, "The Genesis of the Kokinshū Style," trans. Helen McCullough, *Harvard Journal of Asiatic Studies* 38 (1978): 79.

29. Translation from Louise Allison Cort's "Looking at White Dew," *The Studio Potter* 10, 2 (June 1982): 49.

30. Kobori Enshū, *Kobori Enshū kakisute bumi*, in *Chadō koten zenshū*, 11:137.

31. See Nagashima Fukutaro, "Picture versus Word; Trends in Toko-noma Display," *Chanoyu Quarterly* 35 (1983): 7–15.

32. For a discussion of this movement, see *Word in Flower: The Visualization of Classical Literature in Seventeenth-Century Japan*, ed. Carolyn Wheelwright (New Haven, Conn.: Yale University Art Gallery, 1989).

33. On Ninsei and the Kyoto tradition, see Sato Masahiko, *Kyoto Ceramics*, trans. and adapted by Anne Ono Towle and Usher P. Coolidge, Arts of Japan 2 (Tokyo and New York: Weatherhill/Shibundo, 1973).

34. On his work, see Kawahara Masahiko, *The Ceramic Art of Ogata Kenzan*, trans. and adapted by Richard Wilson, Japan Arts Library 13 (Tokyo and New York: Kodansha, 1985).

35. It is not known when the term *tori awase* first came into use, but it appears in *Nanbōroku*. See Nambō Sōkei, *Nanbōroku*, p. 10. Generally it is used to refer to the selection and matching of utensils, but I am using it here to refer to the entire process of preparing the artistic ensemble required for chanoyu.

36. The term he used to denote creativity or inventiveness is *sakui*. See *Yamanoue Sōjiki*, p. 94.

37. Creativity, according to Philip Vernon, consists of "novel combinations or unusual associations of ideas" that may have "social or theoretical value, or make an emotional impact on people." Philip Vernon, *Creativity* (Harmondsworth: Penguin Books, 1970), p. 112.

38. This relationship between the *shōin* and *sōan* arrangement is noted in Nanbō Sōkei, *Nanbōroku*, p. 52.

39. Murata Shukō, *Furuichi Harima Hōshi-ate ichibumi*, in *Chadō koten zenshū*, 3:3.

40. Cited in Yamanoue Sōji, *Yamanoue Sōjiki*, in *Chadō koten zenshū*, 6:101.

41. Nanbō Sōkei, *Nanbōroku*, p. 10.

42. This tea is recorded in Kobori Sōkei and Tanaka Hiromi, "Enshū kuchikirichō," in *Chadō shūkin*, vol. 4, *Oribe, Enshū, Sōtan*, p. 298.

43. See Yamanoue Sōji, *Yamanoue Sōjiki*, pp. 54–90. For an overview of his thoughts on tea, see Tanihata Akio, "Men of Tea: An Evaluation of Yamanoue Sōji," *Chanoyu Quarterly* 26 (1980): 50–60; 27 (1980): 51–58; and 28 (1981): 48–56.

44. Nanbō Sōkei, *Nanbōroku*, p. 10.

45. Tanihata Akio, "Daimyō chadō no keifu," in *Chadō shūkin*, vol. 5: *Chanoyu no hatten*, ed. Murai Yasuhiko, pp. 143–44.

46. An illustrated page from this rare publication is reproduced in *Chadō shūkin*, vol. 5: *Chanoyu no hatten*, p. 110.

47. This record, also known as the *Unshū meibutsu*, is reproduced in *Chadō koten zenshū*, 12:371–411.

48. This summary of the event is based on Louise Allison Cort, "The Grand Kitano Tea Gathering," *Chanoyu Quarterly* 31 (1981): 15–22, and *Kitano daichanoyu no ki* and the commentary following it in *Chadō koten zenshū*, 6:3–48.

49. Kumakura Isao, "Matsudaira Fumai: The Creation of a New World of Chanoyu," *Chanoyu Quarterly* 25 (1980): 29–30.

50. Kramer, "The Tea Cult in History," pp. 113, 139–40.

51. Records of the gathering are reproduced and discussed in Kumakura, *Kindai chadō shi no kenkyū*, pp. 102–10.

CHAPTER 3. A TASTE FOR TEA

1. *Jijōden*, p. 118.

2. On *sencha*, see Patricia Graham, "Sencha (Steeped Tea) and Its Contribution to the Spread of Chinese Literati Culture in Edo Period Japan," *Oriental Art* 30, 2 (Summer 1985): 186–94.

3. Takahashi Yoshio, *Kinsei dōgu idō shi* (Tokyo: Keibundo Shoten,1929), pp. 42–44 and 32–34.

4. Translated in Kramer, "The Tea Cult in History," p. 145.

5. On Gengensai and his activities, see Kumakura, *Kindai chadō shi no kenkyū*, pp. 100–122.

6. Kumita Sōsei, "Kindai no keihanshin no chake," *Chadō shūkin*, vol. 6: *Kindai no chanoyu*, pp. 219–20.

7. Edward Morse, *Japan Day by Day* (Boston: Houghton Mifflin, 1917), 2:210.

8. Article dated Meiji 16/4/12, reproduced in Meiji hennenshi hensankai, comp., *Shinbun shūsei Meiji hennenshi* (Tokyo: Zaiseikyō Saigakukai, 1936), 5:274.

9. Johannes Hirschmeier, *The Origins of Entrepreneurship in Meiji Japan* (Cambridge: Harvard University Press, 1964), p. 312, n. 32.

10. *Jijōden*, p. 346.

11. On Masuda Kokutoku's background, see *Jijōden*, pp. 158–59, and *Nihon jinmei daijiten* (Tokyo: Heibonsha, 1979), 5:598.

12. Andrew Fraser, "Hachisuka Mochiaki (1846–1918): A Meiji Domain Lord and Statesman," *Papers on Far Eastern History* 2 (September 1970): 48.

13. Takahashi, *Kinsei dōgu idō shi*, pp. 36 and 68.

14. Ibid., p. 69.

15. Morse, *Japan Day by Day*, 2:399–400.

16. Kumakura, *Kindai chadō shi no kenkyū*, p. 223. The date was Meiji 17/11/18.

17. These and several other works that belonged to Masuda Kokutoku are reproduced and briefly discussed in *Kindai no chajintachi*, an exhibition catalogue compiled by the staff of the Gotoh Art Museum in 1974. See entries 148–155.

18. On the fabrics designated Kantō, see Oda Eiichi, "Meibutsu-gire: Famous Chanoyu Fabrics," *Chanoyu Quarterly* 45 (1986): 21–22. A *patola* similar to Masuda's is discussed in Mattiebelle Gittlinger, *Master Dyers to the World* (Washington, D.C.: The Textile Museum, 1982), p. 67.

19. Takahashi, *Kinsei dōgu idō shi*, pp. 117–18.

20. Edward Morse, *Japanese Homes and Their Surroundings* (Boston: Tichnor and Sons, 1886). See also his *Japan Day by Day*, 2:363.

21. Ralph Adams Cram, *Impressions of Japanese Architecture and the Allied Arts* (New York: Taylor and Co., 1905), pp. 116–17.

22. On Kashiwagi's involvement with the museum, see Tōkyō Kokuritsu Hakubutsukan, comp., *Tōkyō Kokuritsu Hakubutsukan hyakunen shi*, pp. 118 and 163.

23. Morse, *Japan Day by Day*, 2:371.

24. Tanaka, *Bijutsuhin idō shi*, p. 18, and Meihō Kankokai, comp., *Tanaka Shinbi: Heianchō bi no sosei ni sasageta hyakunen no seijun* (Tokyo: Tendensha, 1985), pp.17–18.

25. Tōkyō Kokuritsu Hakubutsukan, comp., *Tōkyō Kokuritsu Hakubutsukan hyakunen shi*, p. 152.

26. On this scroll see *Zaigai Nihon no shihō*, vol. 2: *Emakimono*, ed. Akiyama Terukazu (Tokyo: Mainichi Shinbunsha, 1980), nos. 12 and 13. Masuda must have acquired it before 1903 since he exhibited it at the Daishi kai that year (see chapter 4).

27. *Shuko zuroku*, a privately printed catalogue of works ranging from archeological materials to paintings, compiled by Yokoyama Yoshikiyo between Meiji 4 and Meiji 9, reproduces the "Jigoku" and "Yamai sōshi" as well as other paintings then in the Kashiwagi collection.

28. Masuda Yoshinobu, "Kaden no Genji emaki—watakushi no kokuhō," *Geijutsu shinchō* (October 1953): 130.

29. Both versions are reproduced and discussed in *Nihon emakimono zenshū*, vol. 6: *Jigoku zōshi, Gaki Zoshi, Yamai Zōshi*, ed. Ienaga Saburō (Tokyo: Kadokawa shoten, 1960), pp. 43–53.

30. Morse, *Japan Day by Day*, 2:364–65.

31. His father had bought the status of *gōshi*, which entitled him to use a surname and wear a sword as well as to qualify for the post of *chabōzu*, the man who officiates at tea gatherings hosted by the domain lord. See Yamamura Kōzō, *A Study of Samurai Income and Entrepreneurship* (Cambridge: Harvard University Press, 1974), pp. 153–59 and note 20, and Yano Fumio, *Yasuda Zenjirō den* (Tokyo: Yasuda Hōzensha, 1925), pp. 55 and 242–43.

32. The diary, entitled *Shōō chakaiki* (Shōō, Old Pine, was Yasuda's teaname), was privately published, and I have not been able to locate a copy. The figures in this paragraph are based on a chart of the names of the hosts, dates, and principal works of art used in each of 350 ceremonies, compiled by Kumakura in his *Kindai chadō shi no kenkyū*, pp. 220–38, and on full transcriptions of the diary for two years, 1880 and 1903, in *Chadō shūkin*, vol. 6: *Kindai no chanoyu*, pp. 275–83.

33. Ashiya, in present-day Fukuoka Prefecture, is the site where the first Japanese tea kettles are thought to have been made. Daitokuji Goki is a style of teabowl of Korean origin whose name derives from the tradition that it was introduced by Koreans who settled in the vicinity of Daitokuji temple. The identity of Shūsetsu is unclear; he may have been a tea master of the Edo period.

34. Kumakura Isao, "Sukisha no chanoyu," in *Chadō shūkin*, vol. 6: *Kindai no chanoyu*, p. 111.

35. Kumakura, *Kindai chadō shi no kenkyū*, pp. 208–11.

36. Oda Eiichi, "Cha dōgushō no seiritsu," in *Chadō shūkin*, vol. 5: *Chanoyu no hatten*, pp. 246–47. Morse mentions Mr. Kohitsu in his *Japan Day by Day*, 2:362. According to a pocket diary entry of May 5, 1907, Charles Freer met a Mr. Kohitsu that day. Charles Lang Freer Papers, Freer Gallery of Art/Arthur Sackler Gallery Archives, Smithsonian Institution (hereafter cited as Charles Lang Freer Papers).

37. On their involvement in Buddhist art, see Tōkyō Kokuritsu Hakubutsukan, comp., *Tōkyō Kokuritsu Hakubutsukan hyakunen shi*, pp. 54 and 155.

38. Tanaka Shinbi, "Shumi kōyū gojūnen," in *Daichajin Masuda Don'ō*, p. 103, mentions Kohitsu as source of the *Kanbokujō* album. On this and other such albums, see Kinoshita Masao, *Te kagami, Nihon no bijutsu* 84 (Tokyo: Shibundō, 1973).

39. Translation from *Kokinshū: A Collection of Poems Ancient and Mod-

ern, translated and annotated by Laurel Rasplica Rodd with Mary Catherine Henkenius (Princeton: Princeton University Press, 1984), p. 168.

40. Kendall Brown has suggested that the popularity of this painter/calligrapher among Meiji collectors may account for the exceptionally high number of forgeries. See his "Shokado Shojo as "Tea Painter," *Chanoyu Quarterly* 49 (1987): 7.

41. Kumakura, *Kindai chadō shi no kenkyū*, p. 239.

42. A painting of a dove by Tan'yū was exhibited at a gathering held in Shōhō 5 (1648/5/11) recorded in *Matsuya kaiki*, a tea diary of gatherings hosted or attended by three generations of Matsuya, a Nara family of lacquerers, that covers the years 1534–1650. See *Matsuya kaiki*, in *Chadō koten zenshū*, 9:443.

43. *Unshū meibutsu*, in *Chadō koten zenshū*, 12:410–11.

44. Fenollosa claimed that his "praise of the dethroned Kano caused, at first, considerable surprise and resentment among the educated classes." See his *Epochs of Chinese an Japanese Art* (New York: Dover, 1963), 2:165.

45. Johanna Becker, *Karatsu Ware: A Tradition of Diversity* (Tokyo and New York: Kodansha International, 1986), pp. 42–44.

46. Fraser, "Hachisuka Mochiaki," p. 48. The income figures were published in *Jiji shinpō*, Meiji 34/9/22, reproduced in *Shinbun shūsei Meiji hennenshi*, 11:314–17.

47. *The Diary of Kido Takayoshi*, September 1871, 2:70.

48. Toku Baelz, ed., *Awakening Japan: The Diary of a German Doctor: Erwin Baelz* (Bloomington: University of Indiana Press, 1974), p. 66.

49. For an excellent account of this event, see Meech-Pekarik, *The World of the Meiji Print*, pp. 155–57. For a summary, with photographs of the costumed guests, see Inoue Kaoru Denki Hensokai, comp., *Seigai Inoue koden* (Tokyo: Shoko Kabushiki Gaisha, 1933–34), 3:789–91.

50. *Seigai Inoue koden*, 5:479–84.

51. Ibid., p. 526.

52. Fujihara Ginjirō, *Omoide no hitobito* (Tokyo: Daiamondosha, 1950), p. 9.

53. *Jijōden*, pp. 423–24. For an overview of the history of this painting, see Yoshiaki Shimizu and Carolyn Wheelwright, *Japanese Ink Paintings* (Princeton: Princeton University Press, 1976), pp. 262–65.

54. On the theater reform movement, see Komiya Toyotaka, comp. and ed., *Japanese Music and Drama in the Meiji Era*, trans. and ed. Seidensticker and Keene, (Tokyo: Obunsha,1956), pp. 215–27.

55. Kumita, "Kindai no keihanshin no chake," *Chadō shūkin*, vol. 6: *Kindai no chanoyu*, p. 221.

56. The events are described in *Seigai Inoue koden*, 3:809 and note 813.

57. See *Sōtatsu kaiki*, in *Chadō koten zenshū*, 7:96, entry for Eiroku 5/2/15.

58. It is generally assumed that Inoue simply could not bear to part with this treasured painting. A letter from Kawasaki preserved by the Imperial Household suggests, however, that the painting was not his to give. See Inoue Kaoru Denki Hensokai, comp., *Seigai Inoue koden*, 3:789–91; Takahashi, *Kinsei dōgū idō shi*, pp. 79–80; and Kunaichō jishūshoku, comp., *Gyomotsu shūsei* (Tokyo: Asahi Shinbunsha, 1978), *Kaiga*, vol. 2, entry 14.

59. Masuda Don'ō, "Don'ō shumi zuisō (2)," *Yakimono shumi*, 5, 4 (1935): 10.

60. Fujihara Ginjirō, "Chitoku kenbi no daichajin," *Daichajin Masuda Don'ō*, p. 121.

61. On his ties with the Sekishū school, see Tsuge Sōkei, "Don'ō no chakei," *Daichajin Masuda Don'ō*, pp. 25–29.

62. *Jijōden*, p. 156.

63. On this event, see Kobori Sūkei, "Chakaiki ni miru Enshū no cha-noyu," *Chadō shūkin*, vol. 4: *Oribe, Enshū, Sōtan*, pp. 137–38.

64. Shirasaki, *Don'ō: Masuda Takashi*, 1:99–100.

65. Masuda Takashi, comp., *Enshū kurachō zukan*, (Tokyo: Hōundō, 1938).

66. Takahashi, *Kinsei dōgu idō shi*, pp. 83 and 110, and "Masuda Don'ō no corekusion," *Geijutsu shinchō* 5 (1983): 59 (special edition). The latter pub-lication also includes a reproduction of this work, still in a private Japanese collection.

67. Ota Eiichi, "Sukisha no chakaiki," *Chadō shūkin*, vol. 6: *Kindai no chanoyu*, p. 154.

68. An example is reproduced in *Masuda Don'ō iai meihin ten*, an exhi-bition of works owned or made by Masuda organized by the Hatakeyama Mu-seum (Tokyo: Hatakeyama Kinenkan and Nihon Keizai Shinbunsha, 1983), catalogue entry 86.

69. Fujihara, "Chitoku kenbi no daichajin," in *Daichajin Masuda Don'ō*, pp. 119–20.

70. "Don'ō yūraiki IV," *Geijutsu shinchō* 5 (1983): 58.

71. On the practice of making copies (*utsushi*), see Cort, *Shigaraki, Pot-ter's Valley*, pp. 171 and 186–90.

CHAPTER 4. FROM TEMPLE TO TEAROOM

1. By 1901 Masuda was among the 518 wealthiest men in Japan. See *Jiji shinpō*, Meiji 34/9/22, reproduced in *Shinbun shūsei Meiji hennenshi*, 11:314–17.

2. Fujiwara Munetada, *Chūyūki*, entry from Eikyū 2/6/4, in Takeuchi Rizō, ed., *Zōho shiryō taisei* (Kyoto: Rinsen Shoten, 1965), 4:313.

3. See, for instance, Kyoko Motomachi Nakamura, trans., *Miraculous Stories from the Japanese Buddhist Tradition: The Nihon Ryōiki of the Monk Kyōkai*, Harvard-Yenching Institute Monograph Series 20 (Cambridge: Har-vard University Press, 1973), pp. 190–91 and 262–63.

4. See, for instance, *The Autobiography of Fukuzawa Yukichi* trans. Eiichi Kiyooka (New York: Schocken Books, 1972), p. 17.

5. *The Diary of Kido Takayoshi*, May 6, 1869, 1:215–16.

6. Honjō Eijirō, *Kyoto* (Tokyo: Shibundō, 1961), p. 176, and Fenol-losa, *Epochs of Chinese and Japanese Art*, 1:50.

7. See Willa J. Tanabe, *Paintings of the Lotus Sutra* (New York and Tokyo: Weatherhill, 1988), especially pp. 38–42.

8. For an overview of this complex phenomenon, see Martin Collcutt, "Buddhism: The Threat of Eradication," in *Japan in Transition: From Toku-gawa to Meiji*, ed. Marius Jansen and Gilbert Rozman (Princeton: Princeton University Press, 1968), pp. 143–67.

9. See Christine Guth Kanda, *Shinzō: Hachiman Imagery and Its Devel-opment* (Cambridge: Harvard East Asian Studies Monographs, 1985), pp. 11

and 51. Buddhist imagery and ritual paraphernalia hidden in 1868 has been discovered as recently as 1983. See James Edward Ketelaar, *Of Heretics and Martyrs in Meiji Japan: Buddhism and Its Persecution* (Princeton: Princeton University Press, 1990), p. 10.

10. Letter dated July 18, 1907, from art dealer Nomura Yōzō to Charles Lang Freer. Charles Lang Freer Papers.

11. Portion of Ninagawa's diary reproduced in Yoshimizu Tsuneo, "Haibutsu kishaku no gyoko: shaji hōmotsu chosa no 'Ninagawa nikki' kara," *Geijutsu shinchō* 3 (1973): 76.

12. The provenance of these works was discovered by Yanagisawa Taka. See her "Bosuton bijutsukanzō no Shitennō zu—shin hakken no hajii Eikyūji Shingondō shoji e," in *Zaigai Nihon no shihō*, vol. 1: *Bukkyō kaiga*, ed. Shimada Shūjirō et al. (Tokyo: Mainichi Shinbunsha, 1980): 98–111. (A translation and adaptation of the article by Samuel Morse appeared in *Archives of Asian Art* 37 [1984]: 6–37.)

13. Yoshimizu, "Haibutsu kishaku no gyoko," p. 77.

14. Guimet, *Promenades Japonaises*, p. 113.

15. Ellen Conant, "The French Connection: Emile Guimet's Mission to Japan: A Cultural Context for Japonisme," *Japan in Transition: Thought and Action in the Meiji Era, 1868-1912*, ed. Hilary Conroy, Sandra Davis, and Wayne Patterson (Rutherford, N.J.: Fairleigh Dickinson University Press, 1984), p. 131.

16. See Bernard Frank, *Le panthéon bouddhique au Japon—Collection d'Emile Guimet* (Paris: Musee National des Arts Asiatiques Guimet, 1991), pp. 18–30. The source of Ph. Fr. von Siebold's information was the *Butsuzō zui*, an illustrated manual of Buddhist iconography. Guimet also consulted a 1796 edition of this text.

17. See note 16 above. These and other acquisitions are also illustrated and discussed in an exhibition catalogue commemorating the centenary of the founding of the Guimet Museum. See Matsumoto Eiichi et al., comps., *Fransu Kokuritsu Guimet Bijutsukan sōritsu hyakunen kinen* (Tokyo: Seibu Department Stores Ltd., 1989), pp. 24–35.

18. Machida's career is discussed in Tōkyō Kokuritsu Hakubutsukan, comp., *Tōkyō Kokuritsu Hakubutsukan hyakunen shi*, pp. 24–37.

19. Germain Bazin, *The Museum Age* (New York: Universe Books, 1967), p. 218.

20. On the evolution of the concept of the museum in Japan, see Shiina Noritaka, *Meiji Hakubutsukan koto hajime* (Tokyo: Shibunkaku shuppan, 1989), especially, pp. 21–36 and 48–54.

21. The survey report entitled *Kohinbutsu mokuroku* is reproduced in *Museum* 263 (February 1973): 30–33; 264 (March 1973): 330–33; and 266 (May 1973): 30–33. Related documents concerning the survey are reproduced and discussed in Tōkyō Kokuritsu Hakubutsukan, comp., *Tōkyō Kokuritsu Hakubutsukan Hyakunen shi*, pp. 72–80.

22. See Matsudaira Sadanobu, ed., *Shūkō jisshū* (Tokyo: Kokusho Kankōkai, 1908). A survey had been carried out still earlier in 1661 under the direction of Tokugawa Mitsukuni, the second daimyo of Mito domain. See Ketelaar, *Of Heretics and Martyrs in Meiji Japan*, pp. 47–48.

23. For a list of exhibitors and their contributions, see Tōkyō Kokuritsu Hakubutsukan, comp., *Tōkyō Kokuritsu Hakubutsukan hyakunen shi*, pp. 54–58.

24. Miki Fumio," Koko chinretsu-hin shūshū no kōgai," *Museum* 262

(January 1973): 4–10 and chronological chart of acquisitions on p. 30. These acquisitions also point to the growing effort to glorify the imperial family and trace its origins to prehistoric times.

25. *The Diary of Kido Takayoshi*, February 9, 1877, 3:439–40.

26. The documents are reproduced and discussed by Okudaira Hideo in "Tōkyō Kokuritsu Hakubutsukan hōkan jōdai retsu ni tsuite—toku ni Hōryūji hōmotsu no kennō to sono go ni kansuru shiryō," *Museum* 390 (September 1983): 4–18.

27. A notice appeared in the *Choya Shinbun* on Meiji 11/1/22 and in the same paper again on Meiji 12/10/5. See *Shinbun shūsei Meiji hennenshi*, 3:348 and 4:111.

28. Fenollosa collaborated with many dealers in organizing exhibitions and writing catalogues. He wrote the text of sales catalogues for the Knickerbocker Club in 1896 and for Yamanaka in 1908 (*The Masters of Ukiyo-e*, [New York: Knickerbockers, 1896] and *Catalogue of an Exhibition of Ukiyo-e Paintings and Prints* [New York: Alexander Press, 1908]). He also was involved in the acquisition of four important Chinese paintings from Daitokuji following their display at the Museum of Fine Arts, Boston, in 1894. See Wen Fong, *Lohans and a Bridge to Heaven* (Washington, D.C.: Freer Gallery of Art, 1958), pp. 2–6.

29. The whole catalogue has never been published. It is reproduced and discussed in part by Yamaguchi Seiichi in *Fenollosa: Nihon bunka no senyō ni sasageta issei*, 1:122–23, and Akiyama Terukazu, "Fenollosa kankei shiryō (1): Tekō Nihon kaiga manshu-hin kaisetsu tsuke so-mokuroku," *Zaigai Nihon no shihō, bekkan* (Tokyo: Mainichi Shinbunsha, 1978), pp. 30–35. On the painting of the Buddha Śākyamuni preaching on the Vulture Peak, see *Zaigai Nihon no shihō*, vol. 1: *Bukkyō kaiga*, ed. Yanagisawa Taka (Tokyo: Mainichi shinbunsha, 1980), entry 1.

30. The text is reproduced in Akiyama, "Fenollosa kankei shiryō (1)," p. 35.

31. Fenollosa, *Epochs of Chinese and Japanese Art*, 1:xviii.

32. *Jijōden*, pp. 599–603, and *Seigai Inoue koden*, 5:528–29.

33. *Seigai Inoue koden*, 3:530. The present whereabouts of these paintings is unknown.

34. Ibid., 3:813.

35. Ko Dan Danshaku Denki Hensan Iinkai, ed., *Danshaku Dan Takuma den* (Tokyo: Kyōdo Insatsu Kabushiki Gaisha, 1938), 2:311, and Yamaguchi, *Fenollosa*, 1:190.

36. Roberts, *Mitsui*, pp. 130–35.

37. *Danshaku Dan Takuma den*, 1:222–24.

38. On the history of this scroll, see Iijina Shunkei, ed., *Nihon shodō taikei*, (Tokyo: Kodansha, 1971), 2:64.

39. This date is based the first reference to the display of this scroll at the Daishi kai. See Takahashi Sōan, comp., *Daishi kai tenkan zuroku* (Tokyo: Shinbi Shoin, 1911), p. 16.

40. Cited in Kenneth B. Pyle, *The New Generation in Meiji Japan: Problems of Cultural Identity, 1885–1895* (Stanford : Stanford University Press, 1969), p. 174.

41. Ibid., p. 174.

42. List based on record of first Daishi kai reproduced in Takahashi Sōan, comp., *Daishi kai tenkan zuroku* (Tokyo: Shinbi Shoin, 1911), p. 3.

43. It is reproduced in Nihon Keizai Shinbun, comp., *Masuda Don'ō ten*, catalogue entry 18.

44. On this work, see Haruna Yoshishige, comp., *Kohitsu daijiten* (Kyoto: Tankōsha, 1979), pp. 46–47.

45. According to the record of the Daishi kai of 1909, they were in the form of three scrolls. By 1928, when Masuda exhibited them again, there were only two scrolls in his possession.

46. On this painting, see John Rosenfield and Elizabeth ten Grotenhuis, *Journey of the Three Jewels: Japanese Buddhist Paintings from Western Collections* (New York: The Asia Society, 1979), pp. 85–87.

47. A photograph taken in 1938 shows this huge work hung in an alcove with a drum core and various Buddhist ritual implements resting on the shelf beneath it. See *Geijutsu shinchō* 5 (1983): 54.

48. See Takahashi, comp., *Daishi kai tenkan zuroku*, p. 3.

49. See photo in *Geijutsu shinchō* 5 (1983): 42.

50. The photograph, the tea it commemorates, and the background of the three lacquer panels are discussed in Matsuda Nobuo, *Bijutsu wadai shi: kindai no sukishatachi* (Tokyo: Yomiuri Shinbun, 1986), pp. 107–12.

51. Masaki Naohiko, "Masuda Don'ō to kobijutsu hōgo," in *Daichajin Masuda Don'ō*, pp. 44–45.

52. Tanaka Shinbi, "Shumi kōyū gojūnen," in *Daichajin Masuda Don'ō*, p. 103. This work is now in the collection of the Gotoh Art Museum.

53. On Masuda's friendship with this Hōryūji monk, see Hagino Chujirō, "Bukkyō bijutsu to Don'ō," in *Daichajin Masuda Don'ō*, p. 49.

54. Takahashi, comp., *Daishi kai tenkan zuroku*, pp. 12–13.

55. Ibid., p. 19. For the early reproduction, see *Kokka* 63 (1894), pl. 1.

56. See *Kokka* 118 (1899): 186. For a modern scholarly assessment, see *Zaigai Nihon no shihō*, vol. 1: *Bukkyō kaiga*, entry 50.

57. For the complete list of items and a photograph of one of the rooms arranged for this tea ceremony, see Tanaka Hisao, "Kindai ni okeru chadō to bijutsu," in *Chadō shūkin*, vol. 6: *Kindai no chanoyu*, pp. 138–40.

58. On the statue of Tobatsu Bishamonten, see *Zaigai Nihon no shihō*, vol. 8: *Chōkoku*, ed. Kurata Bunsaku, entry 56. Both this statue and the shrine panel were also included in a private exhibition organized by Masuda in 1928 that was accompanied by a privately printed catalogue entitled *Hekiundai tenkan*.

CHAPTER 5. THE NEW DAIMYO

1. Nagaoka Osamu, for instance, who joined Mitsui in 1918, declared that the practice of tea was one of the traits that distinguished the executives of Mitsui from those at Mitsubishi. See interview in *Zaikaijin shisō zenshū*, vol. 10: *Zaikaijin no shumi*, ed. Tanaka Yoshinosuke (Tokyo: Daiamondo-sha, 1971), p. 35.

2. Masaki Naohiko, "Masuda Don'ō no kobijutsu hōgo," in *Daichajin Masuda Don'ō*, p. 43.

3. Kozo Yamamura, "General Trading Companies in Japan: Their Origins and Growth," in *Japanese Industrialization and Its Social Consequences*, ed. Hugh Patrick, p. 180.

4. Roberts, *Mitsui*, pp. 227 and 245.

5. Mitsui Trading Company became a joint stock company in 1907,

and in 1909 the various Mitsui enterprises were organized into a holding company. Masuda's share in the company is not known.

6. The marriage also drew Masuda closer to the Sumitomo family, through Morinosuke's brother-in-law Sumitomo Kichizaemon II. See Roberts, *Mitsui*, pp. 235–36.

7. Quoted in ibid., p. 300.

8. Masuda's name appears in list published in *Jiji shinpō*, dated Meiji 34/9/22, reproduced in *Shinbun shūsei Meiji hennenshi*, 11:314–17.

9. Yashiro Yukio, "Sankei Sensei no kobijutsu teiki," *Wasure enu hitobito* (Tokyo: Iwanami Shoten, 1984), pp. 225–30.

10. *Jijōden*, pp. 599–602.

11. Masuda's painting is reproduced in *Chadō shūkin*, vol. 6: *Kindai chanoyu*, pl. 13.

12. Takahashi, *Kinsei dōgu idō shi*, pp. 174–75.

13. Ibid., pp. 150–51.

14. Ibid., pp. 266–67.

15. Shirayanagi Shuko, *Nakamigawa Hikōjirō den* (Tokyo: Iwanami Shoten, 1940), p. 213.

16. Takahashi, *Kinsei dōgu idō shi*, pp. 145–48.

17. Ibid., p. 100.

18. Fujihara, *Omoide no hitobito*, pp. 11–13.

19. Conversation recorded in diary of Takahashi Sōan (Yoshio), *Banshoroku* (Tokyo: Shibunkaku shuppan, 1987), Taishō 4/3/29, 3:105.

20. On this box, see Beatrix von Ragué, *A History of Japanese Lacquerwork* (Toronto: University of Toronto Press, 1976), pp. 116–17.

21. Pocket diary entries for May 11–24, 1907. Charles Lang Freer Papers.

22. Takahashi, *Kinsei dōgu idō shi*, pp. 185–95.

23. Letter from Hara Tomitarō to Charles Freer, December 4, 1916. Charles Lang Freer Papers.

24. This painting is discussed in Miyeko Murase, *Japanese Art: Selections from the Mary and Jackson Burke Collection* (New York: Metropolitan Museum of Art, 1975), entry 43.

25. Takahashi, *Kinsei dōgu idō shi*, pp. 220–21. For reproductions of these works, see *Masuda Don'ō iai meihin-ten*, entry 44, and *Masuda Don'ō Miyabi*, vol. 4 (Tokyo: Setsu Gatodo, 1980), entry 16.

26. For list of items and buyers, see Takahashi, *Kinsei dōgu idō shi*, pp. 213–20.

27. Takeuchi Hirōtarō, "Kore mo yo zo no hakogaki," in *Daichajin Masuda Don'ō*, p. 181, and letter from Charles Freer to Mansfield, April 11, 1908, cited in Helen Nebeker Tomlinson, "Charles Lang Freer, Pioneer Collector of Oriental Art," Ph.D. dissertation, Case Western Reserve University, 1979, p. 519.

28. Takahashi joined Masuda in most of the discussions. See his diary entries in *Banshoroku*, Taishō 6/10/24–29, 6:379–86; 6/11/2, 6:390; and 6/11/9, 6:399–400. An account of the entire proceedings, including the resale following Yamamoto's bankruptcy not covered in the diary, is contained in Takahashi, *Tōto chakaiki*, 5:365–73.

29. For a reproduction and brief discussion of this work, see *Chadō shūkin*, vol. 6: *Kindai no chanoyu*, pl. 1.

30. The 8,204 woodblock prints became the possession of the Fifteenth

Bank. Since the bank was unable to find a buyer for them, they were presented to the Imperial Household. In 1943 they were transferred to the Tokyo National Museum. Julia Meech, *The Matsukata Collection of Ukiyo-e Prints* (New Brunswick, N.J.: Jane Voorhees Zimmerli Art Museum, 1988), p. 17.

31. For summaries of the art auctions precipitated by the bank panic, see National Committee of Intellectual Cooperation, comp., *The Yearbook of Japanese Art* (Tokyo: 1929), pp. 96–102.

32. Thomas R. Schalow, "The Role of the Financial Panic of 1927 and Failure of the Fifteenth Bank in the Economic Decline of the Japanese Aristocracy," Ph.D. dissertation, Princeton University, 1989, pp. 157–58.

33. Cited in Ryusaku Tsunoda, William de Bary, and Donald Keene, eds., *Sources of Japanese Tradition* (New York: Columbia University Press, 1967), 1:394.

34. Cited in Byron K. Marshall, *Capitalism and Nationalism in Prewar Japan* (Stanford: Stanford University Press, 1967), p. 45.

35. Johannes Hirshmeier, "Shibusawa Eiichi: Industrial Pioneer," in *The State and Economic Enterprise in Japan*, ed. William Lockwood (Princeton: Princeton University Press, 1970), pp. 237–45.

36. Masuda, *Japan and Its Commercial Developments and Prospects*, p. 20.

37. Masuda Don'ō "Don'ō shumi zuisō (II)," *Yakimono shumi* 5/4 (1935), pp. 11–12.

38. See Akai Shōtarō, "Joshiki kore wa cha," in *Daichajin Masuda Don'ō*, pp. 145–46.

39. Fujihara, "Chitoku kenbi no daichajin," in *Daichajin Masuda Don'ō*, pp. 117–19. The incident involving Magoshi is also recounted in Otsuka, *Magoshi Kyōhei Ōden*, pp. 381–82.

40. For reproductions and brief discussion of this and similar vases, see *Chadō shūkin*, vol. 10: *Cha no dōgu 1*, ed. Hayashiya Seizō, pl. 2 and 3.

41. Otsuka, *Magoshi Kyōhei Ōden*, pp. 56–70.

42. Roberts, *Mitsui*, p. 225.

43. The screens are discussed and reproduced in their entirety in Nakamura Tanio, *Sesson to Kantō suibokuga*, *Nihon no bijutsu* 63 (Tokyo: Shibundō, 1971), pp. 74–77.

44. Theodore Ludwig, "Chanoyu and Momoyama," in *Tea in Japan*, p. 72.

45. The names of Wakai, Yamazumi, and Umezawa first appear in the record of the fourth gathering, held in 1899. Kohitsu Ryōchū's appears the following year, and Osaka dealer Toda's in 1900. Kōkodō mounted an impressive display in 1903. See Takahashi, comp., *Daishi kai tenkan zuroku*, pp. 5–6 and 11.

46. *Jijōden*, pp. 375–77.

47. Takahashi, comp., *Daishi kai tenkan zuroku*, pp. 12–13.

48. Ibid., pp. 19–22.

49. The *Daishi kai tenkan zuroku* covers only the first fifteen gatherings. The list of hosts and guests at the seventeenth is reproduced in Kumakura, "Sukisha no chanoyu," in *Chadō shūkin*, vol. 6: *Kindai no chanoyu*, p. 112.

50. Takahashi, *Banshoroku*, Taishō 5/III/20, 4:95. This version of the scroll, which belonged to Kōfukuji, has since come to be known as the Masuda B scroll to distinguish it from the slightly earlier one (Masuda A) referred to

in chapter 4. See Rosenfield and ten Grotenhuis, *Journey of the Three Jewels*, pp. 41–43.

51. Shirasaki, *Don'ō: Masuda Takashi*, 1:85.

52. Nakamura Masao, "Sukisha o sasaeta Oki Rōdō," in *Chadō shūkin*, vol. 6: *Kindai no chanoyu*, p. 150

53. The park, which includes a French garden with a fountain surrounded by formal flower beds, opened in 1914 as the centerpiece of a development project conceived by Sōgō Seishirō, head of the Odawara Electric Railroad Company, which ran the cable car that first made this scenic area accessible to tourism. Sōgō, who sold large lots around the park to members of the Mitsui, Iwasaki, Masuda, and other industrialist families, invited Masuda to build a teahouse in the grounds. In 1922 and 1940 two additional teahouses were built adjacent to Masuda's under the direction of two fellow industrialists, Hara Tomitarō and Matsunaga Yasuzaemon (1875–1971). See Nakamura Masao, "Kindai no chashitsu," in *Chadō shūkin*, vol. 7: *Zashiki to roji*, ed. Nakamura Masao, pp. 287–90.

54. Cited in Kumakura, "Matsudaira Fumai," p. 29.

55. The collection was not auctioned until 1925. See Takahashi, *Kinsei dōgu idō shi*, pp. 344–55.

56. Takahashi, *Banshoroku*, Taishō 6/10/20, 5:373–74.

57. *Jijōden*, p. 452.

58. The scroll is reproduced in *Chadō shūkin*, vol. 6: *Kindai no chanoyu*, pl. 85.

59. Letter from Charles Freer to D. W. Tryon, July 7, 1907. Henry C. White Papers, Archives of American Art (D200), Freer/Sackler Galleries, Smithsonian Institution.

60. For photographs of the various historic buildings on Hara's estate, see Christine Guth, "A Tale of Two Collectors: Hara Tomitaro and Charles Lang Freer," *Asian Art* (Fall 1991): 29–49.

61. The following account of the event is based on a report by Takahashi contained in his *Taishō chadōki*, 1:55–72.

CHAPTER 6. NATIONAL TREASURES

1. *Jijōden*, pp. 217–18.

2. See *Seigai Inoue koden*, 5:528; Yashiro, "Sankei Sensei no kobijutsu teiki," *Wasure enu hitobito*, pp. 219–20.

3. Okura's speech is recorded in Takahashi's diary. See *Banshoroku*, Taishō 5/11/27, 4:418.

4. The law is reproduced in *Nihon kindai bijutsu hattatsu-shi (Meiji-hen)*, comp. Urasaki Eishaku (Tokyo: Tokyo Bijutsu, 1974), pp. 182–88.

5. Cited in Eugene Soviak, "Journal of the Iwakura Embassy," in *Tradition and Modernization in Japanese Culture*, ed. Donald Shiveley (Princeton: Princeton University Press, 1971), p. 25.

6. Takahashi, *Kinsei dōgu idō shi*, introduction, p. 2.

7. Rutherford Alcock, *The Capital of the Tycoon: A Narrative of Three Years Residence in Japan* (New York: Harper, 1863), 2:243.

8. For a discussion of this controversy, see Rosenfield, "Western-Style Painting in the Early Meiji Period and Its Critics," in *Tradition and Modernization in Japanese Culture*, esp. pp. 208–10.

9. Quoted in Neil Harris, "All the World a Melting Pot? Japan at American Fairs, 1876–1904," in *Mutual Images: Essays in American-Japanese Relations*, ed. Akira Iriye (Cambridge: Harvard University Press, 1975), pp. 33–34.

10. Percival Lowell, *The Soul of the Far East* (Boston: Houghton Mifflin, 1898), p. 148.

11. Quoted in Pyle, *The New Generation in Meiji Japan*, pp. 69 and 95.

12. *Miyake Setsurei-shū*, in *Meiji bungaku zenshū*, ed. Yanagida Izumi (Tokyo: Chikuma Shobo,1967), 33:216.

13. Ibid., p. 210.

14. Quoted in Pyle, *The New Generation in Meiji Japan*, pp. 85 and 148.

15. Author's translation. Guimet, *Promenades Japonaises*, p. 29; Morse, *Japan Day by Day*, 2:105.

16. James L. Bowes, *Japanese Pottery* (London: Edward Howell, 1890), pp. vii–ix.

17. On this subject, see Masuda Takashi, "Japanese Trade," in *Fifty Years of New Japan*, ed. Okuma Shigenobu (London: Smith, Elder and Co., 1909), 2:639.

18. J. J. Rein, *The Industries of Japan* (New York: Armstrong and Son, 1899), p. 377.

19. This bitter trans-Atlantic feud is discussed and analyzed in Richard Wilson, "Tea Taste in the Era of Japonisme: A Debate," *Chanoyu Quarterly* 50 (1987): 23–39.

20. Louisine W. Havemeyer, *Sixteen to Sixty: Memoirs of a Collector* (New York: privately printed, 1961), p. 74.

21. The article, reprinted as an appendix to Bowes, *Japanese Pottery*, p. 553, must date from before 1890. Its precise date is not known.

22. Letter from Charles Freer to Colonel Hecker, May 30, 1907. Charles Lang Freer Papers.

23. Reitlinger, *The Economics of Taste* (London: Barrie and Rockliff, 1963), 2:216.

24. Letter from Charles Freer to Colonel Hecker, May 6, 1907. Charles Lang Freer Papers.

25. Shimada Shūjirō, Akiyama Terukazu, and Yamane Yūzō, eds., *Zaigai Nihon no shihō*. (Tokyo: Mainichi Shinbunsha, 1980). 10 vols. Although these volumes do offer valuable insights into patterns of collecting in the pre-war years, it is important to keep in mind that the selection reflects the views of individual scholars. Even today there is not always consensus on what constitutes an "important" work of art.

26. Woodblock prints have been omitted from this tabulation since most have changed hands so often that, for the purposes of this study, their accession numbers are meaningless.

27. For reproductions of these scrolls and screens, see *Zaigai Nihon no shihō*, vol. 2: *Emakimono*, ed. Akiyama Terukazu, pls. 1–8, and vol. 5: *Rinpa*, ed. Yamane Yūzō, pls. 26–31.

28. As far as I know, the only first-hand account of their meeting is contained in the unpublished diary kept by Mary, Fenollosa's second wife, during their stay in Japan. Oral communication from Ellen Conant.

29. It is possible that more about their relationship will be revealed when the catalogue of Fenollosa's acquisitions, discussed in chapter 4, is published in its entirety.

30. Walter Muir Whitehall, *Museum of Fine Arts Boston: A Centennial History* (Cambridge: Harvard University Press, 1970), 1:113. The original letter is in the collection of the Peabody Museum, Salem.

31. Cited in Lawrence Chisolm, *Fenollosa: The Far East and American Culture* (New Haven: Yale University Press, 1963), p. 77.

32. Unlike Masuda, Hara was a patron of contemporary painters, many of whom had studied at the Tokyo School of Fine Arts (Nihon Bijutsuin) when Okakura was director there. See Tanaka, *Bijutsuhin idō shi*, pp. 87–91.

33. Whitehall, *Museum of Fine Arts Boston: A Centennial History*, 1:116.

34. Letter from Charles Freer to Colonel Hecker, May 6, 1907. Charles Lang Freer Papers.

35. On these works, see *Zaigai Nihon no shihō*, vol. 3: *Suibokuga*, ed. Shimada Shūjirō, entry 4.

36. Letter from Charles Freer to Colonel Hecker, June 15, 1907. Charles Lang Freer Papers.

37. On the statues of Shō Kannon, see John Rosenfield and Shūjirō Shimada, *Traditions of Japanese Art: Selections from the Kimiko and John Powers Collection* (Cambridge: Fogg Art Museum, Harvard University, 1970), entry 27.

38. Tamai, "Nara kohinbutsu to Masuda Ō," in *Daichajin Masuda Don'ō*, p. 178.

39. Pocket diary entry, May 19, 1907. Charles Lang Freer Papers.

40. On these statues, see *Zaigai Nihon no shihō*, vol. 8: *Chōkoku*, entries 51–52.

41. Tamai, "Nara kohinbutsu to Masuda Ō," in *Daichajin Masuda Don'ō*, pp. 178–79.

42. Letter from Nomura Yōzō to Charles Freer, September 19, 1907. Charles Lang Freer Papers.

43. Letter from Nomura Yōzō to Charles Freer, November 29, 1907. Charles Lang Freer Papers.

44. Tomlinson, "Charles Lang Freer," pp. 517–19.

45. Letters from Masuda Takashi to Charles Freer, February 28, 1916, and December 17, 1914. Charles Lang Freer Papers. For a modern assessment of this work, see *Zaigai Nihon no shihō*, vol. 5: *Rimpa*, entries 5–10.

46. These pots were not included in Freer's bequest to the Smithsonian. Their present whereabouts is unknown.

47. Nozaki Hirota, *Chakai manroku* (Tokyo: n.p., 1923), 10:124.

48. See Takahashi, *Tōto chakaiki*, 2:523–34; 3:415–23; and 5:300–306.

49. Even Masaki Naohiko, director of Tokyo Art School (Tokyo Geijutsu Daigaku) and a close associate of Masuda's, criticized his shortsightedness. Masaki, "Masuda Don'ō to kobijutsu," in *Daichajin Masuda Don'ō*, p. 46.

50. Takahashi, *Kinsei dōgu idō shi*, introduction, p. 2.

51. See Tōkyō Kokuritsu Hakubutsukan, comp., *Tōkyō Kokuritsu Hakubutsukan hyakunen shi*, especially pp. 60–63.

52. See note 4 above.

53. See, for instance, Committee of Living National Treasures of Japan, comp., *Living National Treasures of Japan* (Boston, Chicago, and Los Angeles, 1982–83), exhibition catalogue.

54. For a photograph of the original basket and a discussion of its history, see *Chadō shūkin*, 10: *Cha no dōgu* 1, entry 43.

55. Takeda, *Tanaka Shinbi*, p. 258.

56. On the scroll of "Excellent Bulls," two fragments of which are in American collections, see *Zaigai Nihon no shihō*, vol. 2: *Emakimono*, entries 48–49. The three fragments of the "Anthology of the Thirty-six Poets" in American collections are discussed in John Rosenfield and Yoshiaki Shimizu, *Masters of Japanese Calligraphy 8th–19th Century* (New York: Asia Society and Japan Society, 1984), entries 9–10.

57. Takeda, *Tanaka Shinbi*, pp. 54–70.

58. Takahashi, *Banshoroku*, Taishō 2/3/21, 1:271.

59. Ibid., Taishō 6/3/1, 5:89–90.

60. Ibid., p. 90.

61. Nozaki, *Chakai manroku*, 10:62–74.

62. See, for instance, Takahashi, "Kahō to kokuhō," in *Tōto chakaiki*, 4:388–94.

63. Yokoi Hanjirō, "Odawara no Don'ō," in *Daichajin Masuda Don'ō*, pp. 248–49.

64. See Yoshizawa Chu, "Meiji Taishō jidai to gendai to no kobijutsuhin hyochi no henka: 'koshaji hōzon hō' to 'bunkazai hōgo hō' to no taihi o chūshin ni," *Kokka* 949 (1972): 28–35, and *The Yearbook of Japanese Art 1929–30* (Tokyo: National Committee on Intellectual Cooperation of the League of Nations Association of Japan, 1930), pp. 19–20.

CONCLUSION

1. Okuma Shigenobu, ed., *Fifty Years of New Japan*, 2:342–44.

2. Frederick Baekeland, "Psychological Aspects of Art Collecting," *The Journal of Psychiatry* 44, 1 (February 1981): 46.

3. Ibid., p. 50.

4. Letter from Charles Freer to Frank Hecker, February 23, 1895. Charles Lang Freer Papers.

Select Bibliography

Note: Chadō koten zenshū, ed. Sen Sōshitsu, 12 vols. (Kyoto: Tankōsha, 1956–62) is abbreviated as *CKZ*.

JAPANESE-LANGUAGE SOURCES

Fujihara Ginjirō. *Omoide no hitobito* (Men I remember). Tokyo: Daimondo-sha, 1950.

Hatakeyama Art Museum, comp. *Masuda Don'ō iai meihin ten* (Exhibition of treasures from Masuda Don'ō's collection). Tokyo: Hatakeyama Kinen-kan and Nihon Keizai Shinbun, 1983.

Iguchi Kaisen, ed. *Chadō* (The way of tea). 15 vols. Tokyo: Sōgensha, 1935–37.

Iijima Shinkei, comp. *Nihon shodō taikei* (Comprehensive collection of Japanese calligraphy). 8 vols. Tokyo: Kodansha, 1971.

Imaizumi Atsuo et al., eds. *Kyoto no rekishi* (History of Kyoto). 10 vols. Kyoto: Gakugei Shōrin, 1968–1976.

Inoue Kaoru Denki Hensankai, comp. *Seigai Inoue kōden* (Biography of Inoue Seigai). 5 vols. Tokyo: Naigai Shoko Kabushiki Gaisha, 1933–34.

Kamiya Sōtan. *Sōtan nikki* (The diary of Kamiya Sōtan). *CKZ* 6:175–382.

Kitano daichanoyu no ki (Record of the grand Kitano tea gathering). *CKZ* 6: 3–48.

Ko Dan Danshaku Hensan Iinkai, ed. *Danshaku Dan Takuma-den* (Biography of Baron Dan Takuma). 2 vols. Tokyo: Kyōdo Insatsu Kabushiki Gaisha, 1938.

Kobori Enshū. *Kobori Enshū kakisute bumi* (Kobori Enshū's random jottings). *CKZ* 11:137.

Kumakura Isao. *Kindai chadō shi no kenkyū* (Studies in the modern history of the tea ceremony). Tokyo: NHK Shuppan, 1980.

Kunaichō Jishūshoku, comp. *Gyomotsu shūsei* (Masterpieces from the Imperial Household Collection). 4 vols. Tokyo: Asahi Shinbunsha, 1978.

Masuda Don'ō. "Don'ō shumi zuisō" (Donō's random thoughts about his hobbies). *Yakimono shumi(2)* 5, 4 (1935): 9–13.

Masuda Takashi, comp. *Enshū kurachō zukan* (Enshū's storehouse: An illustrated catalogue). Tokyo: Hōundo, 1938.

Masuda Yoshinobu. "Kaden no Genji emaki—watakushi no kokuhō" (My family's Genji scrolls—our national treasure). *Geijutsu shinchō* 10 (1953): 129–32.

Matsuda Nobuo. *Bijutsu wadai shi: kindai no sukishatachi* (Topics in the history of art: Modern collectors). Tokyo: Yomiuri shinbun, 1986.

Matsudaira Fumai, comp. *Unshū meibutsu* (Treasure of Izumo). *CKZ* 12: 371–411.

Meihō Kankokai, comp. *Tanaka Shinbi: Heian-chō bi no sosei ni sasageta hyaku-nen no seijun* (Tanaka Shinbi: A hundred-year life devoted to the revival of Heian period art). Tokyo: Tendensha, 1985.

Meiji Hennenshi Hensankai, comp. *Shinbun shūsei Meiji hennenshi* (Compendium of articles from Meiji era newspapers). 15 vols. Tokyo: Zaiseikyō Saigakukai, 1934–36.

Mitsui Zaidan Hōnin Mitsui Bunko, comp. *Mitsui jigyō shi* (History of the Mitsui business). 8 vols. Tokyo: Mitsui Bunko, 1980.

Nagai Minoru, ed. Masuda Takashi. *Jijō Masuda Takashi ō-den* (Autobiography of Masuda Takashi). Tokyo: private printing, 1939.

Nakamura Masao et al., eds. *Chadō shūkin* (Tapestry of tea). 13 vols. Tokyo: Shōgakkan,1983–87.

Nanbō Sōkei. *Nanbōroku* (Records of the monk Nanbō). *CKZ* 4:3–451.

Nezu and Tokugawa Bijutsukan, comps. *Higashiyama gyomotsu: "zakkashi-tsuin" ni kansuru shin shiryō o chūshin ni.* (Masterpieces from the Higashiyama Collection: New materials concerning works bearing the "zakkashitsu" seal). Tokyo, 1976.

Nihon Keizai Shinbun, comp. *Masuda Don'ō ten* (Masuda Don'ō exhibition). Tokyo: Nihon Keizai Shinbunsha, 1983.

Nōami and Soami, comps. *Kundaikan sayu chōki* (Manual of connoisseurship of Chinese art). *CKZ* 2:284–322.

Noma Seiroku et al., eds. *Zusetsu chadō taikei* (An illustrated compendium of the tea ceremony). 7 vols. Tokyo: Kadokawa Shoten, 1962–65.

Nozaki Hirota. *Chakai manroku* (Random notes on tea gatherings). 12 vols. Tokyo: N.p. 1923.

Ōtsuka Eizō. *Magoshi Kyōhei ōden* (Biography of Magoshi Kyōhei). Tokyo: Magoshi Kyōhei ōdenki Hensankai, 1935.

Sen Sōshitsu, ed. *Chadō koten zenshū* (Complete collection of tea classics). 12 vols. Kyoto: Tankosha, 1956–62.

Shimada Shūjirō et al., eds. *Zaigai Nihon no shihō* (Treasures of Japanese art abroad). 10 vols. Tokyo: Mainichi Shinbunsha, 1980.

Shirasaki Hideo. *Don'ō Masuda Takashi.* 2 vols. Tokyo: Shinchosha, 1981.

Shirayanagi Shūko. *Nakamigawa Hikōjirō den* (Biography of Nakamigawa Hikōjirō). Tokyo: Iwanami Shoten, 1940.

Takahashi Sōan (Yoshio). *Banshoroku: Takahashi Sōan nikki* (The diary of Takahashi Sōan). 5 vols. Tokyo: Shibunkaku Shuppan, 1961.

———. *Shōwa chadōki* (Tea records of the Shōwa era). 5 vols. Tokyo: Keibun-dō Shoten, 1929.

———. *Taishō meikikan* (Mirror of treasures of the Taishō era). 9 vols. Tokyo: Hōunsha, 1921–26.

———. *Tōtō chakaiki* (Records of tea gatherings in Tokyo). 5 vols. Tokyo: Tankōsha 1989.

Takahashi Soan, comp. *Daishi kai tenkan zuroku* (Illustrated catalogue of the Daishi kai). Tokyo: Shinbi Shoin, 1911.

Takahashi Yoshio. *Kinsei dōgu idō shi* (A history of the transmission of tea-wares in modern times). Tokyo: Keibundō Shoten, 1929.

Tanaka Hisao. *Bijutsuhin idō shi: kindai Nihon no korekutatachi* (History of the transmission of art: Modern Japanese collectors). Tokyo: Nihon Keizai Shinbunsha, 1981.

Tani Shin'ichi. "Gyomotsu on'e mokuroku" (Record of the treasures in the Ashikaga shogunal collection). *Bijutsu kenkyū* 58 (1936): 439–47.

Tokyo Kokuritsu Hakubutsukan, comp. *Tokyo Kokuritsu Hakubutsukan hyaku-nen shi* (One-hundred-year history of Tokyo National Museum). Tokyo: 1973.

Yamaguchi Seiichi. *Fenollosa: Nihon bunka no senyō ni sasageta issei* (Fenollosa: A life devoted to the promotion of Japanese culture). 2 vols. Tokyo: Sanseido, 1982.

Yamanoue Sōji. *Yamanoue Sōjiki* (The records of Yamanoue Sōji). *CKZ* 6: 50–116.

Yano Fumio. *Yasuda Zenjirō den* (The biography of Yasuda Zenjirō). Tokyo: Yasuda Hōzensha, 1925.

Yashiro Yukio. "Sankei Sensei no kobijutsu teichō" (Hara Sankei's notes on traditional art). *Wasure enu hitobito*, pp. 209–343. Tokyo: Iwanami Shoten, 1984.

Yokoi Yau, ed. *Daichajin Masuda Don'ō* (Masuda Don'ō, the great man of tea). Tokyo: Gakugei Shoin, 1939.

Yoshimizu Tsuneo. "Haibutsu kishaku no gyoko: shaji hōmotsu chosa no 'Ninagawa nikki' kara"(A survey of temple and shrine treasures based on Ninagawa's diary). *Geijutsu shinchō* 3 (1973): 71–77.

Zaikaijin no shumi (Industrialists' hobbies). Volume 10 of *Zaikaijin shisō zen-shū*. Edited by Tanaka Yoshinosuke. Tokyo: Daimondosha, 1971.

Western-Language Sources

Alsop, Joseph. *The Rare Art Traditions: The History of Art Collecting and Its Linked Phenomena*. New York: Harper and Row, 1982.

Baekeland, Frederick. "Psychological Aspects of Art Collecting." *Journal of Psychiatry* 44, 1 (February 1981): 45–59.

Brown, Kendall. "Shokado Shojo as Tea Painter." *Chanoyu Quarterly* 49 (1987): 7–40.

Conant, Ellen. "The French Connection: Emile Guimet's Mission to Japan." In *Japan in Transition: Thought and Action in the Meiji Era, 1868–1912*, edited by Hilary Conroy, Sandra Davis, and Wayne Patterson, pp. 113–46. Rutherford, N.J.: Fairleigh Dickinson University Press, 1984.

Cort, Louise Allison. "Gen'ya's Devil Bucket." *Chanoyu Quarterly* 30 (1982): 31–40.

———. "The Grand Kitano Tea Gathering." *Chanoyu Quarterly* 31 (1982): 15–44.

———. "Looking at White Dew." *The Studio Potter* 10, 2 (June 1982): 45–51; *Chanoyu Quarterly* 43 (1985): 36–48.

———. *Shigaraki: Potters Valley*. Tokyo and New York: Kodansha International, 1979.

Elison, George, and B. Smith, eds. *Warlords, Artists, and Commoners: Japan in the Sixteenth Century*. Honolulu: The University Press of Hawaii, 1981.

Evett, Elisa. *The Critical Reception of Japanese Art in the Late Nineteenth Century*. Ann Arbor: UMI Research Press, 1982.

Fenollosa, Ernest. *Epochs of Chinese and Japanese Art*. 2 vols. New York: Dover Editions, 1963.

Fraser, Andrew. "Hachisuka Mochiaki (1846–1918): A Meiji Domain Lord and Statesman." *Papers on Far Eastern History* 2 (September 1970): 43–61.

Gluck, Carol. *Japan's Modern Myths: Ideology in the Late Meiji Period*. Princeton: Princeton University Press, 1985.

Guimet, Emile. *Promenades Japonaises*. Paris: Charpentier, 1880.

Guth, Christine M. E. "A Tale of Two Collectors: Hara Tomitaro and Charles Lang Freer." *Asian Art* (Fall 1991): 29–49.

Hall, John W., and Toyoda Takeshi, eds. *Japan in the Muromachi Age*. Berkeley: University of California Press, 1977.

Haskell, Francis. *Patrons and Painters: A Study in the Relations between Italian Art and Society in the Age of the Baroque*. London: Chatto, 1963.

Hirschmeier, Johannes. *The Origins of Entrepreneurship in Meiji Japan*. Cambridge: Harvard University Press, 1964.

———. "Shibusawa Eiichi: Industrial Pioneer." In *The State and Economic Enterprise in Japan*, edited by William Lockwood, pp. 209–47. Princeton: Princeton University Press, 1970.

Jansen, Marius B., and Gilbert Rozman, eds. *Japan in Transition from Tokugawa to Meiji*. Princeton: Princeton University Press, 1988.

Ketelaar, James Edward. *Of Heretics and Martyrs in Meiji Japan: Buddhism and its Persecution*. Princeton: Princeton University Press, 1990.

Kido Takayoshi. *The Diary of Kido Takayoshi*. Translated by Sidney DeVere Brown and Akiko Hirota. 3 vols. Tokyo: University of Tokyo Press, 1983–85.

Kramer, Robert. "The Tea Cult in History." Ph.D. dissertation, University of Chicago, 1985.

Kumakura, Isao. "Matsudaira Fumai: The Creation of a New World of Chanoyu." *Chanoyu Quarterly* 25 (1980): 22–30.

Marshall, Byron K. *Capitalism and Nationalism in Prewar Japan*. Stanford: Stanford University Press, 1967.

Masuda Katsunobu. *Recollections of Admiral Baron Sotokichi Uriu*. Tokyo: Private printing, 1938.

Masuda Takashi. *Japan and Its Commercial Development*. London: Sisley's, 1908.

Meech, Julia, and Christine Guth. *The Matsukata Collection of Ukiyo-e Prints: Masterpieces from the Toyko National Museum*. New Brunswick: Jane Voorhees Zimmerli Art Museum, Rutgers University, 1988.

Meech-Pekarik, Julia. *The World of the Meiji Print*. Tokyo and New York: Weatherhill, 1986.

Morse, Edward. *Japan Day by Day*. 2 vols. Boston: Houghton Mifflin, 1917.

Nagashima Fukutaro, "Picture versus Word: Trends in Tokonoma Display." *Chanoyu Quarterly* 35 (1983): 7–15.

Okakura Kakuzō. *The Book of Tea*. New York: Dover Publications, 1964.

Okochi, Akio, and Shigeaki Yasuda, eds. *Family Business in the Era of Industrial Growth: Its Ownership and Management*. Tokyo: University of Tokyo Press, 1984.

Patrick, Hugh, ed. *Japanese Industrialization and its Social Consequences*. Berkeley: University of California Press, 1976.

Pyle, Kenneth. *The New Generation in Meiji Japan: Problems of Cultural Identity, 1885–1895*. Stanford: Stanford University Press, 1969.

Reitlinger, Gerald. *The Economics of Taste*. 3 vols. London: Barrie and Rockliff, 1963.

Roberts, John. *Mitsui: Three Centuries of Japanese Business*. Tokyo and New York: Weatherhill, 1973.

Schalow, Thomas R. "The Role of the Financial Panic of 1927 and Failure of the Fifteenth Bank in the Economic Decline of the Japanese Aristocracy." Ph.D. dissertation, Princeton University, 1989.

Shigenobu, Okuma, ed. *Fifty Years of New Japan*. 2 vols. London: Smith, Elder, 1909.

Shiveley, Donald, ed. *Tradition and Modernization in Japanese Culture*. Princeton: Princeton University Press, 1971.

Tanihata, Akio. "Men of Tea: An Evaluation of Yamanoue Sōji." *Chanoyu Quarterly* 26 (1980): 50–60; 27 (1980): 51–58; 28 (1981): 45–56.

Taylor, Francis H. *The Taste of Angels*. New York: Little, Brown, 1948.

Varley, Paul, and Kumakura Isao, eds. *Tea in Japan: Essays on the History of Chanoyu*. Honolulu: University of Hawaii Press, 1989.

Weigl, Gail. "The Reception of Chinese Painting Models in Muromachi Japan." *Monumenta Nipponica* 36, 3 (Autumn 1980): 259–72.

Wilson, Richard. "Tea Taste in the Era of Japonisme: A Debate." *Chanoyu Quarterly* 50 (1987): 23–39.

Yamamura, Kozo. "General Trading Companies in Japan: Their Origins and Growth." In *Japanese Industrialization and Its Social Consequences*, edited by Hugh Patrick, pp. 161–99. Berkeley: University of California Press, 1976.

 Index